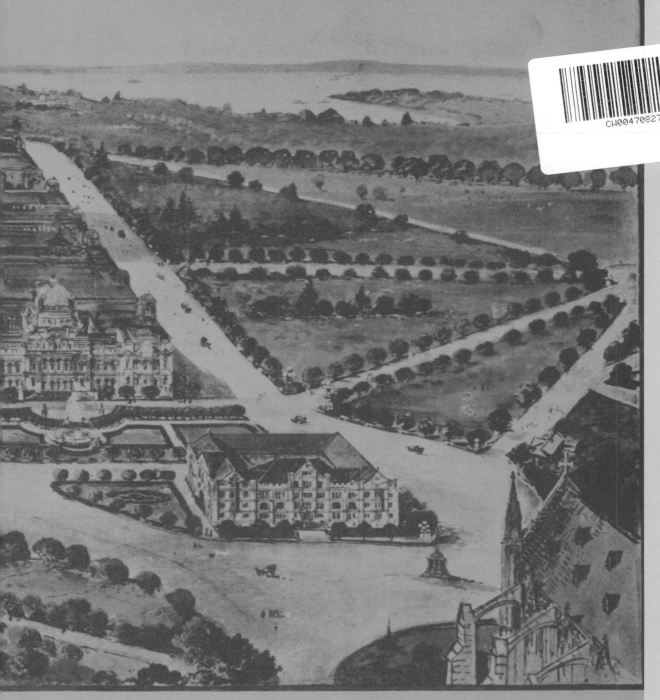

al Government House. New Thoroughfare in Domain. St. Mary's Cathedral.
nd New Moore streets). New Registrar-General's Office.
l Library.
ent House.
Hospital.
w Courts (on Site of Royal Mint).

ING ELIZABETH-STREET AND MACQUARIE-STREET WIDENED;
OUGHFARE IN THE DOMAIN; AND THE REMODELLING OF
Y THE COMMISSION.

The
Accidental
City

'The interval between the decay of the old and the formation and establishment of the new, constitutes a period of transition, which must always necessarily be one of uncertainty, confusion, error, and wild and fierce fanaticism.'

John Calhoun cited in *The Condition of Postmodernity*, edited by David Harvey (Basil Blackwell, Oxford, 1990), p 119.

DARLING HARBOUR, SYDNEY

PLANNING SYDNEY
The Accidental City
SINCE 1788

Paul Ashton

Hale & Iremonger

Authorised by Graham Joss, Town Clerk.

The Accidental City: Planning Sydney Since 1788 was commissioned to mark the Sesqui-centenary of the City of Sydney and forms part of the Sydney History Series. Other titles in the series are:

> *Chippendale: Beneath the Factory Wall*
> *Surry Hills: The City's Backyard*
> *Millers Point: The Urban Village*
> *Sydney 1842–1992*
> *Pyrmont/Ultimo* (forthcoming)

Typeset, printed & bound by
Southwood Press Pty Limited
80–92 Chapel Street, Marrickville, NSW

For the publisher
Hale & Iremonger Pty Limited
GPO Box 2552, Sydney, NSW

National Library of Australia Cataloguing-in-Publication entry

Ashton, Paul, 1959– .
 The accidental city: planning Sydney since 1788.

 Bibliography.
 Includes index.
 ISBN 0 86806 487 4.

 1. Sydney (N.S.W.) Council — History. 2. City planning — New
 New South Wales — Sydney — History. 3. Municipal government — New
 South Wales — Sydney — History 4. Sydney (N.S.W.) — History. I.
 Title. (Series: Sydney history series).

307.1216099441

Front Endpaper: Birds's-eye view of Sydney looking north from Hyde Park, 1909
Back Endpaper: Bird's-eye view showing new wharves and approaches, Jones Bay, Pyrmont, 1919
Pages 2-3: Sydney, around 1890, looking east across Darling Harbour showing the Sydney Town Hall and St Andrews Cathedral (CCS)

Contents

Abbreviations, conversions

ADB	*Australian Dictionary of Biography*
CM	Council Meeting
CPICM	City Planning and Improvements Committee Minutes
CRS	*Council Record Series*
HRA	*Historical Records of Australia*
ML	Mitchell Library
NSWPD	*New South Wales Parliamentary Debates*
NSWPP	*New South Wales Parliamentary Papers*
PC	*Proceedings of Council* (Council of the City of Sydney)
PS	*Planning Sydney: Nine planners remember,* compiled by Paul Ashton (Council of the City of Sydney, Sydney, 1992)
SMH	*Sydney Morning Herald*
TC	Town Clerk (Council of the City of Sydney)
TCR	Town Clerk's Report
VPLA	*Votes and Proceedings of the Legislative Assembly* (NSW)

Conversions

Contemporary units of measurement have been retained in this book. Distance, length and area conversions appear below. In terms of currency, the pound was equivalent to two dollars Australian in 1966. Monetary conversions should be taken as equivalents. Using 1980 values, for example, the pound was equivalent to $19.50 during the 1920s and to $11.50 in 1950.

Distance, length		*Area*
1 mile	= 1.61 km	100 acres = 40.5 hectares
1 kilometre	= 0.62 mile	
1 foot (ft)	= 30.5 cm	
1 metre (m)	= 3.28 ft	

Acknowledgements

Part of the Sesquicentenary History Project, this book owes its existence to the Council of the City of Sydney's generous and wholehearted support. Special mention should be made of Alderman Frank Sartor at whose behest the Sesqui History Project was extended to include a number of additional components, including this book, which was commissioned in mid 1991. The work was doubly facilitated by Council's respect for authorial independence. Ultimately, of course, responsibility for the opinions expressed herein and for the work rests with the author.

Working indirectly with the City Historian, Shirley Fitzgerald, and historian Christopher Keating has been a distinct privilege and a great pleasure. Both colleagues helped me to access more efficiently parts of the Council's massive and largely untapped archive with which I was unfamiliar, and they willingly shared their extensive knowledge of the City's history (not to mention the locations of the best coffee shops within walking distance of the Sydney Town Hall).

I would like to thank the staff of the Council's Information Systems Department, where the project was housed, for their friendly assistance in bringing this book to completion. Angela McGing and Renato Perdon of the City Council Archives kindly and uncomplainingly provided much advice and even more critical assistance in supplying relevant source materials. Administratively, Janet Howse and Mark Stevens looked after the planning history as part of the larger project: for this support, many thanks are due.

Research assistance was also important in bringing this short-term project to a successful conclusion. Beverley Johnson, Mary Sparke (professionally and as part of a placement from an applied history diploma at Western Australia's Murdoch University) and Judy Wing contributed significantly to collecting research material, all of which, along with the results of my own research, is permanently housed in the City Council Archives. Specifically, Mary Sparke researched most of the photographs which appear in this work. The research program was also enhanced by George Clarke who kindly lent me material from his substantial personal papers and archives.

A special debt is owed to Shanti Mandal who took on the task of transforming an untidy manuscript into an impeccable typescript at a time when her own schedule

was already hectic. Her assistance and good humour were greatly appreciated.

Gratitude is due to Jane Varley, Curator of the Town Hall Collection, who generously made available her intimate knowledge of that Collection and of other workings of Council. Also, the staff of the City Library have lessened the burden of authorship, as have the staff of the Council's excellent media-monitoring service, LOGOS.

Several individuals kindly agreed to participate in an oral history program which was run concurrently with archival research for this book: to Nigel Ashton, George Clarke, John Doran, Frank Hanson, Sue Holliday, Bob Myer, John McInerney and Kerry Nash, many thanks. The transcripts from this project have also been collated and published in a limited run. Copies of this compilation have been lodged with the City Council Archives. The City Planning Department's generous contribution to this particular production, including funding for a number of the interviews undertaken, is especially acknowledged.

The many superb images in this book reproduced from Council Archives were skilfully re-photographed by Adrian Hall (colour) and John Prescott (black and white). Credit is due to Adrian Hall for the contemporary black and white photographs in the book. Thanks are also due to Bob Nolan for assistance and Doug McKinnon for his cartographical work on the City boundaries. The efforts of the staff of the Mitchell Library's copying service and the Archives Office of New South Wales' photographic section are gratefully acknowledged. Leanne Buchanan, Jennifer Broomhead and Bill Southall of the Mitchell Library were particularly helpful. Heather Cam's skilful editing of the typescript was also much appreciated, as was Alan Walker's expert indexing.

Finally, to Elizabeth Farrelly, Shirley Fitzgerald, Robert Freestone, John McInerney and Tony Prescott, all of whom were members of the Planning History Advisory Committee, a debt of thanks is owed for advice, comments and support.

P.A.

Introduction

'Let us rain compassion . . . in the shape of regulations . . .'
— T. J. Maslen, *A Friend of Australia*, (Hurst, Chance & Co, London, 1830), p 265.

Today, Sydney has achieved the status, long sought by its promoters, its elites and its cultural cringers, of a first-class world city and clinched its claim to being Australia's premier capital and international gateway, despite an ongoing tug-o-war with Melbourne, its traditional rival. Long-time, outside observers of the City, many of whom once perceived Sydney to be 'no more than a harbour surrounded by suburbs — its origins unsavoury, its temper coarse, its organisation slipshod'[1] — have of late been moved to reassess earlier pronouncements.

Thirty years after pouring scorn on Sydney in the early 1960s (a city then on the brink of momentous redevelopment), Jan Morris returned to find this port and metropolis of the South Pacific the 'most hyperbolic, the youngest in heart, [and] the *shiniest*' of cities left behind by the defunct British Empire.[2] In her recent book, *Sydney*, Morris confessed that 'the explosion of steel, glass and concrete in the past twenty years has given it a cohesive excitement, and the central clump of high rise is nothing if not energetic'.[3] Visitors, Morris was pleased to report, 'are surprised to discover that . . . [Sydney] is really rather picturesque', strewn as it is with charming though submerged remnants of the Victorian, the Edwardian and the 1920s City — 'if only in daintily preserved facades' — and occasional, elegant leftovers from early colonial times. But how did this seeming metamorphosis come about?

It has been observed in a book published in the late 1980s on urban change in the City of Sydney that, after the spectacular growth of the City from the early 1960s, first impressions of Sydney 'could suggest that this development has been thoughtless and uncontrolled'. Closer acquaintance, the book's editor, Peter Webber, contends, 'reveals many delights and surprises'. It is argued that these 'are the result of the efforts of a number of dedicated people who have fought to control and enhance the quality of the City through urban design initiatives, in the face of relentless development pressures'.[4]

Webber notes that, from the beginning of the long boom, vigilant urbanists working as planners, architects and in other related professions had helped to 'mould' Sydney and awaken its 'true personality', the latter being the ultimate task of the 'planner as master-artist'. But he is forced regretfully to reflect that they are in Mark Girouard's words 'the often forgotten heroes who loved cities but fought to remedy

1 Jan Morris, *Sydney*, (Viking, London, 1992), pp 4-5.
2 Ibid, p 5.
3 Ibid, p 33.
4 G. P. Webber (ed), *The Design of Sydney: Three Decades of Change in the City Centre*, (The Law Book Company, Sydney, 1988).

9

their defects without destroying them'. Even less visible, Webber maintains, are 'projects unrealised but often still influential' of forgotten planning heroes from the dim past.[5]

As indicated in the preface to *The Design of Sydney*, much that has been written about the City of Sydney's planning — and indeed this applies generally to the written record of planning in Australia — has arguably been more concerned with hagiography (in this case the study of saintly planners) than history. Reminiscent of John Maynard Keynes' pronouncement on the ghostly voices of long defunct economists living in the heads of later practitioners, much of the literature on planning history also seems frequently preoccupied with 'unrealised', yet supposedly 'still influential', projects of planners and schemes now gone. Attempts often appear to be directed at isolating concrete manifestations of lost projects, ideals and philosophies 'on the ground' or at discerning traces of them in the built environment.

Such undertakings are perhaps in part a response to the at best chequered fortunes of planning in the City of Sydney. Most plans for Sydney — a City whose very boundaries have ebbed and flowed with strong political tides over the past two hundred years — have either died on inadequate drawing boards or been manipulated to the point of almost total negation by the state and its numerous authorities. Only fragments or hints of 'planning' remain to be discovered or explored.

It is undeniable that much of the detail and many of the specific elements which make up contemporary Sydney can not be labelled the product of mere chance. Nor, alternatively, should it be surprising that as part of a capitalist society, most of the City's macro organisation, control and development has been predicated on anarchic, free-market forces,[6] though the dominant powers are not obscure — profit maximisation, personal greed and a belief in private property. Viewed from the perspective of town or city planning, however, Sydney is an accidental city, a city which emerged from a complex web of power relations without recourse to holistic planning. In the drive to expand the City and its capacity to create wealth or facilitate capital accumulation, Sydney has undergone almost constant piecemeal redevelopment since the second half of the nineteenth century. This process is still at work today. In twentieth-century Sydney, planning personified became, for some, a Kafkaesque figure, a nameless hero wrestling with obscure intimidating powers. At least that was the way the Australian Planning Institute viewed the lamentable position of its scientific art in Sydney by the mid 1960s.[7]

This book takes as its subject the 12.95 square kilometres which constitute the City of Sydney today and examines the influence which planners and planning have had on this dynamic and enticing, if somewhat contradictory, city. In order to set Sydney and its planners in context, and to trace the historical processes at work, the City's growth and attempts to control or direct that growth are scrutinised from European invasion in 1788 — when an outpost of the British Empire was tentatively established around Sydney Cove — to the present.

Central to the narrative is the theme of laissez faire. Laissez-faire individualism frustrated effective control of nineteenth-century urban growth in the City of Sydney. Moreover, the doctrine of laissez faire worked effectively against the implementation of planning schemes and concepts in twentieth-century Sydney. Conflict and power are interrelated themes to that of laissez faire and these, too, are dominant in the text. Planning functions and authority in Sydney have remained fragmented. This has been a manifestation of ongoing conflict between the State government, and its many departments and statutory authorities, and the City's local government authority, the Council of the City of Sydney. Viewing planning in Sydney in terms of the power struggle between the 'state' and civic institutions demonstrates the vital connection between the social and spatial outcomes of the process of planning and the City's political economy. Given these themes, what then are our findings?

5 Ibid, p v.
6 For a detailed study of the property market, see M. T. Daly, *Sydney Boom, Sydney Bust*, (George Allen & Unwin, Sydney, 1982).
7 'Editorial', *Australian Planning Institute Journal*, July 1967, p 55.

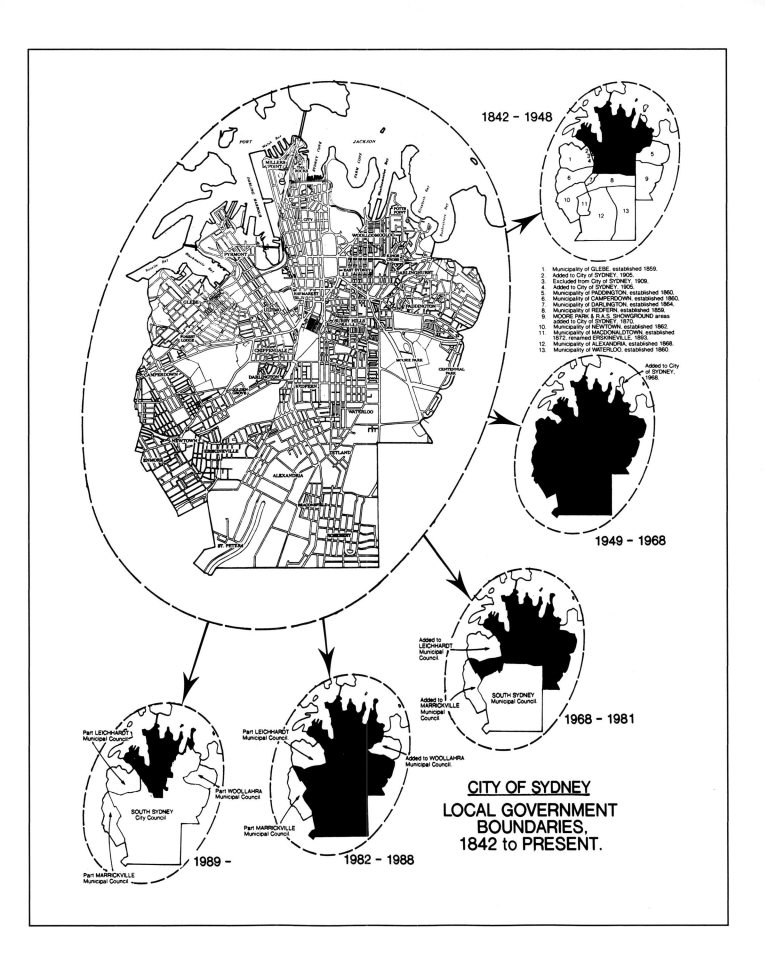

1842 – 1948

1. Municipality of GLEBE, established 1859.
2. Added to City of SYDNEY, 1905.
3. Excluded from City of SYDNEY, 1909.
4. Added to City of SYDNEY, 1905.
5. Municipality of PADDINGTON, established 1860.
6. Municipality of CAMPERDOWN, established 1860.
7. Municipality of DARLINGTON, established 1864.
8. Municipality of REDFERN, established 1859.
9. MOORE PARK & R.A.S. SHOWGROUND areas added to City of SYDNEY, 1870.
10. Municipality of NEWTOWN, established 1862.
11. Municipality of MACDONALDTOWN, established 1872, renamed ERSKINEVILLE, 1893.
12. Municipality of ALEXANDRIA, established 1868.
13. Municipality of WATERLOO, established 1860.

Added to City of SYDNEY, 1968.

1949 – 1968

Added to LEICHHARDT Municipal Council.

Added to MARRICKVILLE Municipal Council.

SOUTH SYDNEY Municipal Council.

1968 – 1981

Part LEICHHARDT Municipal Council.

SOUTH SYDNEY City Council.

Part WOOLLAHRA Municipal Council.

Part MARRICKVILLE Municipal Council.

1989 –

Part LEICHHARDT Municipal Council.

Added to WOOLLAHRA Municipal Council.

Part MARRICKVILLE Municipal Council.

1982 – 1988

CITY OF SYDNEY
LOCAL GOVERNMENT BOUNDARIES, 1842 to PRESENT.

At the peak of economic boom, at times of crisis (such as the outbreak of bubonic plague in Sydney in 1900) or on the threshold of new enterprises (such as post-war reconstruction), planners have been granted opportunities to voice opinions about or prepare schemes for future development. The vehicles for this, however, have invariably turned out to be soap boxes which are removed with the occurrence of economic upsets or the onset of new periods of expansion. Planners, too, have professionalised only recently relative to engineers and architects, for example. Prior to World War II, the few planners working in Sydney were largely gentlemen architects or, on rare occasions, engineers, who strove from outside government institutions for recognition (though they were often involved with these institutions). During the 1950s and 1960s, however, the growth of the status of planning (and a significant rise in the number of planners) was dependent on the profession deriving authority from the state. In the process, planners have been drawn into the governmental apparatchiki. Here, planning practice is often predicated on political agendas. Visions of future development, clear or otherwise, last as long as governments. Plans promote political and financial expedients. Planning becomes sleight of hand.

Despite opportunistic development and disjointed or abortive attempts at overall planning which have characterised Sydney's planning history, the City has weathered well tempestuous redevelopment. Its outstanding natural features − a magnificent harbour and striking topography − continue to contribute significantly to the charm of the place. But like its natural setting, Sydney's transformation from a 'harbour surrounded by suburbs', as Morris has written, to a 'shiny' City exploding in parts with 'steel, glass and concrete' has happened by accident rather than by design.

Courtesy of Bruce Petty,
Daily Mirror, 1977 **"Must have been quite a city before the traffic finally seized!"**

1

'The dry bones of civic life':[1] *Regulating Growth in Nineteenth-Century Sydney*

On 1 September 1828, T. J. Maslen, a retired lieutenant of the East India Company,[2] completed the preface to his 'Plan of an Expedition' to Australia. Animated by the prospects of wealth, knowledge and honour which might accrue to his native England from discoveries in a largely unknown continent, Maslen pledged, given adequate material backing, to explore and survey the Australian interior over a dozen years or so. His plan, published in 1830 as *The Friend of Australia, or, A Plan for Exploring the Interior and Continent of Australia*,[3] though never acted upon, did more than lay down a method for antipodean exploration; it proffered advice on the systematic colonisation of the continent. His advice included observations 'on the prevailing systems of laying out . . . plans of towns'.[4]

Just as the southern continent promised fresh fields for economic exploitation, a 'newly discovered country' presented an opportunity for towns and cities 'to be planned and marked out from the beginning'. With most land still in the Crown's possession, Maslen erroneously argued, 'there cannot be that objection to the adoption of a regular system for the plans and buildings of towns that there is in an old kingdom'.[5]

Maslen's town plan included wide thoroughfares laid out in a grid pattern. Narrow lanes and alleys — the breeding grounds of vice and wickedness — were to be abolished from town and city centres. Squares, fountains, market-places and canals were to be 'placed *ad libitum* in the most advantageous situations'. Room was also made for a 'belt of park of about a mile or two in diameter . . . [to] entirely surround every town, save . . . [such] sides as are washed by a river or lake'.[6] This provision was made to promote civic beautification as well as public health.

Of equal 'perhaps even greater' importance to Maslen's plan was a hierarchy of streets, each accommodating particular social classes and functions. To minimise social tensions,

> the inhabitants . . . of every rank, would have the end of their own streets debouching into . . . the [belt of] park . . . the wealthy would arrive at their own houses without having to pass through the thronged habitations of the poor; and the latter could arrive at theirs without having their envious feelings raised at the sight of the former.[7]

1 TCR, 1898, p 22.
2 See John Ferguson (comp), *Bibliography of Australia*, Vol 1, 1784-1830, (facsimile edition, National Library of Australia, Canberra, 1975), p 496, entry no 1379.
3 T. J. Maslen, *The Friend of Australia, or, A Plan for Exploring the Interior and Continent of Australia*, (Hurst, Chance, & Co, London, 1830).
4 Ibid, p 258.
5 Ibid, pp 269 and 267.
6 Ibid, p 263. This early articulation of the 'green belt' idea is discussed in John W. Reps, 'The Green Belt Concept', *Town and Country Planning*, Vol 28, No 7, July 1960, pp 246-50. Reps ascribes the authorship of *A Friend of Australia* to Allen Francis Gardiner, but Ferguson, op cit, provides evidence for Maslen's authorship.
7 Maslen, p 269.

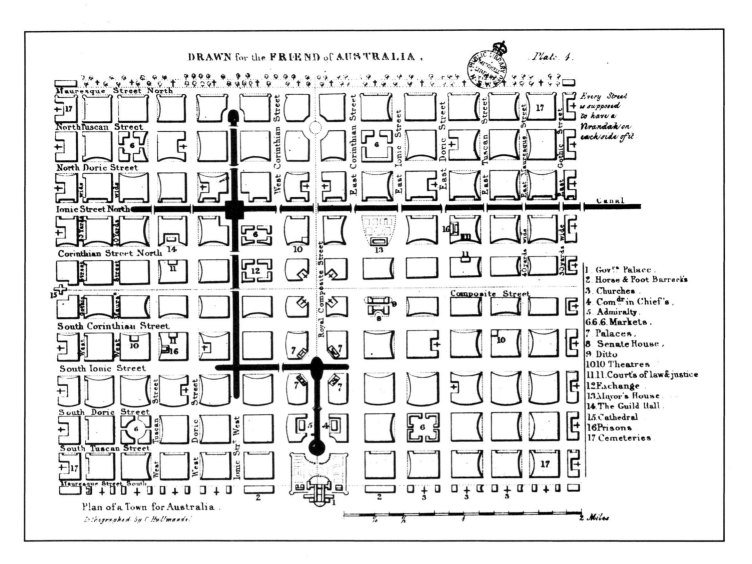

DRAWN for the FRIEND of AUSTRALIA. Plate. 4.

Every Street is supposed to have a Verandah on each side of it

1. Gov.ts Palace.
2. Horse & Foot Barracks
3. Churches.
4. Comdr in Chief's.
5. Admiralty.
6.6.6. Markets.
7. Palaces.
8. Senate House.
9. Ditto
10.10. Theatres.
11.11. Courts of law & justice
12. Exchange.
13. Mayor's House.
14. The Guild Hall.
15. Cathedral
16. Prisons
17. Cemeteries.

Plan of a Town for Australia.
Lithographed by C. Hullmandel.

2 Miles

T. J. Maslen's four-square mile 'Plan for a Town of Australia', lithographed by C. Hullmandel and published in 1830, sought to promote orderly urban development unlike that experienced in much of the Old World. Property relations and laissez-faire policies, however, had already undermined any prospects of regulated growth in the colony of New South Wales and its principal settlement, Sydney
T. J. Maslen, *Friend of Australia . . .* (Hurst, Chance, & Co, London, 1830)

For Maslen, then, a well-conceived plan could ameliorate social problems. But in the case of established towns and cities, or those already in the process of formation, evil arising from an unplanned environment should be alleviated 'by placing it under regulation'.[8]

Though neither architect, surveyor nor engineer, Maslen distilled much of the essence of nineteenth-century (and later) 'planning', in his essay, 'On Laying Out Plans of Towns'. Environmental determinism — the notion that physical surroundings shape moral character and intellect — is evident in Maslen's discourse: narrow 'lanes and alleys', not social disorders and inequalities, produced 'vice and wickedness' in town and city centres. Reflecting contemporary and earlier writings,[9] Maslen's 'belt of park' also indicated a physical determinism which was tied to an agrarian mythology. Rural life was somehow purer and happier than life in the teeming metropolis or the dirty town. Thus to import strips of country — much later called 'green belts' — into urban areas was to import some of the physical or aesthetic ingredients which would make for a better existence.

Maslen's work also evinces a faith in 'the plan'; in the power of 'Plans of Towns' to impose order on reality. *The Friend of Australia*, too, highlighted the individualistic nature of the role of 'Planners of Towns'. Other individuals, however, were to influence the development of colonial Sydney.

Around the time Maslen's book was first published (1830), Sydney was undergoing a transformation from a rural outpost to a commercial capitalist entrepôt. Though still a modest town, Sydney in the 1830s boasted a busy port, a crop of small

8 Ibid, p 265.
9 Reps, op cit.

industries and works, some respectable public buildings and a growing commodity-driven economy which was progressively being locked into world markets. But despite official dictate and intervention, much of this growth had been the product of the will and wealth of individuals.

Within months of initial European colonisation, New South Wales' first governor, Arthur Phillip, had marked out the 'principal street of the intended town', defined 'the limits of future building'[10] and ordered the preparation of a plan for the town of Sydney. Most likely executed by Lieutenant William Dawes and Augustus Alt,[11] Phillip's plan envisaged the 'principal streets . . . placed so as to admit a free circulation of air'; they were also to be 200 feet wide. Other provisions were made to 'preserve uniformity in the buildings, prevent narrow streets, and the many inconveniences which the increase of inhabitants would otherwise occasion hereafter'.[12]

Phillip's early administrative decision to segregate convict, military and a number of civil establishments from bureaucratic and legal functions was to influence Sydney's development. Building was to concentrate in the western part of the fledgling town, while the eastern area, naturally separated by the Tank Stream, was to be characterised by open spaces and later provide the location of Sydney's first 'genteel' suburbs.[13] But the Governor's somewhat ambitious plan did not materialise. His last order, that land be retained by the Crown within the town of Sydney — defined on yet another map — was likewise ineffective. After Phillip's departure from the colony in 1792, some of his successors leased into private hands and, from 1808, granted title to land within Sydney Town. The alienation of town sites compounded Sydney's disorderly growth, so much so that by 1807 its most irascible governor, William Bligh, was to complain to his superiors in England 'how much Government [was] . . . confined in any arrangement it may think proper to make for its use or ornament of the Town'.[14]

Greatly annoyed by the illegal occupation of town allotments, Bligh attempted late in 1807 to enhance Sydney's appearance and efficiency by requiring some illegal occupants to move, while querying the validity of other leases. But his actions in this regard had very different outcomes. Bligh managed to upset numerous colonial notables — including John Macarthur ('the virtual ruler of New South Wales');[15] surgeon Thomas Jamison; surgeon, magistrate and trader John Harris; merchant and trader Garnham Blaxcell; and Major George Johnston.[16] Moreover, his meddling with the rights of property, whether legal or otherwise, 'increased the opposition to his role'[17] and saw him deposed by rebellion less than three months later.

Bligh's inability to enforce Phillip's parting memorandum — 'that no part of Sydney should be leased away'[18] — denoted the dead-letter status of any plan that may have existed for Sydney and the power that private, self-interested individuals

10 David Collins, *An Account of the English Colony in New South Wales* (first published 1798), Vol 1, (A. H. & A. W. Reed, Sydney, 1975), p 17.
11 See J. M. Freeland, *Architecture in Australia: A History*, (Penguin, Ringwood, 1974), p 19.
12 Phillip to Sydney, 9 July 1788, *HRA*, Ser 1, Vol 1, p 48.
13 Norman Edwards, 'The Genesis of the Sydney Central Business District 1788-1856', in Max Kelly (ed), *Nineteenth Century Sydney: Essays in Urban History*, (Sydney University Press in association with the Sydney History Group, Sydney, 1978), pp 37-8; James Broadbent, 'The Push East: Woolloomooloo Hill, the first suburb', in Max Kelly (ed), *Sydney: City of Suburbs*, (NSW University Press in association with the Sydney History Group, Sydney, 1987), pp 12-13.
14 Bligh to Windham, 31 October 1807, *HRA*, p 156.
15 B. H. Fletcher, *ADB*, Vol 1, p 519.
16 *HRA*, Ser 1, Vol 1, p 155.
17 A. G. L. Shaw, *ADB*, Vol 1, 1788-1850, p 120.
18 *HRA*, Ser 1, Vol 1, p 155.

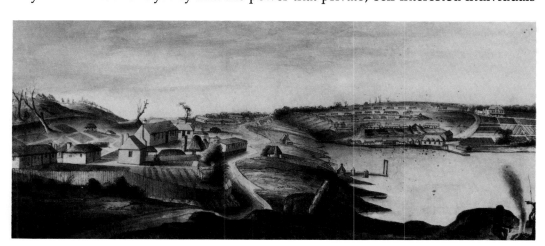

Sydney, 1794. The Government wharf extends into Sydney Cove around which a six-year-old settlement clings. European tracks would in all probability have followed those of the Cadigal Tribe, the local Aboriginal people who had inhabited the area for time immemorial (ML)

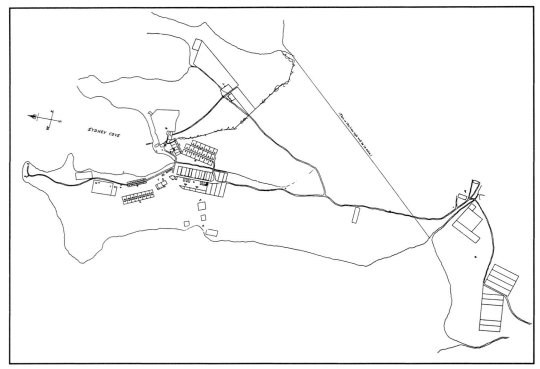

'A Survey of the Settlement in New South Wales New Holland', 2 December 1792. The oblique line on the right side of the map was set by Governor Arthur Phillip as the Town's boundary. Just before leaving the colony, Phillip ordered 'that no ground within the Boundary line is ever [to be] granted or let on lease'. His parting directive was not obeyed
(AONSW Map 52430)

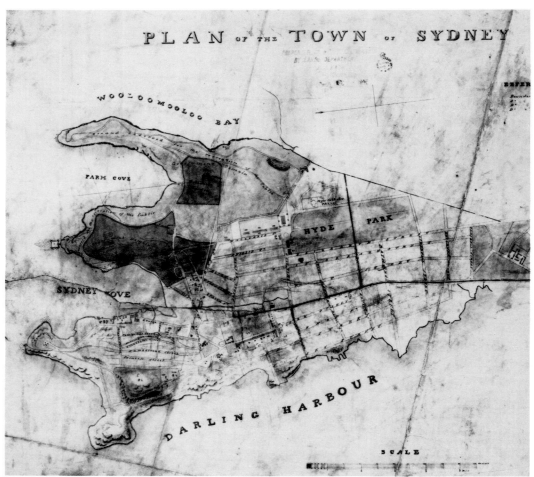

'Plan of the Town of Sydney', c. 1828. Phillip's boundary line for the township appears on this plan (starting at the end of Woolloomooloo Bay). Its presence, however, was moot. Much of the town had been alienated into private hands that developed the land largely at will
(AONSW Map 6243)

wielded over the shaping of the town. Indeed, after 1792, maps and plans made of colonial Sydney simply recorded the place's unruly growth; none directed, let alone controlled, development. Lack of regulation was also evident in the detail of the built environment. On taking command after Bligh's deposition, Lieutenant Governor Joseph Foveaux 'found the Public Buildings of every description in a state of shameful dilapidation, or of rapid decay'. 'The streets of Sydney,' he further complained, 'were almost impassable, and the principal roads and bridges were, if possible, in a still more dangerous and neglected state.'[19]

Governor Lachlan Macquarie (ML)

When Lachlan Macquarie, fifth Governor of New South Wales, arrived in the colony at the close of 1809 conditions were not conducive to planned growth: Sydney had become a thriving, regular port of call with a rising mercantile capitalist economy. The town's officially recognised population was then around 6150 (accounting for just under sixty per cent of the colony's non-Aboriginal population), among which were included 'a considerable number of Opulent Merchants'.[20] Though still in its infancy,[21] Sydney showed great promise to individuals with capital or access to it. Macquarie, the last of the autocratic governors, made it his 'particular study to have Edifices of All Descriptions within the Town built on a regular Plan, so as to Combine Convenience with Ornament, and preserve the Regularity of the Streets and Houses'.[22]

Not only did Macquarie have clocks installed in the major public buildings that he had commissioned in order to instil discipline into the colonial workforce, he also had a host of regulations decreed to bring order to Sydney Town. Thorough-fares were regularised and renamed; narrow streets were widened; building rules were promulgated. But he further alienated land from the Crown and helped create property relations. All persons 'able and willing to Erect substantial and handsome Buildings within the Town' were also encouraged to do so by promises of land grants instead of leases.[23]

Towards the end of Macquarie's governship (which ceased in 1821), William Charles Wentworth, landowner, explorer and, later, politician, could write:

> Until the administration of Governor Macquarie, little or no attention had been paid to the laying of streets, and each proprietor was left to build on his lease, where and how his caprice inclined him . . . The town upon the whole may be now pronounced to be tolerably regular; and, as in all future additions that may be made to it, the proprietors of leases will not be allowed to deviate from the lines marked out by the surveyor general, the new part will of course be free from the faults and inconveniences of the old.[24]

Considerable personal pride mixed with some public spirit had spurred Macquarie to foster in Sydney 'as fine and Opulent a Town as any one in His Majesty's other foreign Domains'.[25] But Wentworth's pronouncement on the orderly influences that would flow from Macquarie's ordinances was at best optimistic.

Like the squatters who flaunted vice-regal proclamations and colonial authority and spread inland during the 1820s and 1830s to illegally take possession of 'Crown Lands', residents of Sydney appear to have built generally what they liked where they liked for a good while after Macquarie's departure. Laissez-faire capitalism and liberal individualism were in the ascent and would characterise much of Sydney's growth in the nineteenth century. Officials also condoned eccentric or irregular development, particularly if alternatives involved spending money. The Colonial Office constantly reiterated the British Government's desire to keep the costs of running the colony to a minimum. Consequently, the colonial government passed minimal legislation to deal with disasters. The poor state of public health and the presence of noxious trades in Sydney also were indicators of the general preference for laissez faire.

At the close of the 1820s, Thomas Livingston Mitchell, Surveyor General of New South Wales (1828–55), was greatly vexed to discover in the 'new part' of Sydney,

19 Macquarie to Castlereagh, 8 March 1810 (quoting Foveaux), *HRA*, Ser 1, Vol VII, p 233.
20 Macquarie to Castlereagh, 30 April 1810, *HRA*, Ser 1, Vol VII, p 269.
21 Developments in Sydney up to 1810 are treated in Graeme Aplin (ed), *A Difficult Infant: Sydney Before Macquarie*, (NSW University Press in association with the Sydney History Group, Sydney, 1988).
22 Macquarie to Castlereagh, op cit.
23 Ibid.
24 W. C. Wentworth, *Statistical, Historical, and Political Description of The Colony of New South Wales . . .*, (first published 1819, facsimile edition, Doubleday Australia, Adelaide, 1978), pp 6-7.
25 Macquarie to Bathurst, 24 June 1815, *HRA*, Ser 1, Vol VIII, p 554.

which lay at the southern end of the town, a variety of 'faults and inconveniences' — all too similar to those which Wentworth claimed would be banished by his favourite viceroy. In 1829 landowner Frederick Wright Unwin was about to run two thoroughfares through his substantial subdivision which straddled Redfern and Surry Hills. In the midst of preparing a plan for this area, Mitchell secured a guarantee from Unwin that these roads (which were formed by twenty convicts) would adhere to the Surveyor General's design. Due largely to resistance from other landowners, however, Unwin's roads turned out to be at odds with Mitchell's plan. Further, as Christopher Keating has observed, 'Mitchell's attempts to enforce more regular alignments were dashed by the Colonial Secretary's assertion [in September 1829] that the Government could not "prescribe to these people how they shall lay out their ground" '.[26]

In his 1832 *Report on the Limits of Sydney*, Surveyor General Mitchell noted that 'most of the [peripheral town] land has been alienated and that roads and boundary lines were oblique and irregular'.[27] Further chaos was superimposed on the ground, setting off a deal of litigation, when Mitchell attempted to 'square the lands of individuals conformably to a general plan of Streets'. Disaster followed disaster. Mitchell's roads, published on a plan of 1831, were proclaimed rights of way during 1834. Adversely affected landowners swamped the government with claims for compensation, leading by mid year to the establishment of a commission of compensation and, a little later, to the appointment of a select committee to inquire into the tangled web of claims and counterclaims that had been spun over this southern town quarter. Recognising the area's importance to the swiftly expanding town of Sydney — and the commensurate land values — the commission,

> perhaps not surprisingly, decided that no compensation would be paid. More importantly, the ruling that owners would not be compelled to follow the street alignments gave them carte blanche to build wherever they chose, and it was not long before fences and even houses were built across the very roads that formed the basis of Mitchell's grand plan for the extension of the town. . .[28]

In the end, both the pressure for economising in the colony and the interests of private property won out.

The rapid economic and demographic expansion which had caused the colonial government to commission Mitchell's initial *Report on the Limits of Sydney* was, however, to necessitate the making of general controls for development. Physical expansion and a burst of building activity also put pressure on officials to clearly define the town's boundaries. Thus, provisions for regulating some features of the built environment were incorporated into the Police (Sydney) Act which passed into law on 6 August 1833.[29]

Signifying an ascendant civil (as opposed to penal) society,[30] the Police Act allowed for the regulation of shop awnings and house gutterings; directed that carriage and footways 'be marked by posts at the corners and intersections of streets'; and ordered that the Surveyor General 'set out and name with sufficient marks the limits of the town' and its immediate port. Further, the Act prescribed a general method for the formation of footways for 'greater regularity and convenience' and made provision for the erection of boarding and scaffolding. The latter were to be licensed by a town surveyor who, under the Act, had to be appointed by the Surveyor General and work regular hours in a publicly gazetted office.[31] The creation of this position, however, reflected other difficulties being experienced in Sydney and New South Wales generally. Understaffed and flooded with work, the colony's Survey Department, headed by Mitchell, was faced with a huge backlog of work for many years. Competent surveyors, too, were in short supply in the antipodes.[32]

During the 1830s other pieces of legislation were to be applied to the town of Sydney to curb bad building and subdivision practices. A Streets Alignment Act was passed in 1834 which aimed to straighten and widen thoroughfares.[33] Three years

26 Christopher Keating, *Surry Hills: The City's Backyard*, (Hale & Iremonger, Sydney, 1991), p 18.
27 Ibid, p 17.
28 Ibid, p 18.
29 4 Wm IV, No 7.
30 One view of the transition from penal/military to civil planning is presented in J. E. Sait, 'Public building and town planning: the first 100 years', in Lenore Coltheart (ed), *Significant Sites*, (Hale & Iremonger, Sydney, 1989), pp 15-39.
31 Police (Sydney) Act, ibid, pp 7, 11, 12, 14, 15-16.
32 D. W. A. Baker, *ADB*, Vol 2, p 239.
33 5 Wm IV, No 20.

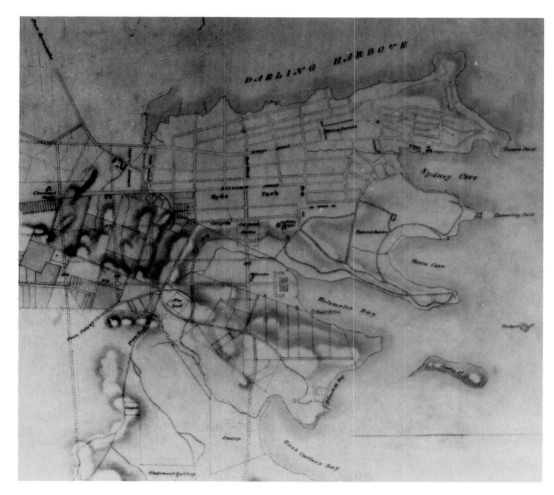

Above, *Surveyor General Thomas Livingston Mitchell* (ML)

Left, *Mitchell's 1831 plan, shown here, attempted to regularise the streets at the southern end of Sydney. His imagined street layout, indicated by dotted lines, was eventually aborted since it cut across property boundaries that had been established by a predecessor, James Meehan* (AONSW Map 5535)

later, An Act for Regulating Buildings and Party-Walls, and for Preventing Mischiefs by Fire, in the Town of Sydney came into force.[34] Based on the 1774 London Building Act,[35] Sydney's Building Act, as its formal title suggests, was in effect concerned only with structural considerations and the 'security of the property' within the town against the ravages of fire. Throughout the nineteenth century, much human life was to be lost due to the accidental outbreak of fire, and the Building Act duly noted the need to secure 'the safety of the inhabitants of the Town of Sydney'.[36] Most of this tedious Act, however, dealt with the relations between adjoining property owners regarding matters such as party walls, which were in part to protect against fire, while various provisions dealt with fire fighting and insurance.[37] The only other significant feature of this Act was the provision for different 'rates' of buildings. Each rate or class of structure was determined by its use, size and proximity to the street and to other buildings; each required owners to comply with different standards of construction.

It is difficult to gauge the overall impact of the new legislation. But it appears that, limited as they were, building regulations were not enforced with vigour. Many residents, too, flouted the spirit as well as the letter of these laws. Wooden houses, to take one example, were forbidden to be erected in the Town of Sydney under the 1837 Building Act. To evade control, many owner-builders and speculators of modest means built wooden cottages just beyond the town limits which the Surveyor General had set down and marked clearly towards the close of 1837. A decade later over two-fifths of the dwellings in Redfern, Chippendale, Strawberry Hills and Surry Hills were made of timber.[38]

Deficiencies in Sydney's Building Act resulted in its amendment in October 1838

34 8 Wm. IV, No 6 (passed 8 September 1837).
35 Dawkins, op cit. p 63.
36 p 3 of the Act.
37 Dawkins, op cit, pp 64-5.
38 Keating, op cit, pp 26-7; Shirley Fitzgerald, *Chippendale: Beneath the Factory Wall*, (Hale & Iremonger, Sydney, 1990), pp 25-31; Shirley Fitzgerald, *Sydney 1842-1992*, (Hale & Iremonger, Sydney, 1992), pp 31-2.

and again in the following year. Talk, however, of the possibility of incorporating the town of Sydney was to provoke much heated debate among many well-heeled residents and property owners. Shortly after his arrival in the colony in 1832, Governor Sir Richard Bourke, inspired by his imperial mission and hoping to promote civilisation in the imperial outpost, tried to introduce a municipal bill for the incorporation of Sydney.[39] Politically savaged by the conservative colonial 'exclusives' class for his 'democratic' tendencies and by others who did not want municipal taxes levied on their property, Bourke withdrew this bill. In its stead, a collection of environmental regulations (discussed earlier) were dumped into the 1833 Police Act. Bourke's successor, Sir George Gipps, was finally to succeed in having a municipal bill enacted in 1842 but, once again, not without a fight. Having succumbed to political pressure and great public protest, Gipps had been forced to scuttle a bill for Sydney's incorporation two years earlier.[40] The onset of economic depression in 1841 would undoubtedly have added weight to the argument for handing over various functions to another partially self-financing tier of government.

Based on the British Municipal Corporations Act of 1835, the Sydney Corporation Act brought into being the Sydney Corporation and bestowed the status of City, albeit prematurely, on the colony's 54-year-old capital.[41] Ostensibly, the Act empowered the Corporation to suppress and restrain 'disorderly houses', roads and pavements, while allowing the new municipal authority to make by-laws to control urban development. Provision was also made for the Corporation to appoint a city surveyor who was charged with the responsibility of enforcing regularity and good order on the rising centre. Deficiencies, however, (the origins of which were numerous) were soon discovered in the legislation.

Colonial authority had seen fit to devolve the responsibility for various mundane tasks and procedures to a local form of government. Shifting the economic burden for a good many administrative processes and infrastructural requirements onto local ratepayers was in line with the Colonial Office's directives to cut running costs in the colonies. But the 'state' was loath to transfer power to civic functionaries. Thus, concerned not to impinge on the interests of private property, the Corporation Act lacked legal clout and effective remedies to environmental problems. Vague wording throughout further diminished the legal as well as technical precision of the legislation and, consequently, its enforceability.[42]

While some of the Corporation's powers and functions were loosely framed and weak, others were duplicated in or tangled up with various pieces of legislation. Corporation functions were scattered through the Police Act (1833), the Road Act (1833), the Streets Alignment Act (1834) and the Building Act (1837). By-laws, too, could be framed by the Corporation to regulate undesirable aspects of urban growth. But by-laws, like most other Corporation powers, were subject to the discretion of the colonial government. Moreover, any deficiencies in the Acts which empowered the Corporation to impose order on Sydney could be redressed only by recourse to a conservative and dilatory legislature. Deficiencies proved legion and the legislature unwilling to significantly modify enabling Acts.

Minor alterations were made by the colonial government to some legislation to accommodate the new Council and its Corporation Act. City boundaries were redefined in the Building Act during 1845 and provision was made for any fines and fees recovered by the City Surveyor to be paid to the Treasurer of the Council 'for the local improvement and benefit' of Sydney.[43] But great difficulty was experienced in collecting fees and fines, let alone applying them to civic improvements.[44] Two years later, the Police Act was amended 'though to no avail' to lend police assistance to the suppression of nuisances by City officials. By the mid 1840s, however, it was not only defeats in legislation which were becoming apparent. Tension and conflict between the State and the Corporation — a recurrent theme in the history of attempts to control growth in Sydney — emerged during the 1840s as the two levels of government sought

39 Fitzgerald, *Sydney 1842–1992*, pp 42-3.
40 See F. A. Larcombe, *A History of Local Government in New South Wales*, Vol 1, *The Origin of Local Government in New South Wales 1831–58*, (Sydney University Press, Sydney, 1973), Chapters 2-4.
41 For a detailed account of the Act and the Corporation's early years, see Fitzgerald, *Sydney 1842–1992*, pp 39-44, and Dan Coward, *Out of Sight . . . Sydney's Environmental History 1851–1981*, (Department of Economic History, Australian National University, Canberra, 1988), pp 25-48.
42 See Sydney Corporation Act, (1842).
43 *An Act for Regulating Building and Faulty Walls . . . in the Town of Sydney*, (D. L. Welch, Sydney, nd), p 3.
44 See, for example *SMH*, 3 August 1847 and 3 April 1851.

to define their roles in relation to Sydney and each other.

Strained relations were nowhere more manifest than in the regulation of Sydney's streets, a responsibility that was a primary part of the Corporation's mandate. During a Corporation meeting in December 1844, a heated debate flared up regarding the appropriate salary for 'a properly qualified surveyor and engineer'. Alderman Edward Flood — a radical politician in his day who supported the extension of the municipal franchise to all householders and refused 'to toady to "autocrats"'[45] — entered the fray arguing that, no matter what the salary, the Corporation had 'at present . . . no such occasion for such an officer'. What they needed, Flood sarcastically contended, was a 'principal overseer' since the colonial

> government, in fact, performs the duties of the City Surveyor. In the *Herald* of that morning there was a long notice of streets being opened by the Government at the north end of the town, of which the Corporation and their Surveyor had no knowledge whatever.[46]

45 R. W. Rathbone, *ADB*, Vol 4, pp 190-91.
46 *SMH*, 10 January 1845, in Mitchell Library newspaper cuttings book MLQ352.091/S.

Woolcott and Clarke's 1854 'Plan of the City and Suburbs of Sydney' indicates the extent of the City by mid-century. Sydney, however, grew like Topsy: maps and plans recorded development; they did not control it (ML)

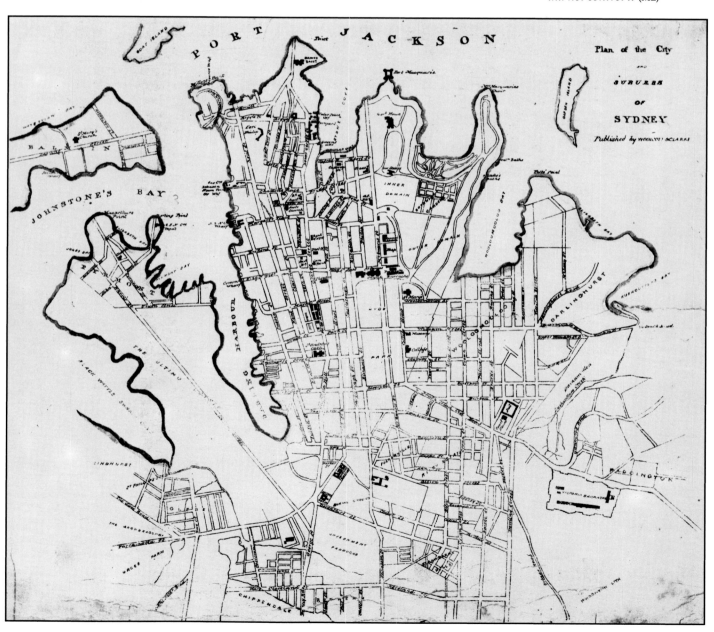

From the mid 1840s, conservative colonial political factions were to chip away at the City Corporation's powers and public profile. Finally, charged with having failed to bring about improvements — and what were to become the 'usual' allegations of corruption and nepotism — the Corporation was dissolved for a 'limited time' by the colonial government in September 1853.[47]

Although the charge of ineffective intervention in the built environment stuck, there was little evidence to support the legislature's action. The Improvement Committee, which 'had charge of the [Corporation's] most important fund',[48] had spent an average of between £4000 to £6000 per annum in the 1840s on municipal works and by 1850 this Committee was receiving the substantial annual allocation of over £8000. Major thoroughfares had been either opened and formed or reshaped — including George Street South and Harris, William and Argyle streets — and other 'prominent improvements' effected.[49] These too had been achieved under far from perfect conditions. Depression in the colonial economy had abated only from the mid 1840s; defective enabling Acts continued to impede the collection of revenue and the enforcement of environmental laws despite the passing of a new Sydney Corporation Act in 1850; and support from the State was not forthcoming. Fiscal difficulties, for example, were exacerbated by the colonial government's refusal to refund 'all sums which had been raised by direct taxation on the citizens of Sydney, and appropriated to police purposes' which were controlled exclusively by the State. Arguing for the return of these monies to the Corporation's coffers 'for the general improvement of the City', Alderman Flood observed of this situation:

> It was quite a mistake . . . to imagine that the city had representatives in the Legislative Council; true there were two gentleman who were called members for Sydney, but these gentleman did not perform their duty to the City. In December [1844] . . . Mr [William Charles] Wentworth undertook to present a petition from this Council to the Legislative Council, praying that the City might be placed on the same footing as other parts of the colony, by having the funds it had expended on police purposes refunded to it; but he had done nothing in the matter since. The members for the City, instead of representing the City, rather represented individuals . . . Nor were the Citizens neglected only — they were insulted, and their petitions neglected. . .'[50]

Hard in both politics and business, Edward Flood was a 'self-made' man of action. His civic pride had earlier cost him the considerable sum of £50, a fine imposed on him by a magistrate for striking conservative solicitor George Kenyon Holden, who had publicly pronounced the City councillors 'idiots'.[51] But his commentary on State-Council relations was telling. For decades after its incorporation, the City was viewed by the State 'primarily as an entrepôt for channelling raw produce to the imperial power, and urban government [was regarded] primarily as a nuisance'.[52] The City's growth was not to be hampered by an interfering civic authority nor were unhealthy democratic tendencies, evident in a good many of the councillors, to curb economic development and the process of capital accumulation. Urban growth was to be left to that invisible hand in which liberal political economists were to invest so much faith and capital during the nineteenth century, and to the individual and corporate interests of the urban bourgeois.

Between 1854 and 1857, the City Corporation was replaced by three government-appointed commissioners who, spending more on improving Sydney than the State thought warranted, were eventually dismissed. There was, however, never any intention on the State's part to permanently dismiss the Corporation, though some members of the legislature thought it a good idea. Colonial developments closely followed the British example and mundane chores *were* to be handed down to local government. But the removal of the Corporation by its political superior was to establish a stark precedent which was to be resorted to by a number of governments of different political persuasions over the next century and a half. Sacking (or the threat

47 *SMH*, 15 and 21 September 1853.
48 *SMH*, 22 June 1847.
49 *SMH*, 3 September 1845.
50 *SMH*, 14 October 1845.
51 Rathbone, *ADB*, p 190.
52 Fitzgerald, *Sydney 1842–1992*, p 24.
53 See W. A. Sinclair, *The Process of Economic Development in Australia*, (Longman Cheshire, Melbourne, 1985), Chapter 4; Shirley Fitzgerald, *Rising Damp: Sydney 1870–90*, (Oxford University Press, Melbourne, 1987); and A. J. C. Mayne, *Fever, Squalor and Vice: Sanitation and Social Policy in Victorian Sydney*, (UQP, St Lucia, 1982).
54 *Report from the Select Committee on the City of Sydney Improvement Bill . . .*, (Government Printer, Sydney, March 1879), in *Journal of the Legislative Council*, 1878-79, Vol XXIV, Pt II, p 179.
55 *Journal of the New South Wales Legislative Council*, 1878-79, Vol XXIV, Pt II, p 173. The Committee members were Joseph Docker, Sir Alfred Stephen, Professor John Smith, John Marks, Thomas Smart and William Macleay.
56 Ibid, p 193.
57 Ibid, pp 187-88.

of sacking) the City Council was to become part of the apparatus of regulating or not regulating growth. Dismissal was often also the civic cornerstone of new periods of marked change in urban policies and development. When the City fathers — there being no mothers — demonstrated significant reluctance to facilitate the changing demands of manufacturing, industrial or finance capital, the State stepped in and removed them.

For the next twenty years or so the City Surveyor and other Corporation officials were to become increasingly demoralised as their attempts to regulate development in the City were frustrated by inadequate legislative tools and an uninterested colonial government. By the close of the 1870s, a decade of significant and complex economic growth and of increasing social problems,[53] no one could credibly doubt 'the urgent necessity . . . for legislation on this subject'.[54] Outbreaks of deadly diseases, an

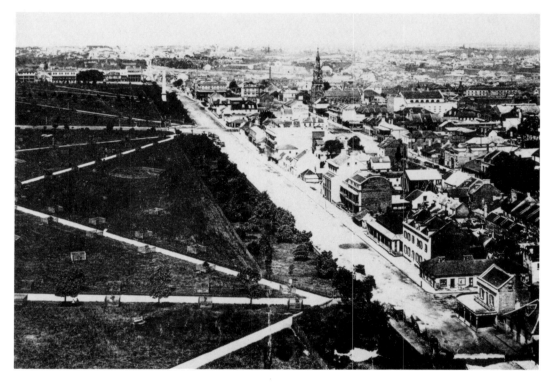

Looking south down Elizabeth Street around 1871-72. A church steeple, now gone, and an elaborate, sandstone 'stink pipe' in Hyde Park (on the left hand side of Elizabeth Street) stand out as landmarks (ML SPF)

accumulation of structurally dangerous or unsanitary buildings and an urban infrastructure which increasingly was unable to cope with the pressures of urban growth had spurred the City Corporation to commission the drafting of a City Improvement Bill which it placed before the colonial legislature towards the end of 1877.

Aimed at replacing the virtually inoperative and by then forty-year-old Building Act, the Improvement Bill, prepared by ex-City Building Surveyor Edward Bradridge, was tardily referred by the State to a Select Committee on 6 February 1879 after petitions had been received from numerous builders and contractors and thirty-three prominent landed proprietors, house-owners and architects.[55] Chaired by eminent, wealthy barrister and Member of the Legislative Council William Bede Dalley, the Committee was to politely but firmly emasculate the Corporation's Bill. No one could deny that 'for all purposes of controlling building operations . . . [in the City the Building Act] was inoperative'.[56] The various witnesses examined by the Committee all recognised the pressing need for a new Act, but not the one proposed by the Corporation. With the exception of Charles James Roberts, the Mayor of Sydney, who thought that the Bill would be 'a great boon to the city' and should be 'left as it is',[57]

Architect Edmund Blacket
(ML SPF)

professional and non-professional witnesses alike mounted strong opposition to the City Improvement Bill.

Two primary objections centred on concerns that the powers proposed in the Bill were 'arbitrary and excessive' and the penalties 'utterly disproportionate' to the offences. Under Clause 6, any person laying out land or disposing of it for building purposes on which it was proposed to open any road or street, without first submitting full plans and particulars and obtaining approval from City Council, was liable to two years' imprisonment — and in a 'common gaol' at that. Most witnesses found the lack of an appeal mechanism deplorable, as did the Select Committee. But much debate centred on the requirement that 'plans and particulars' be submitted for the City Surveyor's approval. Represented by three of the most influential architects in the colony,[58] Edmund Blacket, George Allen Mansfield (architect to the Council of Education) and John Horbury Hunt, the architects viewed the provision for vetting plans as a direct attack on their status. With a long way to go in the process of professionalisation, architects resisted direct intervention in their work. George Mansfield feared that various powers in the proposed Bill would 'to a great extent relieve architects of their responsibility which properly attached to them for . . . safety', while leaving the way open for untutored and unqualified minds to 'upset the plan and make the whole thing as may seem good to them'. Plans, too, were 'the result of very great labour and years of study', and Mansfield further contended that it was 'a monstrous thing that the Building Surveyor or anyone else should be in possession of the results of such labour'.[59] Costs in time and trouble to prepare materials and the resources required to process plans and specifications were also put forward by builders' representatives, as well as architects. William Wallace, Vice-President of the Builders' and Contractors' Association, for one, thought that 'it would be quite sufficient for the Building Surveyor to have a rough block sketch; he would', Wallace suspected in any event, 'never have time to look over all these plans'.[60]

From the evidence in the Select Committee's *Report*, the City was growing like Topsy. Futhermore, judging from the Committee's selection of witnesses, its use of leading questions and other irregularities, it seemed set on allowing this pattern

58 See J. M. Freeland, *The Making of A Profession: A History of the Growth and Work of the Architectural Institutes in Australia*, (Angus & Robertson, Sydney, 1971), Chapter 3.
59 Ibid, p 195.
60 Ibid, p 201.

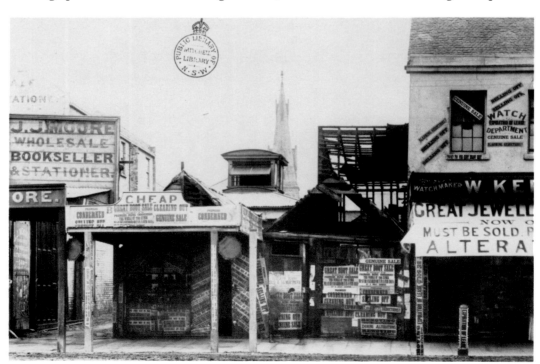

George Street, Sydney, around 1883. This, indeed, was the site of a 'Genuine Sale': as the posters proclaim, these ramshackle premises had been condemned. Inadequate controls over urban development in the nineteenth century was to see Sydney littered with a crop of dangerous or dilapidated buildings (ML SPF)

of growth to continue unhampered in favour of the interests of private property. Support for a rigorous Improvement Bill was forthcoming only from the City's Mayor, Charles Roberts. Indeed, if not for Roberts' strenuous recommendation that the Committee 'send for Mr Edward Bradridge, the late Building Surveyor',[61] little criticism, if any, of the real nature of urban building and other regulations would have come to light in the Committee's report.

Edward Bradridge was summoned before the Select Committee at the end of February 1879 as an eleventh-hour concession to Mayor Roberts. Bradridge, a professional architect and surveyor, had been with the Corporation for eighteen difficult years. In his measured evidence, Bradridge, clearly out of step with his recalcitrant, laissez-faire colleagues, was to take issue with the Select Committee's findings and tentative recommendations.

Countering the assertion that the Improvement Bill had been sloppily thrown together without due refinement or consideration, Bradridge gave an account of its coming into being. In 1873, after years of trouble with implementing the old Building Act, the Corporation formally resolved that its Building Surveyor, in partnership with the City Solicitor, prepare a Bill for the Government's approbation. Bradridge duly collected together the English Building Act, the Melbourne Act and a draft Act, intended for Brisbane. As he told the committee, he 'also got the present city of Sydney Building Act — the one supposed to be in existence'.[62] Having framed a Bill, Bradridge submitted the draft to the recently formed and soon to collapse Institute of Architects of New South Wales, the Society for the Promotion of Morality, and Reverends Dean Cowper and Shepherd. (Advice from the Clergy was deemed necessary given the contemporary connections drawn between moral rectitude and physical surroundings.) Various suggestions were incorporated into the draft which was finally placed before C. J. Manning (barrister and parliamentary draftsman, 1870–74)[63] with whom Bradridge 'spent many hours' revising the Bill and giving it 'suitable legal phraseology'.

Rather than restrict the Improvement Bill to the City of Sydney and hobble its provisions, Bradridge insisted that the legislation should be applied to all municipalities 'to prevent the abuses that have sprung up in this city from being continued in the suburbs'. The regulation of building in the City had, in the ex-Building Surveyor's candid opinion, reached a level of sheer farce. Thus, when asked by chairman Dalley if he had 'anything further to add', Bradridge launched into a bittersweet parody of what he described as 'the present mode of procedure with regard to our present Building Act':

> A builder goes to the Town Hall, asks for the City Building Surveyor, and sees him or not, but he gives notice that he is going to put up a certain building. That's all he is required to do under the present law. The Surveyor, on receipt of that notice, goes round to inspect the building and to see that the provisions of the present Act are carried out. When the Surveyor gets there perhaps he finds a labourer at work; he asks, 'Who is building this house?' 'Don't know.' 'Have you got any plans here?' 'No.' Next time he comes round the Surveyor probably sees the mason. 'What sort of house is this going to be?' 'Don't know anything about it.' 'Who has the plans?' 'Don't know.' The Surveyor goes round again in a few days and sees the bricklayer. 'Have you the plans of this house?' 'No.' 'Who has them?' 'I suppose the builder has got them.' He goes round again in a few days, and finds the brickwork commenced, probably up 3, 4, or 5 feet. He asks the bricklayer again, 'Have you got the plans?' 'No.' Well, he goes again in a few days more and finds the builder on the ground. 'Have you got the plans?' 'Yes.' 'Will you allow me to look at them?' 'Yes.' The plans are then brought forward; the surveyor examines them. 'These walls are not sufficiently thick, and you are wrong in so and so.' 'Oh, I know nothing about that — you had better go to the architect.' . . .[64]

Theoretically, Bradridge coolly concluded, if a case ended up in court, and laws were found to have been breached, it was the builder — 'who has nothing to do with the

61 Ibid, p 187.
62 Ibid, p 210.
63 H. T. E. Holt, *ADB*, Vol 5, p 203.
64 *Report from the Select Committee* . . ., op cit, p 212.

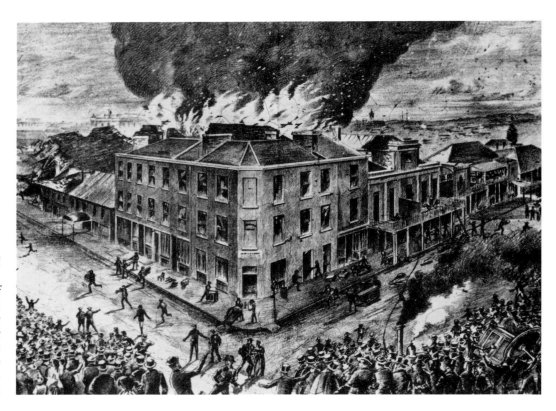

The Prince of Wales Hotel ablaze in Sydney during 1872. Fire was a common cause of death in the nineteenth century. Warren-like building interiors, inadequate fire escapes and narrow lanes contributed significantly to this situation in nineteenth-century Sydney (ML SPF)

preparation of the plans' — who faced in some circumstances the possibility of a gaol sentence, since architects were not recognised by the court. In practice, however, Bradridge noted that no action was taken under the Building Act 'because the City Solicitor advises the Council that the legal provisions are so deficient that he cannot secure a conviction'.[65]

In reporting back to the legislature, the Select Committee on the City of Sydney Improvement Bill dismissed Edward Bradridge's expert evidence and pointed instead to numerous errors and flaws in the Bill, many of which were little more than typographical. Objections voiced during the taking of evidence — the 'arbitrary and excessive' powers, the overly harsh penalties, the lack of avenues for appeal — were supported by Committee members. Rather than give uncertain powers to the Corporation and its City Surveyor, the Committee recommended that a Board, independent of the Corporation or any other council, be established to enforce orderly growth and promote public health and safety. Such a Board would best be served by a membership of 'professional gentleman': the architects and allied professions were well pleased. As for the much decried provision in the Improvement Bill for the compulsory submission of 'plans and particulars' to the City Building Surveyor, this was branded as being unnecessarily costly and potentially 'oppressive'. Any requirement to lodge plans permanently with a board or civic body was, in the Committee's opinion, 'entirely superfluous'. Adding a fourth item to its list of objections, the Committee condemned this level of intervention as an act 'calculated to impede and embarrass rather than to facilitate and simplify the means of public [by which they meant private] improvement of the city'.[66] This important clause was 'entirely remodelled' by the Committee: the Improvement Bill, as originally intended, was in tatters.

Unruly and ragbag as the city's development may have been — and injurious to the environmental amenity, health and well-being of many of its less well-off citizens as this development certainly was — the Select Committee was not about to tamper with market forces or the rights of property, the latter having been especially and

65 Ibid, p 210.
66 Ibid, p 181.

steadfastly defended by the slum landlords, Thomas Buckland and Sydney Burdekin, during their evidence to the Select Committee. Burdekin, pastoralist and politician who controlled a family real-estate empire,[67] was particularly ardent that the Improvement Bill was 'perfectly unworkable'. Like other opponents of the Bill, he also advanced the idea of a Board appointed by the State and immune to any powers that the City Corporation and its parvenu Building Surveyor might have.

The Select Committee's *Report* was tabled in Parliament on 12 March 1879. Less than three months later, the City of Sydney Improvement Act, a shadow of the Improvement Bill, was assented to by a largely uninterested colonial government.[68] Effective from 3 August 1879, the Act, which was to be central to building control in Sydney for over half a century, allowed the City Corporation to make by-laws to regulate building in Sydney and obliged it to appoint a surveyor to enforce the legislation. But an appeal body, the City of Sydney Improvement Board, which fettered, as it was intended to do, decisions of the Council, was also established under the Act. The Improvement Board was to be chosen by the Governor with advice of the Executive Council, and it was to 'consist of five members of whom one at least . . . [would] be a professional architect, one a practical builder and one a medical practitioner'. As a result of the new legislation, a Sydney Corporation Amendment Act — which featured a more detailed building code and mayoral powers to order the making good or demolition of 'ruinous or dangerous buildings' — was also passed in 1879, though its efficacy was severely limited.

Over the next eight years scores of dilapidated and dangerous buildings were demolished in Sydney, though it is probable that a good many of these would have fallen down if they had not been pulled down, as the Volunteer Artillery Hotel did in 1890, killing two people.[69] The new legislation spurred much of this activity, at least initially. But given Sydney's building boom, which lasted into the mid 1880s, and resultant increases in land values, it is again difficult to know what proportion of this rotten building stock would have otherwise vanished in the boom.

In any event, almost from the instant of becoming law, these new legislative mechanisms for controlling the City's growth were found to be stunningly defective and incomplete. From 1881 until well into the next century, Corporation officers were to draft and redraft a myriad of amendment Bills, none of which were taken seriously by the Parliament in Macquarie Street.[70] Further, though grossly inefficient in terms of regulating faulty or dangerous buildings, the Improvement Board did serve the function for which it had originally been set up, and achieved an outstanding success as far as curtailing the powers of the Council was concerned. Constant occasional conflicts between paid Boards and government departments on the one hand, and the Corporation on the other, generated additional confusion while making the City Surveyor's job extremely difficult. The Corporation saw itself 'as a deliberative and legislative body of vastly more importance than that of any institution outside parliament'. Its administrators earnestly directed the State's 'attention to the desirability of all civic service being under absolute municipal control, and with headquarters located at the [Sydney] Town Hall'.[71] But Macquarie Street had other priorities which did not include relinquishing absolute control of anything to the City Council.

During the 1890s, the Australian colonies experienced severe economic depression. For the fittest private enterprises, this was a period of consolidation and expansion. More broadly, leaving aside widespread and deep social suffering, the decade was one of forced reassessment which saw the beginnings of economic reconstruction. In the mid 1890s, Henry J. Daniels, Town Clerk of the City of Sydney, looked forward to the day when, given adequate powers, 'municipal authority and the comfort and well being of the people, would . . . become synonymous terms in fact, rather than in theory'.[72] Three years later, Daniels' successor, John Palmer, could

67 Shirley Humphries, *ADB*, Vol 3, pp 298-99.
68 Fitzgerald, *Rising Damp*, p 66.
69 TCR, 1890, p 2.
70 See, for example, TCR, 1889, p 8 and 1890, p 7; Building Surveyor's Report, *PC*, 1898, p 3.
71 TCR, 1893, p 2.
72 TCR, 1895, p 15.

not report any improvement in the Corporation's invidious position:

> Civic unrest and general municipal awakening, have characterised the past year, both in the City and its suburbs. Expressions of intense dissatisfaction at the utterly inadequate systems of local government have emanated from the people and their local representatives in and around the Metropolis; while the Press, in dealing more particularly with the City, in demanding immediate reform, have in unmistakable terms scathingly denounced the situation, and unsparingly criticised those who were considered responsible therefor. While the deductions of the Press were not, perhaps, in every case wholly correct, still it must be admitted that the commotion caused among the dry bones of civic life, has had the effect of galvanising into useful activity, such forces as will ultimately make for the public good.[73]

Restrictions placed on the Corporation's ability to act by the 'delusive political promise of successive governments' were to be problematic for many years to come. But difficulties surrounding the regulation of the City's growth were not exclusively the product of the State's machinations. Municipal politics were to see successive Councils vacillate between the needs of the City's populus and the interests of capital and its infrastructural demands. Precedence flowed from political circumstances.

As Palmer predicted, the growing commotion 'among the dry bones of civic life' was to eventually stimulate activity among 'the most earnest and energetic' of Sydney's citizens. Representatives of both capital, labour and a new style of Liberalism were to engage vigorously in debate over questions of planning the City. New ideas from Britain and Europe increasingly were applied to urban questions by the close of the nineteenth century as decision makers and experts tried to 'embrace the advantages accruing from the science of life as exemplified in other cities'.[74] Much, indeed, that was written, spoken or fought about regarding the planning and regulation of Sydney in the early decades of the twentieth century was to be based on imported ideologies emanating from an ascendant international town planning movement. Much that was to happen in the City, however, was to be predicated on its political economy.

73 TCR, 1898, p 22.
74 Ibid, p 2.

2

'In the interests of economy and efficiency':[1] National Efficiency and the City Beautiful

As a City we have been, and still are, in a momentous period of our history; the limit of prosperity under natural simple means may be said to have been reached, and further advance can now only be made by the bringing of scientific knowledge and sound practical experience to bear on every fresh undertaking. There are circumstances affecting communities, as well as the lives of individuals, under which success cannot be missed, but with their alteration, calculation, foresight, and persistent exertion become necessary to a continuance of such achievement.

Our City may certainly be said to be in this latter condition at the present time — primitive actions, purposes, and ideals are rapidly becoming useless as means to our continued advancement.[2]

Despite municipal hopes for an immediate upsurge in civic-mindedness and action in the midst of civic and economic adversity, agitation for environmental reform in the City of Sydney was to languish during the 1890s. At the beginning of that decade, however, a number of early advocates of reform through planning were to articulate many of the ideas which were to underpin future moves towards a planned City. Pre-eminent was the lately arrived, Greenwich-born architect, John (later Sir John) Sulman.[3]

Supremely self-confident, superior and stubbornly 'English', Sulman, a leading conservative figure in the town planning movement until his death in 1934, was to foreshadow much of the essence of the movement to come in two papers which he delivered to the second and third meetings of the Australasian Association for the Advancement of Science in 1890 and 1891.[4] Not long into his first paper, 'The Laying Out of Towns', Sulman declared that the 'typical mode of sub-division' in Australia was

> a case of *individualism* run mad. And with no better result than that in the course of years, and after many rebuildings, some kind of *order and classification* will have been *evolved* out of the *chaos of the commencement*. Whereas it should not be forgotten a modern town is an *organism* with *distinct functions* for its different members requiring separate *treatment*, and it is just as easy to allot these to suitable positions at first, as to allow them to be shaken with more or less difficulty into place. . .[5]

1 *Royal Commission. . . into the questions of. . . a Greater Sydney*, (Sydney, 1913), p xviii.
2 Henry Daniels (Town Clerk), TCR 1891, p 1.
3 Richard E. Apperly and Peter Reynolds, *ADB*, Vol 12, pp. 137-38; Robert Freestone, 'John Sulman and "The Laying Out of Towns" ', *Planning History Bulletin*, Vol 5, No 1, 1983, pp 18-24.
4 John Sulman, 'The Laying Out of Towns' in Australasian Association for the Advancement of Science, *Report of the Second Meeting*, (Melbourne, 1890), pp 730-36; and 'The Architecture of Towns' in *Report of the Third Meeting*, (Christchurch, 1891), pp 424-33.
5 Op cit, p 731-32 (my emphasis).

It could justifiably be said that these observations represent, in part, an early Australian reference to what would later be called 'zoning'.[6] Far more importantly, however, Sulman's sentiments illuminate the strong influence of British social theory on the planning ideologies which were to be transported to the colonies and espoused by planning luminaries. Specifically, his early writings evince the grip which social Darwinism had taken on nascent planning thought.[7]

For Sulman, the 'modern town' was a social organism, the shape and functions of which emerged through an ongoing evolutionary process. As with natural organisms, modern urban formations had to be ordered and their constituent elements classified. Lending a medical metaphor to his argument, Sulman was to forcefully assert:

> At the present time, when it is beginning to be understood that the land is the heritage of the whole people, and its absolute ownership is permitted to individuals only as a matter of convenience, the right of the community to enforce provisions against misuse is, I think, undoubted; and when this misuse takes so glaring a form as originating conditions that must inevitably tend to produce diseases it is the absolute duty of the State to interfere. As in medicine, so in legislation, 'Prevention is better than cure.'[8]

Urban organisms, like their natural counterparts, were prone to the ravages of disease. Thus, if 'the towns [and cities] of the future . . . [were to] far surpass those of the present in convenience, healthfulness, and beauty',[9] if society in general and individuals in particular were to advance and be uplifted to a higher level of being, urban disease would have to be planned away and present cankers cured.

Capitalist growth in the nineteenth century had proceeded virtually unrestrained. Growing economic, political and social crises in the late 1880s and early 1890s highlighted the urgent need 'not simply to restrain capitalism but to civilise it'.[10] In terms of urban growth, from Sulman's point of view, colonial liberalism had literally 'run mad'. Social Darwinist thought provided flexible arguments which could be applied to the case for the amelioration of urban nuisances and the reform of the nastier effects of laissez-faire capitalism.

Based on his addresses to the Australasian Association for the Advancement of Science, Sulman would probably have agreed with the contemporary influential Scottish thinker and eccentric professor of biology, Patrick Geddes, in the latter's insistence on the necessity to recognise 'the vast modifiability of life through its surroundings'.[11] This was an approach influenced by euthenics — that environmentally deterministic 'science' of improving living conditions so as to 'improve' human beings. In adopting euthenics as a tool, among other things, for social engineering and urban reform, Sulman embraced the liberal collectivist tradition which placed on centre stage a common good, or common social goals, based on consensus. This was not to accept some esoteric, fanciful doctrine. These ideas were seen to have great practical social utility. Through them the race could be improved and society made more efficient. But Sulman, typical of later Australian town planners, was by no means an idealist. Governments might be implored to intervene in the 'evolving' urban environment and to set about planning for growth, 'but at the same time', he reminded his 1891 audience, 'the fullest liberty consistent with respect for the rights of others should be allowed to individuals, for it is mainly through the individual that any advance is made'.[12]

The 'New Liberalism', which 'could breach laissez-faire theories of the state, while remaining true to an ethic of individualism',[13] had tentatively arrived in the colonies from England, where for the previous decade it had given political liberalism a new flexibility. While specifically addressing the question of the laying out of new towns, Sulman was to contend in 1890 that 'the time is ripe for a change' in the way in which colonial authority spatially organised society. He was also to 'claim, on behalf of . . . [his] profession, the honoured position . . . [architects] once occupied, viz., that of the chief designers of our towns and cities'.[14] 'Town Planning', as Sulman called

6 Freestone, op cit, p 20.
7 See Greta Jones, *Social Darwinism and English Thought: The Interaction Between Biological and Social Theory*, (The Harvester Press, Brighton, 1980).
8 Op cit, p 735.
9 Ibid, p 736.
10 Bede Nairn, *Civilising Capitalism: The Beginnings of the Australian Labor Party*, (MUP, Melbourne, 1989), p 6.
11 Patrick Geddes, 'On the Application of Biology to Economics', 1885, quoted in Jones, op cit, p 71.
12 Op cit, p 427.
13 Tim Rowse, *Australian Liberalism and National Character*, (Kibble Books, Melbourne, 1978), p 37.
14 Op cit, p 736.

the sum total of tasks involved in this 'honoured' role, was to be pursued by other expectant professionals for decades to come. Factors other than professional entreaties for legitimisation and power, however, were to stimulate governmental intervention in the City of Sydney's growth.

Late in the summer of 1900, bubonic plague broke out in Sydney.[15] During the epidemic, which lasted for over six months, 303 people were reported to have contracted this painful and terrifying disease. Just over a third of these victims died. Life in Sydney was dislocated, particularly in the City's central business district and around its wharves which bore the brunt of the plague's impact. Numerically, Sydney's poor inner-city, working-class residents suffered longest and hardest. As a result of emergency operations, almost four thousand premises were inspected and cleansed, over eighteen hundred people were officially quarantined, 105,915 tons of silt, sewage and garbage were discovered and removed and tens of thousands of rats were caught and destroyed.

Though the plague was an incubus for many Sydneysiders, the Town Hall sardonically hailed it as the 'greatest blessing that ever came to Sydney, viewed from the standpoint of the future welfare of our City'.[16] The presence of plague in Sydney starkly exposed the gross deficiencies in the regulation of the City's development. Fear of contagion also generated popular demands for immediate reforms, as was evident in the outcome of the Sydney Council election towards the end of 1900. Of the twenty-four seats on Council, fifteen were filled by new aldermen, including medical practitioner, James Graham, who had headed a Reform League, and J. D. Fitzgerald, a thirty-nine-year-old, radical Labor politician, who sought gradual social reform through the efforts of 'concerned' professionals.[17] Some older, conservative politicians had retired, but this was clearly a reform council. Its reformist zeal was backed by the extension of the franchise from 1900 to lodgers and occupiers who potentially controlled seventy-seven per cent of the vote, leaving property owners and leaseholders little hope of overall electoral victory.[18]

Warmly welcoming his freshly elected political masters, Robert Anderson, Sydney's Town Clerk, observed that the 'new Council came in, as the result of public upheaval, charged with the great work of bringing Sydney into line with other cities of the same magnitude in other parts of the world'.[19] Aware of the enormity of the task ahead, Anderson nonetheless congratulated the aldermen 'on coming in at a time when there is a much better prospect of realisation of their desires than ever before in the history of the Council'.[20]

Contemporary urban reformers had some reason to be optimistic about the City's future development, or at least its redevelopment. Apart from a popular mandate to put Sydney on a safer, more efficient footing, City aldermen and their municipal servants looked forward to the real possibility of creating a 'Greater Sydney'. Municipal moves to establish a central metropolitan council to administer both the City and its suburbs more effectively were first made in mid 1899 when a committee of suburban aldermen gathered together to set down and promulgate a 'Greater Sydney' scheme.[21] Some writers had been promoting the 'Greater Sydney' idea since the early 1890s. Though pursued in vain, the Greater Sydney cause célèbre was to gain momentum over the next decade. Political Labor's ascendance into State and federal as well as local politics also heartened reformers; the Labor Party already had secured the vote for lodgers and occupiers in the City and 'radicalised' the Council. Overall, however, responses to crisis in the City were piecemeal and generally disappointing — J. D. Fitzgerald, for one, was to abandon his aldermanic position on the Council in 1904.

State initiatives in the face of the plague menace did not include far-reaching reforms or regulations. Rather, the State deftly strove to place 'the whole blame [for the outbreak of bubonic plague] upon the shoulders of the City Council'[22] while focusing its attention on restructuring the City's infrastructure for improved

Sir John Sulman (1849-1934), patrician and leading figure in Australian town-planning, in his latter years (ML SPF)

15 See P. H. Curson, *Times of Crisis: Epidemics in Sydney 1788–1900*, (SUP, Sydney, 1985), Chapter 8; and Max Kelly, *A Certain Sydney 1900*, (Doak Press, Sydney, 1977).
16 TCR, 1900, p 3.
17 B. Nairn, *ADB*, Vol 8, pp 513-14; see also Neil O'Flanagan, 'John D. Fitzgerald and the Town Planning Movement in Australia', in *Planning History*, Vol 10, No 3, 1988, pp 4-6.
18 F. A. Larcombe, *The Stabilisation of Local Government in New South Wales 1856– 1906*, (SUP, Sydney, 1976), pp 39-41.
19 TCR, 1900, p 21.
20 Ibid.
21 'The Greater Sydney Scheme', in E. J. Brady (ed), *Sydney: The Commercial Capital of the Commonwealth*, (Sydney, 1904), p 35.
22 TCR, 1900, p 3.

John Daniel ('Jack') Fitzgerald (1862-1922), journalist, barrister, politician and leading Australian advocate of town-planning (ML SPF)

commodity circulation. Thus on 23 March 1900, New South Wales' State government took control of the waterfront areas abutting the City's commercial wharfage along Darling Harbour. Major shipping companies and other interested groups supported these moves since State intervention promised the upgrading of port facilities at no cost to private enterprise. The resumption of The Rocks during the following year was also to put paid to any serious debate as to where a harbour bridge or tunnel was to land in the City.[23]

Government plans for the seemingly beleaguered City were slow to materialise, while some disappeared without trace.[24] Plans for The Rocks, to take one example, were placed on paper by the City Improvement Advisory Board, but these came to nothing. Enabling legislation also further complicated environmental control and regulation in the City of Sydney. Several emphatic protests, for example, were to be made to the State Premier by the City Council regarding both the diminution of local government's control over its municipal domain and the duplication of functions. Flowing from a number of recent Acts of Parliament made in 1900 and 1901, the Sydney Harbour Trust and the Rocks Resumption Board could now be added to the lengthy list of Boards and Departments which had a hand in the City's management. Long unresolved deficiencies in the City Council's own enabling legislation also saw its Building Surveyor urgently advise in September 1901 that it was 'essential that the Council should endeavour to obtain greater legislative powers, without which there is but small hope of improvement'.[25]

Earlier, during Sydney's first plague year,[26] the State government had been roused to put together a Sydney Corporation (Consolidation) Bill. This legislation sought mainly to substitute State parliamentary electoral divisions for old City wards to extend the franchise and to alter various procedural matters, such as those for the election of aldermen and mayors. No existing Corporation powers were extended in the Bill nor were any new powers granted by it. Needless to say, the City Council had to all intents and purposes been excluded from the framing of this Bill. Indeed, only a few months prior to its enactment by Parliament late in 1902, Council administrators were still desperately attempting to obtain a final draft of the Bill from the Clerk of the Parliaments and the Colonial Treasurer.[27]

Unaided in their municipal mission by the 1902 Act, the City Council, at the insistence of the radical middle-class reformer, Alderman Fitzgerald,[28] had its own Sydney Corporation (Amendment) Bill drafted. As the newly appointed and highly officious Town Clerk, Thomas Nesbitt,[29] gruffly pointed out, this Bill had been submitted to the State Premier, the Hon. Sir John See, MLA, in 1902 and 1903. Yet again, Nesbitt complained in 1904, 'and for the third year in succession a draft Bill has been submitted, but in this instance to the representative head of another Government, and for the third year in succession the Council has experienced disappointment and failure'.[30]

A verbose bureaucrat who seized every opportunity to berate aldermen and members of parliament alike, Nesbitt was to oversee numerous abortive Corporation Amendment Bills until his retirement in 1924. His successors were to grapple with the legislature over the matter well into the 1930s. The Council's Amendment Bill, however, was assented to on 9 December 1905, in part due to the entreaties of Lord Mayor Allen Taylor, a 'self-made' man who, it was thought, would not allow his mind to run wild with notions of municipal socialism. But the Premier, J. H. Carruthers, had agreed only conditionally to introduce the Bill into parliament and promote it. Numerous clauses and provisions for a number of much needed powers were eliminated from the Draft Bill by a select committee of the Legislative Assembly which had been appointed to review the document. Under the original draft, for example, Fitzgerald had made it 'obligatory upon the Council to submit a scheme for the re-housing of persons displaced' as a result of resumption schemes. This provision, among others, was to be emasculated. But when passed, the legislation was to

23 Fitzgerald, *Sydney 1842–1992*, pp 220-22.
24 TCR, 1903, pp 20; 219.
25 *PC*, 1901, p 455.
26 See Curson, op cit, chapter 8. Plague was to break out on ten subsequent occasions up until the 1920s.
27 *PC*, 1900, p 339; CM 1144, 2 September 1900, p 299; TCR, 1902, p 26; Larcombe, op cit, Vol 2, p 43.
28 TCR, 1905, p 92.
29 Janet Howse, *ADB*, Vol 2, p 43.
30 TCR, 1904, p 61.

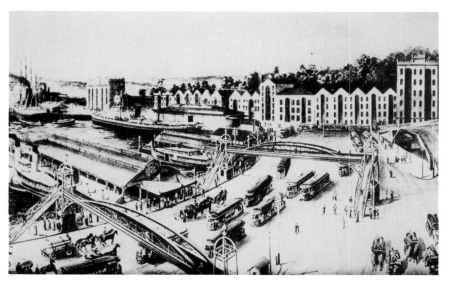

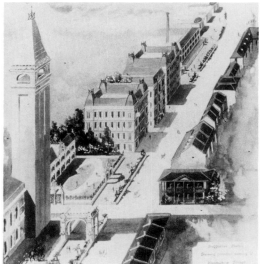

Above, *A 1902 proposal for widening Macquarie Street, Sydney's premier thoroughfare* (ML GPO 1 09248)

Left, *Intolerable traffic conditions in parts of Sydney by the turn of the century stimulated various suggestions for reform. This proposal for overcoming the 'dangerous' traffic at Circular Quay was published in a 1901 edition of the* Town and Country Journal

contain clauses which were to make it a very important Act. In essence, as far as 'planning' requirements were concerned, the Sydney Corporation (Amendment) Act of 1905 conferred 'additional powers upon the Council in regard to resumption of lands for widening streets . . . [and] improving localities'.[31] This was the first time that the Council had been given such powers. Questions as to what constituted an improvement, however, were left open to the imagination; housing was cast off as a residual.

As was usual with legislation which affected the Corporation, this 'Act was not without serious faults and blemishes in certain particulars' and yet another Amendment Act had to be passed in the following year to simplify the process of settlement for resumptions.[32] Nonetheless the Council viewed its newly won power as a significant victory for municipal government and a long awaited boon for the City. It had been pressing the State for rights of resumption since at least the 1880s. Calls for such powers were renewed with the outbreaks of plague and it was a 'grievous matter of complaint' for the City Council to see the Sydney Harbour Trust and The Rocks Resumption Board entrusted with the very function that was, Alderman Lindsay Thomson argued, so 'essential to proper modern city development'.[33]

Resumption was effectively to become the City reformer and improver's most powerful instrument; it was wielded often and with vigour by both the State and its various agencies and by the Council of the City of Sydney. Provisions in the amended Corporation Act permitted the City Council to open, widen, enlarge or extend public ways; to improve or remodel any portion of the City; and to undertake works relating to the Sydney Corporation and Sydney Electric Lighting Acts. Mention was also made in the head of the Act for the construction of dwelling houses, reflecting a little of the most up-to-date English municipal legislation regarding housing schemes, notably the Housing of the Working Class Act (1903).[34] But the amended Act lacked enabling clauses in this regard. Private enterprise, however, had been profitably engaging in bourgeois housing schemes around the City since the 1890s. The model suburb of Kensington, named after the fashionable, West End London suburb, for example, was advertised in 1891.[35]

Council resumptions began in earnest in March 1906 when Althone Place — despised by middle-class moralists and secular reformers as a breeding ground for disease and vice — was singled out for destruction. One of the largest City resumptions, the razing of Althone Place involved a loss of 435 dwellings and the displacement of 1779 people. In good time the notoriously insanitary area was transformed into a busy manufacturing and storage locality as other inner-city, working-class areas were to be.[36] By 1917, 119 compulsory resumptions, ranging from individual properties to large-scale clearances, had been conducted by the City Council at an enormous gross cost of over £2.3 million. This zeal was to be continued

31 TCR, 1905, p 92; *PC*, 1905, pp 354, 514.
32 TCR, 1916, p 354; *PC*, 1906, p 377.
33 CM 1154, 16 Dec 1902, p 385; CM 1102, 10 June 1901, p 83; *PC*, 1902, p 972.
34 TCR, 1905, p 92.
35 See Paul Ashton and Kate Blackmore, *Centennial Park: A History*, (NSW University Press, Sydney, 1988), pp 99-100.
36 TCR, 1916, p 355; See also Keating, *Surry Hills*, op cit, and Fitzgerald, *Chippendale*, op cit.

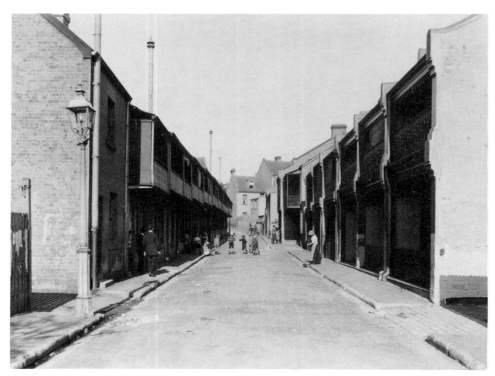

Above, *Bennett Street, Surry Hills, 1913. Middle-class reformers viewed streets such as this and the 'mean terrace' as productive of vice and crime. Men of business and commerce viewed such inner-city areas as suitable locations for factories and warehouses. For many Sydneysiders, however, this was home* (ML SPF)

Right, *This lane, photographed by a City Council photographer to protect the Council from possible later claims for compensation, was taken on a winter's day in June 1916. It was part of a 7.5 acre resumption – the Brisbane Street resumption – which began in 1912 and continued until the late 1920s* (CCS)

throughout the 1920s and into the 1930s.[37] State initiatives in the City concentrated on wharfage and projects such as the extension and rather grand reconstruction, which began in 1904, of the Sydney rail terminal at 'Central'. This culminated in the opening of the first part of the City underground railway in 1926.

New powers and the transfer of Land Tax from State to City coffers for the purpose of redevelopment saw a renewed optimism among reforming civic worthies in the Council's ability to treat the ailing City environment. As early as 1901, the Council had resolved on the motion of J.D. Fitzgerald, to have appropriate municipal officers 'prepare a comprehensive scheme of City improvement'. City improvement, in the aldermen's collective opinion, which was shared by many other Sydney residents concerned with planning and urban renewal, was meant 'to aim at the destruction of slum areas, the widening of narrow streets, the creation of new and broad thoroughfares, the opening of squares and spaces, and generally the improvement and beautification of the City'.[38] 'Improvement' and 'beautification' were seen to be central to human and environmental efficiency and thus to material progress. Lord Mayor Allen Taylor, a timber merchant and ship-owner, embarked ruthlessly on 'civic improvement' until his retirement in 1912.[39] Taylor was to inform his fellow aldermen in a minute of 1906[40] that even parks should be maintained at 'the highest state of efficiency'. Parks were not only 'the lungs of the city' and a manifestation of civic pride and worth, they were morally and mentally uplifting and thus reacted on human efficiency.

Taking the initiative, the City Council instructed the City Surveyor in April 1907 to 'prepare a carefully considered and elaborately designed plan of reconstruction and improvement of the City'. Three months later, various Council committees also looked into 'the advisability of inviting competitive designs for the remodelling of the City of Sydney, special consideration being given to sanitation, artistic improvement, and effective ingress and egress from the City and suburbs'.[41] Deeming such an undertaking to be beyond its resources, the City Council turned to the State Parliament in Macquarie Street to take an active lead. 'The whole question of re-modelling Sydney on a comprehensive plan', wrote solicitor-businessman Thomas Hughes in January 1908, 'is ripe for consideration'. Having just been elected Lord Mayor of Sydney, Hughes warned:

The City is being rebuilt with great rapidity, and the type of buildings in course of

37 TC 2307/17; TCR, 1917, p 437; TCR, 1934, pp 101-03.
38 CM 1090, 5 February 1901, p 28.
39 Alan Roberts, *ADB*, Vol 12, p 175.
40 *PC*, 1906, pp 348-50.
41 *PC*, 1907, pp 83; 218.

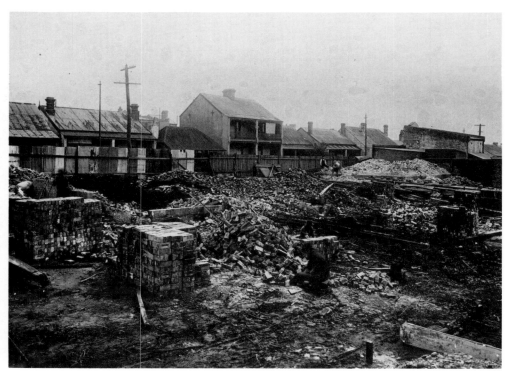

Above, *Part of resumption at Grose Street, Camperdown, behind the University of Sydney, in 1919. (Camperdown was absorbed into the City of Sydney for a number of years in 1908.)* (CCS 51/20/2083)

erection will in the near future render the cost of extensive remodelling almost prohibitive. I therefore recommend that we should invite the Government to appoint a Royal Commission to enquire into the whole subject and to submit a scheme. . .[42]

Earlier Hughes had successfully extended the franchise in the City to business people leasing or renting premises to counteract the votes of the working-class lodgers and occupiers.[43] He now promised cordial co-operation between the City Council and the State Government. Following a Council deputation which waited upon the Premier, a Royal Commission, over which Lord Mayor Hughes presided, was appointed on 14 May 1908 to investigate proposals for the remodelling of Sydney and for the general improvement of the City and its suburbs.[44]

Between 22 June 1908 and 10 May 1909, the Royal Commission convened ninety separate meetings during which it heard the evidence and opinions of forty expert witnesses. Indicating the very practical nature of inquiry, the largest professional group of witnesses — nine in all — were engineers. (Two engineering draftsman and one assistant engineer also gave evidence.) Three architects and three clergy came before the Commission, along with feminist and labour leader, Catherine Dwyer, who represented Trades Hall. Numerous senior public servants also had a say during the proceedings. But no one gave 'Town Planner' as their stated profession or occupation. Coyly pointing to his personal accumulation of experience, architect John Sulman, by then retired from practice and immersed in the new 'science' of planning, explained to the Commission that:

> It is only in Europe and America that such men [town planners] at present are known, but it is my sincere hope that the opportunity will produce the man, and that Sydney may owe its rebirth to one whose life has been spent under the Southern Cross.[45]

John Sulman, who had spent the best part of twenty-three years under that particular constellation, was to be examined on eleven occasions over just as many months by the Commissioners. Sulman had not long since published his most recent thoughts on the subject of town planning. The *Daily Telegraph*, of which he was a director,[46] had run a series of four articles by Sulman in 1907 on 'The Improvement of Sydney'. Here he pointed to the likelihood of Sydney grinding slowly to an economic halt if nothing were done to upgrade many of the City's antiquated streets. He

42 *PC*, 1908, pp 23; 443.
43 Peter Spearritt, *ADB*, Vol 9, p 393.
44 'Royal Commission for the Improvement of the City of Sydney and its Suburbs', *NSWPP*, 1909, pp vii-lxi; 17-259. An interim report was presented on 3 December 1908. See also TCR, 1909, pp 45-52.
45 'Royal Commission. . .', p 63.
46 R. E. Apperly and P. Reynolds, *ADB*, Vol 12, p 137.

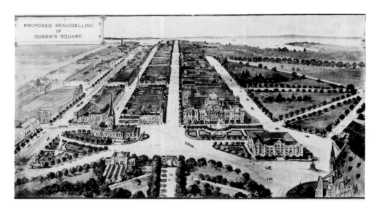

PROPOSED REMODELLING
OF
QUEEN'S SQUARE

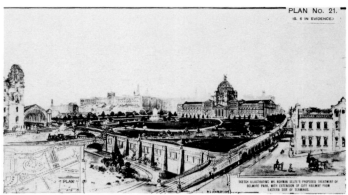

PLAN No. 21.
(S. 5 IN EVIDENCE.)

Above, *This scheme for remodelling Queen's Square was proposed by the Commissioners on the Royal Commission for the Improvement of the City of Sydney and its Suburbs which reported to the NSW State Government in 1909*
(ML M14 811.17/1909/1)

Above right, *Engineer Norman Selfe's proposal for Belmore Park in front of Central Railway submitted to the Royal Commission*
(ML M14 811.17/1909/1)

Right, *J. D. Fitzgerald's recommendations to the Royal Commission for improving Sydney's transport systems*
(ML M14 811.17/1909/1)

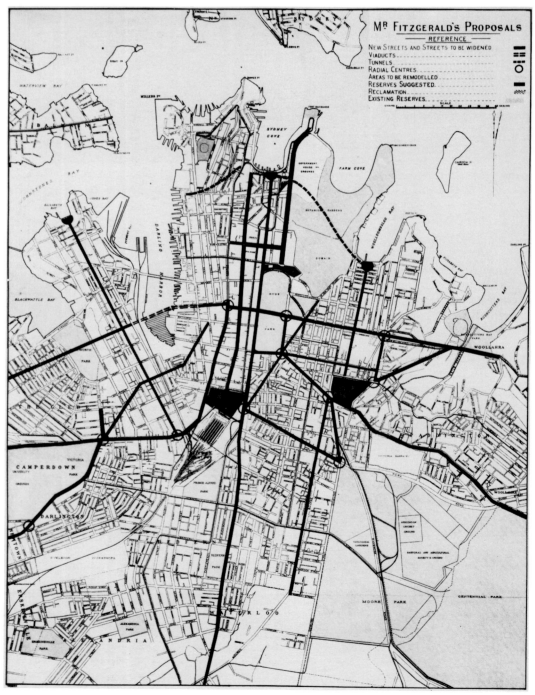

MR FITZGERALD'S PROPOSALS

REFERENCE

NEW STREETS AND STREETS TO BE WIDENED
VIADUCTS
TUNNELS
RADIAL CENTRES
AREAS TO BE REMODELLED
RESERVES SUGGESTED
RECLAMATION
EXISTING RESERVES

surmised that with the beginnings of the iron industry and manufacturing underway, population 'must of necessity grow with rapid strides'. 'Settlement', Sulman went on to observe, 'is increasing, and immigration is to be fostered'. Primary industry, too, was expanding remarkably. Therefore, he contended given the City's great importance as an entrepôt, it would not be long before 'the streets that appeared so ample to our forefathers will be unable to carry the traffic. Indeed, in some places, they are already insufficient to meet present requirements, and are a cause of delay and loss and even danger'.[47]

Sulman's ideas concerning the City's streets were duly noted and his plans for the City railway complex rated a special mention in the Commission's report. Arguably, however, of most concern to him was the initial 'preparation of a fully detailed and complete scheme . . . on which action can be based'. More importantly, Sulman reiterated a number of times, an holistic, practicable plan would have ultimately, after proper consultations, to be left to a sole expert — 'a genius', no less — since such a scheme could 'only be done by one man, and an expert at that in city design'.[48] The Commissioners, however, were of the opinion that 'the municipality . . . [was] best fitted to undertake this important work'.[49]

One other witness who could boast, but did not, of pre-eminence in the fledgling town planning movement in Sydney, indeed in Australia, was J. D. Fitzgerald. Fitzgerald had tirelessly promoted the improvement of both Sydney and the lot of its poorer inhabitants for almost two decades. One of his most recent and telling pieces on the city's plight, 'Sydney, the Cinderella of cities', had been published in 1907 in the progressive publication, *Lone Hand*:[50] it spoke of the 'civic anarchy' which had 'had its own way with Sydney'. Fitzgerald was 'delighted over the appointment of this Commission', as he told its members: it looked to him 'as if we Australians were going to do something big at last in the matter of civic Government'. Reciprocating his goodwill, the Commission was 'anxious to hear . . . [his] views regarding the question of Sydney improvement'.[51]

Content to leave discussion of technical minutia and 'the physical plan merely' to 'experts', Fitzgerald spoke learnedly on city planning in general and the reconstruction of slum areas in particular, both of which, if intelligently pursued in Sydney, would make for a City both beautiful and efficient. He tabled plans showing improvement schemes from all over the globe and furnished maps 'presenting the ideal features of city planning — radial centres, large straight avenues going in all directions from the centres . . . with smaller streets in between . . . even curved streets!'[52] Authorities from Britain, and the Continent and America — notably Daniel Burnham, guru of the City Beautiful movement in the United States[53] — were cited and quoted. Fitzgerald conferred with the Commissioners on overseas planning and other legislation — principally England's Housing of the Working Classes Act of 1890. There was a clear need to establish a firm legislative base from which town planning and urban renewal could proceed.

In concluding his evidence to the Royal Commission on 2 November 1908, Fitzgerald reiterated his firmly held belief that questions of civic beauty deserved equal weight to those of economy if real social progress and urban improvement were to be achieved. Narrow concerns with economics, which had disfigured the City and disinherited many of its citizens, characterised the avaricious individualism of an earlier era. But times, according to Fitzgerald, were rapidly changing. Reading at some length from H. G. Wells' recently published *Future in America*, Fitzgerald praised highly the 'serene preparation of Boston through its Metropolitan Parks Commission', holding it up as yet another dramatic example of the blessings which could accrue from rational, humane planning. Quoting Wells, he said:

> 'Nowhere now is growth still so certainly and confidently going on as here [in Boston] . . . Nowhere is it upon so great a scale as here, and with so confident an outlook towards the things to come. And nowhere is it passing more certainly

47 *Daily Telegraph*, 7 December 1907; see cuttings book ML Q981.1.
48 'Royal Commission. . .', p 63.
49 Ibid, p lvi.
50 *Lone Hand*, Vol 1, No 1, May 1907, pp 56-60.
51 'Royal Commission . . .', p 136, 117.
52 Ibid, pp 136, 134.
53 See Peter Hall, *Cities of Tomorrow*, (Basil Blackwell, Oxford, 1990), pp 175-81.

from the first phase of a mob-like rush of individualistic undertakings into a planned and ordered progress.[54]

Almost twenty years had passed since Sulman had bemoaned the excesses of laissez-faire individualism. But for Fitzgerald, just as 'a proper balance . . . [had to] be struck between the picturesque features of the harbour and the requirements of our growing commerce' in terms of Sydney's wharves,[55] both communal and individual interests had to be accommodated through the planning process. Indeed, in Fitzgerald's scheme of things, well-placed individuals, such as the professionals who attended the Commission, would be essential in the transformation to a higher phase of 'planned and ordered progress'. Undoubtedly, Sulman would have agreed.

In their *Final Report*, the Commissioners presented their findings under two principal heads. The first, 'Traffic Considerations', highlighted the 'difficulties which beset the carriage of merchandise between the wharves and the city warehouses'. To remedy this 'unsatisfactory and dangerous' situation they urgently recommended the 'immediate introduction of a system of underground electric railways for Sydney and suburban passenger traffic' and the widening of twelve major thoroughfares, the realignment of one other and the creation of two new arterial roads. The removal of the Pyrmont Bridge was also recommended so that Darling Harbour could be reclaimed up to Bathurst Street and a new link formed with the busy Pyrmont-Ultimo Peninsula.[56]

Next on the Royal Commission agenda was 'Beautification of the City'. The Commission noted,

> While it is true in a general sense that works designed to meet the necessities of our growing traffic should have precedence over those of a purely aesthetic character, the importance of Sydney as the chief metropolitan city of Australia demands that improvements designed to add to its beauty and attractions shall have the fullest consideration.

Beautification of the City of Sydney, if the Royal Commissioner's chief recommendations are any guide, was in large part to be effected by more street widening, extensions and continuations. Other ingredients included the cultivation of trees ('much neglected in Sydney') in places where 'they would least interfere with business and traffic' and the erection of water fountains: the City, alas, was 'sadly deficient in fountains, both of the display variety, and the ordinary street-drinking type'. 'Art' was also to be cultivated in the streets. Utilities such as pavements, kerbs, hoardings, monuments, lamp-posts and letter boxes were to be made to be beautiful.[57]

A recognition of the influence of environment on individuals was inherent in some of the Commission's recommendations and observations. Streets as playgrounds were viewed as the 'most unpromising school for the production of good citizens' at a time when the newly formed Australian Commonwealth and its States were attempting to populate the continent with a 'superior' white race. In keeping with the dichotomy between a healthy body and a healthy mind, wholesome physical surroundings were portrayed as both producing and reflecting moral strength, or lack thereof. Healthy, supervised and didactic playgrounds, the Royal Commission believed, had to be provided for children. Parks and recreation areas were to serve similar functions while adding beauty, and perhaps a little piece of arcadian countryside, to the City.

Environmental determinism was to have a significant impact on the regulation of development in Sydney. Indeed, it was employed to classify or condemn urban precincts. On 'social and hygienic grounds', the Royal Commission was to argue, for example, 'workmen [and their families] should be encouraged to live in separate houses in the suburbs'. Tenements and overcrowded inner-city areas were associated with disease and degeneracy; the suburbs were supposed to be salubrious. This

54 'Royal Commission . . .' p 137.
55 Ibid, p 117.
56 Ibid, pp xxiii-xxiv.
57 Ibid, pp xxvi-xxvii, xxiv-xxv.

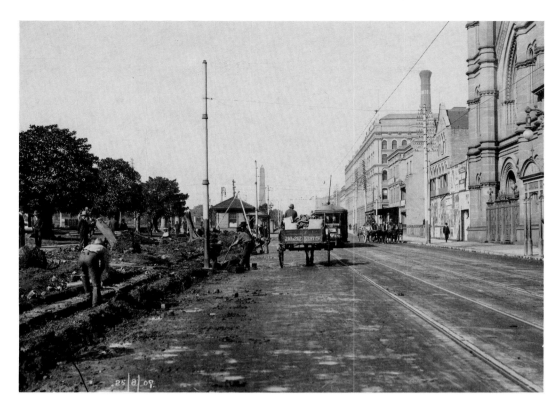

Street widenings became a major feature of attempts to 'improve' the City of Sydney. Here, in August 1909, Elizabeth Street is being widened by City Council workers (CCS HP1/4)

argument could be and was applied carte blanche to increasingly valuable working-class areas in the City which were coveted by commercial interests. Exceptions, however, existed: the Royal Commission was quick to 'recognise that waterside workers prefer to reside within easy reach of the wharves'. (It should have said were *compelled* by the nature of their ever uncertain and casual employment.) Special provisions were to be made for this essential pool of labour.[58]

Numerous people and interested bodies anxiously awaited the Royal Commission's findings and recommendations. Sooner or later, some were to be disappointed. Town planning was extolled by the Commissioners as the optimal way to 'ensure the development of Sydney along harmonious lines' and to remedy environmental defects. Their pronouncement, however, was aimed at new suburbs. As for the 'Future Growth of the City', historical circumstances and 'the mistakes of early rulers and residents' now meant that 'the city presents few opportunities for town planning on modern lines'.[59] Piecemeal restructuring and redevelopment would continue to characterise the City's growth pattern. Despite State intervention in the built environment, the demands of commerce were not to be fettered in the City of Sydney.

R. H. Brodrick, the City Building Surveyor, was to be particularly vexed by the outcomes of the Royal Commission. On 22 June 1909, three days before the Commission presented its final report, Brodrick informed the Town Clerk of Sydney that he and his staff looked forward to the Commissioners' report 'with the sincere hope that they may urge forward the passing of an up-to-date Building Act, giving powers to your officers to effect improvements'. A good deal was being done to regulate growth in the City by Council officers. But the Building Surveyor frankly admitted that it could not 'be expected that they . . . [could] use persuasion and personal advice so frequently'. What they needed was a Building Act similar to the Bill which the Council had prepared and passed on to the State Legislature in 1903 for sanctioning. 'It is a significant fact', the Surveyor concluded without being specific as

58 Ibid, p xxvii.
59 Ibid, pp lvi, xvii, xxix.

Thomas Nesbitt (1853-1935), Sydney's Town Clerk between 1902 and 1924 (CCS)

to why, 'and a tantalising one, that while Sydney is being practically rebuilt we await the benefits of a new Building Act'.[60]

The City Building Surveyor would have been mightily pleased to read the first and most important general recommendation put forward by the Royal Commission. An 'immediate necessity', it wrote, was a 'comprehensive Building Act'; 'without such a measure', little real progress [could] . . . be made in city improvement'.[61] Moreover, the Royal Commission urged that the Bill which had been prepared by Council officers in consultation with the Institute of Architects and the Master Builders' Association be adopted, with only a few minor alterations: it was not. Requests for an adequate Building Act continued to be included regularly in the City Building Surveyor and City Engineer's *Annual Reports* until 1934.

Other recommendations made by the Commission were put into practice, though many of these were somewhat cosmetic. Well before the Commission's *Final Report*, the City Council resolved to 'get surveys. . . plans and sections prepared for the purpose of beautifying the city'.[62] And from mid 1909, the Council embarked on a City beautification scheme which was in part linked to the Council's ongoing program of resumptions for street improvements. Significantly, the process of beautification was to be overseen by the Council's Health Committee.

Part of the City Council's beautification scheme included investigations into street furniture, such as electric signs and other devices, building uniformity, the abolition of ugly advertising hoardings and aesthetic control of awnings and flower sellers' stands. A 'grouping of . . . royal statues of Queen Victoria, the Prince Consort, and the new equestrian statue of King Edward VII' along with laying out a more attractive entrance to Hyde Park from Macquarie Street was also part of Council plans.[63] But the bulk of municipal activity in this direction concentrated on street planting and the refurbishment of parks.[64]

In his voluminous *Annual Report* for 1911, the Town Clerk, Thomas Nesbitt, clearly inspired by antipodean possibilities for city beautification, waxed lyrical on the subject. He informed his Lord Mayor and Alderman that the founding Professor of Civic Design at Liverpool University, Professor Stanley Adshead, had stated that 'Paris, of modern cities the most beautiful in the world, is a city of ivory, studded with pearly grey in a setting of green'. Here, for Nesbitt, 'was a clear objective, an ideal to struggle after and to seek to attain . . . the simple, clear and intensely beautiful description of Paris, the city of the Seine, the masterpiece of Baron Haussmann'. Sydney was by now a commercial city *'par excellence'* — it had its 'grey' which suggested 'endurance' rather than 'grandeur and romance'. In due course, Nesbitt forecast, the City would acquire architectural greatness. To achieve 'the higher and more cultured and refined plane of city beautification', to civilise the City, municipal government had to engage in 'providing the "setting of green" '.[65]

On taking up his position with the Council in 1902, Thomas Nesbitt had emphasised 'the fact that intelligence, good taste, and municipal government must necessarily encourage tree-planting in public places and thoroughfares'. In recent years, he proudly noted, the City Council had planted some fourteen hundred trees in Sydney. Though the City was well supplied with parks and gardens,[66] much remained to be done in beautifying Sydney and this would 'necessarily have to be done by degrees'. According to Nesbitt, the greening of Sydney was the way forward. Trees were relatively cheap and the latest theoretical and practical literature from overseas added further weight to such a course of municipal action. In 1910, a paper presented at the Town Planning Conference in London on the design of parks and gardens was republished in an issue of *The Town Planning Review*, at least one copy of which was held at the Public Library of New South Wales. Its author, Thomas Mawson, the leading British planner and landscape architect, generally observed:

> There are many standpoints, economic and aesthetic, from which the Civic Park can be viewed; but there is one upon which most people now agree, which is that

60 PC, 1908, pp 578-79.
61 'Royal Commission . . .', p lii.
62 CM 1368, 16 February 1909, p 49.
63 PC, 1912, p 515.
64 TCR, 1910, pp 75-7.
65 TCR, 1911, pp 121-22.
66 Paul Ashton and Kate Blackmore, op cit, p 48.

they are not a luxury but a necessity. Many things have combined in the hurry and haste of latter-day life to make them so. The stern and ceaseless demands of modern industry with its noise, machinery, and dust, the dangers of the streets with the maddening haste of motor-driven vehicles, which in many towns like London call aloud for the spaces apart. Founders of modern industrial villages believe that parks and aesthetic amenities are necessary for the physique and working power of the worker and his progeny, and put their faith into practice. It is this attention to the health and physique of posterity that is to ensure the continuity and prosperity of commercial enterprise, and it is this consideration which places the provision of public parks and open spaces in the first rank of progressive municipal enterprise . . .

You will see, therefore, my contention that the provision of parks and open spaces is not primarily an aesthetic but a practical question, bearing upon the moral and physical condition of the whole country considered from whatever standpoint — whether of industrial or social.[67]

Thus beauty fostered national efficiency.

Nesbitt conceded that 'the municipal Utopia of the municipal idealist . . . [was] not likely to be discovered until the dawn of the Millennium', particularly given that the City Council was 'cribb'd, cabin'd and confined in all its administration, possessing powers of the most meagre and faulty description when compared with . . . [Sydney's] commercial and maritime importance'.[68] Nonetheless, questions of national efficiency were central to remodelling and related town-planning issues in Sydney. Aside from the obvious attempts to modernise the City's infrastructure and commercial building stock (in 1911 alone, 1122 applications were made to the Council to construct new buildings or substantially alter existing premises),[69] the remodelling of slum areas was seen to promote national efficiency.

During 1910, a deputation from the Church of England Social Reform Association of the Diocese of Sydney, accompanied by a Sydney Trades and Labour Council representative waited on the Lord Mayor, Allen Taylor, to press for the resumption and redevelopment of Sydney's slums. Especially concerned with the moral and material welfare of Surry Hills and Chippendale residents, the deputation asserted that these and other similar areas were 'a menace to civilisation' and should, as on the Continent, be wiped out by municipal authority and replaced with model, hygienic housing. The Lord Mayor concurred: this was a subject that appealed 'to every human-heart with a desire to endeavour to improve humanity'. Though the Council did not have specific 'power to build workmen's dwellings', the Lord Mayor

> had no hesitation in saying that the Council must recognise the responsibility upon its shoulders, and make a determined effort to meet the wishes of the people on true business lines. In this way the progress of the City would be greater, the health better, and the citizens more valuable to the State as a whole.[70]

Politically conservative (he eventually became a member of the Citizens Reform Association which broke Labor's domination of the City Council in 1921),[71] Allen Taylor was clearly concerned with national efficiency. But he was far more interested in demolishing what he believed to be uneconomic slum areas, in building factories and warehouses in the City and in improving urban transport facilities than with housing displaced people.[72] The same, however, could not be said of Arthur Griffith, a colleague of J. D. Fitzgerald's, who became Minister for Public Works in October 1910 in New South Wales' first Labor Government. Griffith was keen to improve the City's infrastructure. But during the early months of 1912, urged on by municipal reformers,[73] he forcefully pushed a Bill through Parliament enabling the City Council to acquire land and borrow money for the erection of houses for displaced City workers. Demolitions of housing stock in the City and some of its older suburbs had made demands for working-class housing 'more or less acute'. 'Private enterprise', Griffith told the State's Legislative Assembly in March 1912, was 'not constructing

67 Thomas Mawson, 'The Design of Public Parks and Gardens', *The Town Planning Review*, Vol 1, No 3, 1910, p 205.
68 TCR, 1911, p 402.
69 *PC*, 1911, Building Surveyor's Report, p 1.
70 TCR, 1910, p 24.
71 Alan Roberts, *ADB*, pp 175-76.
72 Lord Mayor's Minute, 5 August 1911, pp 1-2 and 13 December 1911, in *PC*, 1911, pp 429, and 1912, pp 405.
73 TCR, 1911, pp 135-36, 162-63.

Professor of economics, Robert Irvine (1861-1941) (ML SPF)

74 *VPLA*, 18 March 1912, p 3971.
75 See Fitzgerald, *Chippendale,* op cit, pp 128-29, 229-30.
76 Fitzgerald, *Sydney 1842–1992,* pp 229-31.
77 See B. McFarlane, *Professor Irvine's Economics in Australian Labour History,* (ASSLHC, Canberra, 1966).
78 Robert Irvine, *Report of the Commission of Inquiry into the Question of the Housing of Workmen in Europe and America,* (W. A. Gullick, Government Printer, Sydney, 1913), p 4.
79 Ibid, p 186 ff.
80 Ibid, pp 249, 247, 238.
81 *Art and Architecture,* Vol 7, No 1, 1910, p.1 cited in Robert Freestone, 'John Sulman and "The Laying Out of Towns" ', op cit, p 22.
82 See Peter Spearritt, *Sydney Since the Twenties,* (Hale & Iremonger, Sydney, 1978), pp 12-15.
83 *SMH*, 21 March 1912, p 7.

new houses speedily enough to provide the necessary accommodation' and it was 'desired that the City Council shall be in a position to emulate the municipal authorities of the old world and build residences for the class of people most in need of them'.[74]

Under the Sydney Corporation (Dwelling-houses) Act of 1912, the City Council was permitted to construct flats and semi-detached houses (for example, the Strickland Flats in Chippendale and Ways Terrace in Pyrmont)[75] though Council experiments with municipal housing were extremely limited relative to the quantity of housing it was to pull down.[76] A tandem Act was also passed which gave the State government the right to construct dwellings outside the City (a right which J. D. Fitzgerald had attempted to secure for the City Council). Thus in August 1912, during the life of the McGowen Labor Government, Robert Francis Irvine, MA, was commissioned to investigate the housing of 'workmen' in Europe and America.

Robert Irvine, founding Professor of Economics at the University of Sydney,[77] got down to tintacks on the opening page of his lengthy and detailed report. In 1913, after around a year of extensive travel and reading, he wrote that 'The housing question is concerned mainly with two questions': firstly, how 'to get rid of the results of unregulated housing' and, secondly, how to affordably provide 'a home that shall be artistic and hygienic, a home environment which shall be if not actually constructive, at least not destructive, of either body or character'.[78] Whatever the answers advanced to these vital social questions, and Irvine had many answers, they were, the energetic Commissioner insisted, invariably and 'inseparably connected with Town Planning'. Drawing on a wide range of authorities ranging from Patrick Abercrombie through Ebenezer Howard to Raymond Unwin, Irvine urged that the principles and practices extolled by city beautiful advocates and the Garden Cities movement — 'one of the most fruitful movements of the present day' — be applied to both City and metropolitan housing.[79] Housing, too, had to be viewed as part of a larger organic system. So if Sydney were to be successfully reshaped into 'a conveniently arranged and beautiful city' and not just 'a place of business . . . a mere hive of industry', Irvine contended, making a passing jibe at Allen Taylor, then talented experts, such as architects, landscape architects and engineers, would have to be co-opted to work on a scheme 'inspired and guided by men trained in the best schools of Town Planning'. Sydney, 'a fortuitous medley of bricks and mortar and macadam', was in desperate need of a City survey and an overall plan.[80]

Town planning seemed to be on the lips of just about everyone with an interest in social progress and national efficiency. As one fashionable journal put it, this new science was 'one of the subjects of the hour'.[81] Impressed by what it saw as 'Municipalism at Work', the *Sydney Morning Herald* announced in its columns devoted to local government that a leap forward had been achieved regarding planning for the City and the State. Not only was a Greater Sydney Bill (albeit eventually abortive) before State Parliament; but the Housing Bill which Griffith had resolutely promoted looked sure to succeed, as it did. At last, the *Herald* noted approvingly, the City Council would be able 'to build as well as to destroy'. And there was even more good news. Plans for a model garden suburb just outside the City of Sydney, Daceyville, were also well underway.[82] Designed by Fitzgerald and Sulman, Daceyville was heralded as the 'first city beautification scheme on modern lines in Australia'. Modern planning lines, according to the journalist, were reflected in a street layout where the 'gridiron' plan was 'now condemned'.[83]

Later in the year, the *Herald* would be able to add to this list a piece of legislation which was, unlike much of the other lauded municipal planning advances, to have a significant and long-term impact on the City. During 1912, conservative Lord Mayor George Clarke, along with Allen Taylor and other aldermen, attempted to rescind a resolution of Council passed on 27 July 1908 which limited the height of buildings in the City to 150 feet and raise the maximum building height to 200 feet. (Skyscrapers in

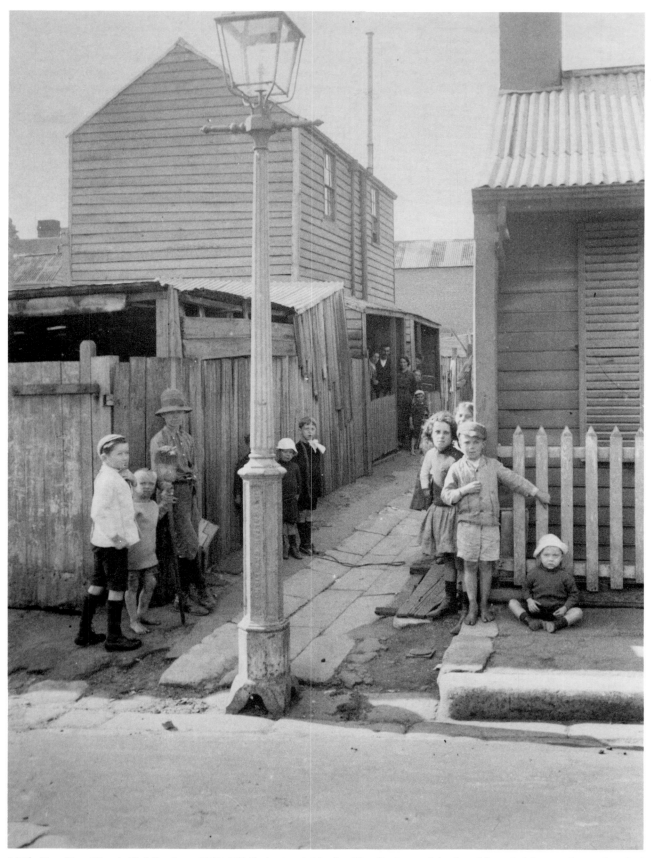

Little Dowling Street, Paddington, 1913. While just outside the City limits at this time (though 36 years later absorbed into the City), a good deal of similar working-class housing could be found in areas such as Chippendale and Surry Hills. In terms of 'slum' clearances, the camera was to be used as a class weapon. Reformers could capture a moment in the 'slum' and the back lane and use the resultant images as arguments for sweeping them away. The photograph, however, dissociated family and community life and a sense of place from mere physical surroundings (ML SPF)

*George Taylor (1872-1928),
journalist, town-planning
proponent and husband of
Florence Taylor* (ML SPF)

New York at that time, it was reported in defense of higher structures, ran up to 775 feet.) Intervention by the State Labor Government, however, pegged the limit to that of 1908. Independent of the City Council, the government placed on the statute book a Height of Buildings Act (1912) which restricted Council power to accede to buildings up to 100 feet in height. Any taller strutures were subjected to the approval of the State government which was to take advice from the Superintendent of the Metropolitan Fire Brigade.[84] Limitations on fire-fighting capabilities thus appear to have secured a more human scale of building for the City of Sydney than many other world capitals, at least for the following half century.

It seemed to many preachers of town planning that 'out of the present systemless methods of doing things' a public, non-partisan spirit of town planning was growing which had the potential to correct past 'evils'.[85] Secular evangelists all,[86] two of their most passionate 'theologians' were George and Florence Taylor, publishers of the influential Sydney journal *Building,* among other periodicals. As advocate rather than practitioner, George Taylor had a 'mission'. Planning, he wrote in lofty prose,

> stands for pure air and abundant light. We are missionaries of sunshine, and preach the gospel that 'cleanliness comes before godliness'. Without cleanliness there is no pure religion . . . Crime is mostly a matter of environment. Give a man healthy conditions and faith in himself and you reform him.
>
> Whatever uplifts mankind by making a virile race with purity of body and soul is surely a religion worthy of adherents from all creeds.[87]

Appealing to men of commerce, and using the example of Sir William Lever's English experiment, Port Sunlight, Taylor added that in this modern age 'we realise that there is an economic value as well as a moral obligation in improving the conditions of the workers'.[88]

Earlier J. D. Fitzgerald stressed the ecumenical nature of the new religion, though he was to secularise his text. In 1912, while vice-president of the Labor Party — which he firmly believed was 'here to stay' — Fitzgerald penned an article on 'Cities of the Future'. It was published in *The Sunrise,* a radical journal which bade farewell to laissez-faire capitalism and mean individualism and welcomed the dawn of a new socialist deal for the City and its citizens. Here he argued that the

> extension of commercial services of a city has made a beginning of a new line of governmental effort, in which party government has no share — a neutral ground where the citizen of the future cities may escape the fate of the older cities and the older civilisations.[89]

Undoubtedly, Fitzgerald would have had a Greater Sydney in the back of his mind when he jotted down this sentence, even if only on a limited scale. In the following year, as a member of the Royal Commission of Inquiry into the question of a Greater Sydney, Fitzgerald and his fellow Commissioners noted that to 'remedy present evils, . . . [a] strong authority is necessary . . . in the interests of economy and efficiency, for general municipal operations and services in at least a number of the inner municipalities', including the City of Sydney.[90]

In *The Sunrise,* however, Fitzgerald concentrated on outlining his vision of a utopian city — 'rich, healthy, and beautiful — a true Commune' — 'where manhood and womanhood . . . [would] be higher and more productive; its men . . . better wealth creating machines; [and] its childhood . . . sweeter'.[91] His other primary concern was to sell the idea to the business community. 'Make your own fortune by making the city's fortune', Fitzgerald pointed out, though perhaps stretching the truth, was the motto of 'rich merchants in Glasgow, Birmingham, Belfast and on the Continent, whose fortunes have been co-incident . . . with the growth of the fortunes of the city'. There was 'no millionaire merchant prince among them', he asserted, 'who is not a rank and boastful civic socialist'.[92] But this so-called 'municipal socialism' was in fact enlightened liberalism. In any event, Sydney business interests remained, for the time being, content to listen.

84 *PC,* 1912, pp 521-22, 511-13, 378-79, 392-93.
85 See Town Planning Association of NSW, *Town Planning Display,* (Sydney, 1913), p 1.
86 See Tim Rowse, op cit, ch 2.
87 George A. Taylor, *The Town Planner and His Mission,* Monograph No 2, Town Planning Association of NSW, March 1914, p 12.
88 Ibid, p 4.
89 *The Sunrise,* (E. Findley, Melbourne, 1912), p 22.
90 *Royal Commission . . . into the question of . . . a Greater Sydney,* (Sydney, 1913), p xviii.
91 *The Sunrise,* op cit, p 25.
92 Ibid, p 23.

During the evening of 17 October 1913, a well-attended public meeting was held in the Sydney Town Hall, that most visible symbol of civic pride and municipal progress. Organised by George Taylor, Sydney's town planning fraternity had turned up en masse to inaugurate the Town Planning Association of New South Wales. Colonel Walter Vernon, ex-government architect, presided over the gathering which heard addresses from Walter Burley Griffin (Canberra's designer and Federal Capital Director of Design and Construction), John Sulman, J. D. Fitzgerald, Richard Stanton (auctioneer, real estate-agent and planning enthusiast), Sir Allen Taylor (now a member of the State's Legislative Council), City alderman R. D. Meagher (who the State would appoint in 1916 as the first Labor Lord Mayor of Sydney and who staunchly supported housing for workers and public servants), and civil engineer Leslie Wade. Among others in attendance were Professor Irvine, soon to write several tracts on the 'new science' of town planning and national efficiency,[93] and architect John Burcham Clamp, who was also an Anglican activist. Both Irvine and Clamp were elected into the Association's ten-member, provisional constitutional committee.

Politely acknowledging the various improvements in Sydney which the City Council were continuing to bring about through street widenings and resumptions, John Sulman reiterated the need for 'a preconceived plan' for Sydney: the 'intense industrialism of the time demanded town planning'. Fitzgerald prioritised planning needs in Sydney. Of first importance was the admittedly 'difficult and costly', but nonetheless necessary, undertaking of 'the replanning of the central portion of the city'. Then there 'was the planning of the virgin areas in advance of the city'.[94] These essential tasks, too, had to be conducted using the latest methods and information. 'Science', Fitzgerald was glad to report, 'had now adopted town planning as a subject worthy of investigation' as had the Academy: the University of Liverpool, he noted, had recently established a chair for the discipline. While euthenics with its dictum that 'man is the product of his environment' remained the central tenet in town planning, Fitzgerald also pointed to a new 'phase of the movement that had not been touched upon by Mr Sulman but [to] which considerable importance was attached': eugenics. Eugenic practices, which sought to selectively breed better races and which culminated horrifically in thousands of forced sterilisations in the United States and the death camps of Nazi Germany, were not, however, adopted. Rather, planning advocates took on board those eugenic aims (such as, to engineer higher forms of human life and to guide the development and administration of society)[95] which neatly fitted euthenic objectives. The latter sought to 'produce a higher type of human being — a civic superman —'[96] and to redeem wretched individuals who were 'the product of conditions for which they were not responsible'.[97]

High, if not unproblematic, ideals were to be accompanied by much hard work and lobbying. But the practical outcomes in the City of Sydney were to be scant as the outbreak of World War I caused a lull in the discourse between State and civic authorities and independent planners which was not to be revived until questions of post-war reconstruction and repatriation loomed large towards the close of hostilities.

Florence Taylor (1879-1969), architect, publisher and town-planning advocate (CCS)

93 See R. F. Irvine, *Town Planning: What it means and what it Demands*, (Town Planning Association of NSW, Sydney, July 1914) and 'Town Planning and National Efficiency' in R. F. Irvine et al, *National Efficiency . . .*, (Melbourne, 1915).
94 Town Planning Association of NSW, *Town Planning Display*, op cit, pp 19, 15.
95 See Greta Jones, op cit, p 99.
96 J. D. Fitzgerald, 'Town Planning and City Beautification', in *The Lone Hand*, 1 May 1914, p 389.
97 *Town Planning Display*, p. 19. On contemporary eugenic ideas see C. B. Davenport, *Heredity in Relation to Eugenics*, (Williams & Norgate, London, 1912), especially ch 8.

3

'A new battleship just launched'?: Planning in Sydney Between the Wars

> Town Planning is like a new battleship just launched. It is crowded with guests — political and otherwise. They saunter along the battle deck, they worry the officers on the bridge, they tell the captain what to do, and crowd into the engine-room and make foolish remarks to the engineers.
>
> It is about time the ship was cleared. It is time the town-planning movement got rid of its useless passengers — the extremists, the posturing philanthropists, the freakish faddists and the dreamy designers with a soul above finance.[1]

Towards the end of June 1917, Charles Reade, Town Planner to the South Australian Vaughan Labor government,[2] wrote to Richard Meagher, MLC, and Sydney's Lord Mayor, regarding final arrangements for the first Australian Town Planning Conference and Exhibition at which Meagher already had willingly agreed to be the New South Wales Executive President. (A similar letter had been forwarded to J. D. Fitzgerald, the Conference President, who, having been expelled from the Labor Party in 1916 for supporting conscription, was then Minister for Local Government in the New South Wales Holman National Government.) Reade now sought the Lord Mayor's consent to act as Chairman of the New South Wales Section of the conference. He also informed Meagher (who, like Fitzgerald, had been tossed out of the Labor Party) that Melbourne City Council had contributed £50 towards the cost of preparing an exhibit of its City, hoping that the Council of the City of Sydney might see its way clear to do the same for the capital of New South Wales.[3]

Meagher perused this correspondence 'with much interest', particularly the draft program which promised not only general papers on subjects such as civic art and the future of Australian cities, but addresses on specific issues such as 'Greater Sydney and New South Wales in relation to municipal town planning and central administration'. He also thought it 'highly desirable that a similar exhibit [to that for Melbourne] should be prepared in connection with the City of Sydney' — the capital of the 'Mother State of Australia' — and managed to persuade the City Council to vote £50 for that purpose.[4] Though provisionally agreeing to chair the New South Wales section of the conference, pressing Council business close to the day forced his withdrawal. Meagher did, however, take the trouble to write to Alderman Sir Allen Taylor, MLC — 'knowing the great interest . . . [he had] taken in connection with the

1 George A. Taylor, *Town Planning with Common Sense*, (Building Limited, Sydney, 1918), p 10.
2 J. M. Tregenza, *ADB*, Vol II, pp 340-42 and Robert Freestone, *Model Communities: The Garden City Movement in Australia*, (Nelson, Melbourne, 1989), pp 75-6.
3 TC 2307/17.
4 Lord Mayor's Minute, 26 June 1917, *PC*, 1917, p 544 (also pp 260, 338); TCR, pp 106-09.

improvement of the City of Sydney — asking him 'to represent the City Council'.[5]
Taylor obliged his Lord Mayor.

Over two hundred and fifty delegates from across the continent attended the
conference which was held 17-24 October 1917 in the Adelaide Exhibition Buildings.
During his presidential speech, J. D. Fitzgerald, now fifty-five and in declining health,
but unfailingly optimistic about the positive powers of apolitical planning, rejoiced
'with the Adelaide people in the fact that they . . . [had] a City planned in advance'
Sydney, sadly, was 'a City without a plan, save whatever planning was due to the
errant goat. Wherever this animal made a track through the bush', Fitzgerald
regretted, 'there are the streets of to-day'. But he digressed. There was a war on.
'We must defeat the Huns, as the first business of civilised humanity', he told his
colleagues.

> But that is not the 'be all and the end all'. We must prepare for the reconstruction
> of the world, which will follow the re-establishment of peace. We must provide for
> 300,000 valiant soldiers who will return victorious to Australia from the battlefield.
> Many of these will go back to City life; and we must make City life better for them.
> This is the sphere of the town planner. Town planners will be the protagonists of
> the great drama of future development in the reconstructional period.[6]

Never before in Australia had the 'great brotherhood' of town planners been
afforded an opportunity to launch afresh their profession — 'the science of applied
civics' — to so many influential people. Indeed, this had been the primary objective in
convening the conference: to call together representatives from local, State and
federal government, as well as professional organisations. This object was clearly
achieved. Even the Governor-General, Sir Craufurd Munro Ferguson, travelled
specially from Melbourne to address the delegates; and Fitzgerald made the most of
his well-developed oratorical skills to yet again drive home the nature and rewards of
modern town planning.

Declaring town planning to be 'a neutral zone, free from bitterness and rancour',
Fitzgerald invited 'the benevolent co-operation of statesmen of all parties — Liberal,
National, Labor — of men of good will of all churches and creeds . . . [and] of
[all] unclassified bodies of men and women who love their country and desire its
development and progress'. While the 'unclassified bodies' would have included rival
professional groups — architects, engineers, surveyors — Fitzgerald was most alive to
the need to coax men of commerce and industry into the planners' camp after fighting
'enthusiastically for town planning for 27 years'. Thus the fundamental aim of
planning, Fitzgerald observed, was to 'develop a higher civic conscience and awaken a
greater civic pride'.[7] Alluding to contemporary industrial strife — wartime strikes
were to culminate in the Great Strike of 1917 — Fitzgerald even accorded planning the
power of being able to abate class conflict: there were, he suggested to eventual
applause, 'no strikes at Bourneville or Port Sunlight. If Australia had such towns for
its toilers all discontent would disappear'.[8] As though acting as a demonstration of
this point, the Western Australian delegates had been prevented from attending the
conference due to strike action.[9]

Another speaker, Walter Burley Griffin, attempted an holistic overview at the
conference. Griffin argued for 'planning for economy in its broadest sense' and opted
for direct, more aggressive intervention in the moulding of the physical environment.
Much had been said within the town planning movement 'in nebulous, if delightful,
discussions over emotions, aesthetics, tastes, and distastes' with 'very small resultant
improvement'. The coming generation, he asserted,

> will have to learn that preparedness for meeting the new community problems
> can no more grow out of general and erudite consideration than could sculpture
> arise out of literary critiques. It must arise out of experiments and progressive
> accomplishments in the art itself and their demonstrated effectiveness — greater

5 TC 2307/17 (29 September
1917).
6 J. D. Fitzgerald, Presidential
Address, in *Australian Town
Planning Conference and Exhibition,
Official Volume of Proceedings*,
(Varden & Sons, Adelaide, 1918),
p 35.
7 Ibid.
8 Ibid, p 36.
9 'The First Australian Town
Planning and Housing
Conference . . .', *The Surveyor*,
31 October 1917, p 132.

or less — and their mistakes . . . Advance is, consequently, to be expected only where greatest freedom and scope to individual initiative are offered.[10]

Burley Griffin was indirectly defending his own beleaguered position over the design and construction of Canberra, from which he resigned two years later. Nevertheless, he indicated the strong desire of planning lobbyists to identify their discipline with sound business practice[11] as well as scientific method, which was also being applied in the factory, through Taylorism, and in the home, through the soon-to-blossom domestic science movement.[12] In his adherence to a system of trial and error — 'experiments and progressive accomplishments', whatever the social or spatial outcomes — Griffin also distinctly articulated the planning movement's deep roots in English positivism. Step by step, despite casualties or disasters, great men would eventually get it right.

John Sulman, internationally known and undoubtedly the conference's grand old man, may have held the odd reservation about Griffin's sweeping thesis, though he would, with the conference, have concurred with the claim that planning was the province of liberal-minded experts who could transform visions into reality. If his views did diverge in any way, he kept them to himself. Instead, on 'Navy Day', 19 October 1917, Sulman presented a somewhat prosaic paper on 'The Cities of Australia and their Development'.[13]

Most of Sulman's paper was devoted to Sydney, the City which he had written about, and dreamed of, lectured on and lived in for the past thirty-two years. Some improvements, he claimed, had been wrought on the City. But its inadequacies were still numerous. Transit problems were 'acute', slums needed to be eradicated, harbour foreshores protected and more park, playgrounds and trees provided. Adequate regulations for the height and design of commercial buildings in the City — based on the 'modern continental method' and not the 'go-as-you-please system at present in vogue' — were also required, in Sulman's view. This, of course, would need legislation, which in turn demanded 'much [public] education'.

Though successful in its own right, the First Town Planning Conference and Exhibition proved ineffective as stocks from which to launch the 'battleship' of town planning. The 'useless passengers', of which George Taylor had written scathingly, were still on board. (Ironically, Taylor himself was a classic 'passenger'.) Worse still, few if any town planners were on the bridge or in the engine room. Only occasionally were they invited to enter these crucial quarters and more often than not their advice was ignored.

In mid May 1918, the Federal Executive of the Australian Town Planning Conference and Exhibition decided to hold a second conference. Brisbane was chosen as a location and the dates set for 30 July to 6 August. Conference President, J. D. Fitzgerald, was to write to various tiers of government throughout Australia urging their attention to planning and seeking delegates to the event. In his letter to Sydney's Lord Mayor, Independent Alderman James Joynton-Smith, Fitzgerald went to some lengths to explain that

> the subject of Town Planning has come into greater prominence in Europe owing to the desire of reconstruction after the war and both France and England have called Town Planners to their counsels. France, in particular, has created a Central Town Planning Commission . . . to rebuild the destroyed towns and replan others in preparation for the future.
>
> The period of Australian reconstruction after the war will also call for the experience and skill of the Town Planner . . .[14]

The State had a specific agenda in mind for this second and final conference. Apprehensive about possible post-war social dislocation and politically committed to prepare a 'land fit for heroes', Queensland's government had agreed to host the event on the understanding that it would address town-planning problems relating to 'the establishment of new industries for returned soldiers' and the 'housing of the

10 Town Planning Conference and Exhibition, op cit, p 44.
11 On business practice, see J. C. Morrell, 'Modern City Building: The Value of a Town Planning Association', *Land and Transport*, Vol 2, No 4, July 1918, p 32.
12 See Kareen Rieger, *The Disenchantment of the Home*, (OUP, Melbourne, 1985).
13 Town Planning Conference and Exhibition, op cit, pp 58-62.
14 TC 1651/18 (5 June 1918).

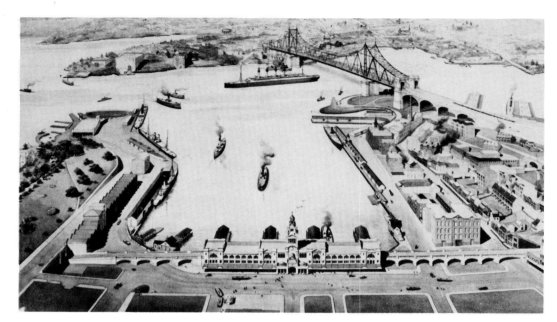

Proposed improvements for Circular Quay and a Harbour Bridge (on the current site of the Sydney Opera House), c.1918. Though none of the elements of this scheme materialised, the proposal highlights the important role transport has played in shaping Sydney. The need to provide for trams, trains, buses, cars and ferries has determined much about the city's development. But many of the City's worst urban problems have stemmed, as they continue to do, from the fragmentation of planning powers in relation to transport and the lack of any overall strategy (ML GPO1 18270)

working classes'.[15] The City Council's contribution to and later reflections on the second gathering also indicated a deal of ambivalence concerning the town planning movement; outright hostility was also directed towards it from some quarters.

Though not an avid improver like his predecessor, Lord Mayor Joynton-Smith was keen to have the Council of the City of Sydney represented at the Conference. Good publicity for Council endeavours never went astray and to that end a journalist from the *Daily Telegraph*, a Mr McCarthy, was engaged by the Council for the duration of the conference. Joynton-Smith also wrote to John Sulman asking if, as a director of the newspaper, Sulman could use his influence to secure an 'allotment of space for the adequate reporting of the proceedings of the Conference'.

Joynton-Smith attended the conference along with aldermen Michael Burke, R. D. Bramston, J. Farrell, E. Lindsay Thomson, A. Vernon, C. W. Bridge, John McGree, J. English, Charles Mallett and R. W. S. Harris. They were accompanied by principal staff members W. G. Layton (Deputy Town Clerk), A. H. Brigg (City Surveyor) and R. H. Brodrick (City Building Surveyor). The exhibition that had been mounted for Adelaide was reused in Brisbane, indicating as it did the Council's public view of town planning, or at least that of the City Building Surveyor's. Comprised of twenty individual framed photographic views of Sydney, each roughly a metre square, the exhibition showed a City more beautiful and efficient than ever before through a series of 'then and now' images of streets (now widened), squares (now spacious) and various amenities (now salubrious). Photographs of modern parks and playgrounds, of the statue of a Captain of industry (T. S. Mort) and of a monument to Captain Cook were also part of the Council's Brisbane Town Planning Exhibition. There were, however, a few new additions. Three views mounted together of flowering dahlias in Hyde Park and a very large, 56" x 46" photograph of HMAS *Sydney*, which had been lent by Mr Layton, were included in the 1918 display. A plan, now lost, prepared by the City Surveyor showing 'improvements' was also forwarded to Brisbane.

Addresses made to the conference ranged widely. Some speakers, such as Fitzgerald and his Under-Secretary in the New South Wales Department of Local Government, John Garlick, outlined the principles and priorities of town planning as the nation prepared to face 'the second great war — that struggle for commercial and industrial supremacy, which . . . [would] begin on the day peace . . . [was]

15 Ibid. The following detail is based on this file.

declared'.[16] Others spoke of specific planning mechanisms. Henry F. Halloran, Sydney-based realtor extraordinaire, identified 'Districting' (the American term) or 'Zoning' (a 'nasty' German word) as the 'most important and far-reaching problem connected with Town-planning'. Had he been present, T. J. Maslen, the long-dead 'Friend of Australia', would have smiled with approbation, his early policy vindicated, when Halloran forcefully argued that residential sections of cities and towns should contain

> intermediate grades with detailed regulations, as required, the successive grades to be as [geographically] near one another as possible, so as to avoid having too distinct a line drawn by the poorer citizens being placed alongside the elaborate houses of the richer . . .[17]

While in favour of zoning for different purposes, another delegate rebuked Halloran, noting that 'the segregation of citizens according to their wealth' would 'perpetuate and widen the . . . existing gulf between the worker and those who are well-to-do'.[18]

Among others, W. G. Layton, Sydney's Deputy Town Clerk, was to provide a view from local government. Reading a paper which had been prepared by Sydney City Council Alderman Milner Stephen, in conjunction with Thomas Nesbitt, Sydney's Town Clerk, and the City Treasurer, S. H. Solomon, Layton gave numerous facts and figures concerning 'the question of financing resumption schemes undertaken with a view to the improvement of the planning of existing City areas' in Sydney. Over the preceding twelve years, Layton told the conference, the Sydney City Council had built up a considerable amount of experience in this regard. Indeed, for the Sydney Council, the process of resumption was town planning's civic surrogate. But a number of delegates were greatly disappointed with the paper: its title promised an insight into 'Methods of Financing Town Planning';[19] its content looked at nothing more than the Council's method of financing resumptions.[20] Responding to criticism, Layton admitted that 'Aldermen and officers are so occupied with the material side of municipal work that the aesthetic side is lost sight of'. He might, given the tack of his argument, have pointed to the images of flowering dahlias and parks which were hanging in the exhibition in defence of his Council. But Layton had missed the point of the criticism which centred on town planning schemes per se. As medical practitioner and Mayor of Toowoomba, T. A. Price put it, the paper was 'one of the most important brought before the Conference, because this is where Town Planning butts up against the Community. "How are you going to pay for it?" is the question'.[21] President Fitzgerald diplomatically brought this discussion to an end suggesting that interested delegates 'should obtain something on this subject for the next conference', but the matter was to lapse.

Thomas Nesbitt, Sydney Council's Town Clerk, was later to compile a typically

Below, *The City Council's Pine Street Playground, Chippendale, in 1931. Secure, supervised playgrounds were supposed to encourage the right sort of development in children. At first influenced by the German kindergarten movement (or at least the British and American examples of this), the City Council began introducing playgrounds for children from the first decade of the twentieth century* (CCS CRS 57/236)

Below right, *Brisbane Street resumption area No. 1, with Hunt Street in the foreground, February 1928. For people like Anglican Archdeacon F. B. Boyce, the destruction of the Brisbane Street area was 'a splendid step forward', wiping out a 'network of narrow streets . . . having some respectable people in them, but otherwise having a bad criminal record'* (CCS)

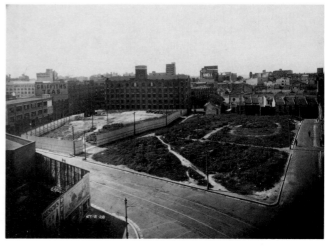

lengthy report on the Brisbane town planning conference.[22] Nesbitt had been officially invited to address the conference. But he had made it quite plain to the City Council that he 'had no desire or inclination to attend'. Nor, he also thought, was the presence of any other Council representatives at such a meeting justifiable on civic grounds. But Council, in its wisdom or otherwise — and in Nesbitt's estimation it was often 'otherwise' — had decided to authorise not a small delegation to attend the conference but 'the whole of the Aldermen', as well as a number of senior staff. As for any benefit, Nesbitt sententiously reported,

> The Town Planning Conference, it may be here stated, has been not inaptly defined as a huge and mysterious academic fiction, literally teeming with a maximum of idealistic sonorosities and platitudinous pabulum, vaticinatory in character, resulting in a minimum of educational value and practical application by no means commensurate with the talent engaged or the immensity of the labour involved.[23]

Nesbitt may have been peevish about the mixed reception that the paper he had collaborated on had received in Brisbane. But the equally practical City Surveyor made a similar assessment of the conference. There was, he observed, a 'diversity of opinion on most of the subjects that were discussed, and no conclusive decisions were arrived at . . . Viewed from the standpoint of all officials connected with a City already existing the views put forward were mostly academic'.[24]

The City Building Surveyor, Robert Brodrick, who had joined the City Council in 1883 and risen by 1897 to head the Council's Architect's Department, was more philosophical about the outcomes of the gathering. He was particularly concerned with slum eradication in the City and working-class housing, and he had been impressed by a paper on the subject given by architect and Lord Mayor of Melbourne, Frank Stapley. Large Australian cities were experiencing the 'general and natural eradication' of dilapidated, inner-city residential areas; 'natural' forces were bringing about their 'gradual' change from living to industrial sites. Architects elsewhere had done much to produce ideal homes for workers. But in Sydney the attention of the City Council, as with the Harbour Trust, the Housing Board and the Railway Commissioners, had focussed on pulling down rather than putting up dwellings. 'Little', Brodrick noted 'had been done to re-settle the outgoing tenants within the City area'. The Council had constructed a large block of tenements in Chippendale, but the inexorable forces of progress meant that the place 'must eventually become distinctly an industrial area'.[25]

Brodrick's remarks in his report on the Brisbane conference concluded with reference to the perennial City Council complaint of inadequate powers. As with 'every responsible officer of the City Council', he wanted a 'complete and modern Building Act', the lack of which remained a stumbling block to civic progress. The securing of such an Act, however, had been thwarted, Brodrick correctly pronounced, 'by supine, if idealistic, Government after Government'.[26]

Brodrick's choice of words was remarkably accurate. Some State governments had been purposefully inactive in dealing with the City Council's proposed building and other legislation, preferring development and redevelopment to proceed along more or less laissez-faire lines. At times, too, Macquarie Street even flaunted the City of Sydney Improvement Act.[27] Misplaced idealism, however, had become an even greater barrier to the realisation of broader and effective powers over the built environment.

During the Second Australian Town Planning Conference, J. D. Fitzgerald had heralded:

> Of Sydney, I can only say that she is on the eve of great events. The Government of which I am a member hopes to throw the present antiquated civic machinery on the scrap heap — (applause) — and launch a new scheme for the government of

16 *Second Australian Town Planning Conference and Exhibition* (hereinafter SATPC), (Brisbane, 1919), p 28.
17 Henry F. Halloran, 'Districting or Zoning of Cities and Towns', in ibid, p 165.
18 T. A. Price, 'Written Criticisms', ibid, p 167.
19 *SATPC*, pp 177-79.
20 T. G. Ellery, 'Written Criticisms', ibid, p 179.
21 T. A. Price, 'Discussion', ibid, p 182.
22 TCR, 1918, pp 96-103.
23 Ibid, p 98.
24 Ibid, p 100.
25 Ibid, p 101.
26 TCR, 1918, p 104.
27 TCR, 1919, p 189.

Sydney which will give the governing and business powers of the citizens free play, and allow commerce, industry, and public utilities to be developed to their fullest extent.[28]

One month before the second conference, Thomas Nesbitt had written to the Secretary of the Premier's Department concerning the City Council's need for more comprehensive powers to deal with building and public health matters. In reply it was indicated that the Premier had been advised by Fitzgerald that the powers specified were 'included within the scope of the Greater Sydney Bill [which was] to be submitted to Parliament' and that Fitzgerald, the Minister for both Local Government and Public Health, would not permit the consolidation or amendment of any legislation which the Greater Sydney Bill was intended to replace. Premier Holman was also unwilling to turn his office into 'a Court of Appeal in respect of his Colleague's decision'.[29]

Tensions between the State government and the City Council mounted over this legislative impasse. 'Greater Sydney' was a major and difficult issue in itself. City Council aldermen had been deferring, amending and adopting motions regarding the creation of a 'Greater Sydney' Council for almost twenty years. Sydney's fine Town Hall would make an excellent headquarters, most City aldermen thought, for a centralised, powerful metropolitan government. Aldermen and councillors from surrounding and outer local government areas also thought the 'Greater Sydney' idea a good one. But from the earliest discussions, it was apparent that a federation of existing local government bodies was the only path these suburban politicians were prepared to be led down. Indeed, it had been observed as early as 1902 that 'it was contrary to human nature to expect suburban aldermen to commit municipal suicide by mutually agreeing to perform the happy dispatch and extinguish themselves'.[30] State parliamentary debates also indicated that suburban aldermen had a good deal of support in the matter from members of parliament, many of whom had been or were still on local councils. Some parliamentarians, too, had their own reasons for blocking such legislation. During a debate in 1911, one member asserted that the creation of a Greater Sydney would constitute a 'delegation of the business of Parliament'. Another did not wish to see regional Sydney 'governed by a coterie sitting in the Sydney Town Hall'.[31]

Whatever the arguments for or against a Greater Sydney, while the Bill over its creation lingered in Sydney's Parliament House, the City Council's powers remained significantly curtailed. The Town Clerk, stirred to anger, pronounced the Bill's chief protagonist, J. D. Fitzgerald

> a municipally gilded god, possessing feet of clay, when matters of practical application municipally were involved, whose iteration and reiteration of the parrot-like cry, the voice of one crying in the wilderness 'wait for the Greater Sydney Bill', ultimately developed into arrant nonsense, mere claptrap and sheer humbug.[32]

Nesbitt's vitriolic criticism was too hard on Fitzgerald. But things had gone terribly wrong. While continuing the fight for Greater Sydney, Fitzgerald had spent much time and effort putting together a Local Government Bill which was passed by the State Parliament in 1919. Dealing in part with town planning, the Act was little more than 'a pale projection of Fitzgerald's ideas and aspirations'.[33] It became the general enabling Act for all local government areas, except the City of Sydney which was totally excluded and left to make the best of extremely defective and antiquated legislation.

In poor health, Fitzgerald left the Legislative Assembly in 1920 after the electoral defeat of his party in April. This marked a significant turning point in attempts to introduce effective town planning into the City of Sydney, whatever their underlying ideology. With the emergence of the Labor Party, which was working out its own destiny during the first two decades of the twentieth century, Fitzgerald and most of

28 *SATPC*, p 27.
29 TC 331/18 (letters 19 February, 28 February, 20 June and 5 July 1918).
30 TCR, 1903, p 74.
31 *NSWPD*, Vol 44, pp 3196; 3201. See also Vol 43, pp 1164; Vol 45, pp 3987-4007 ff.
32 TCR, 1920, p 140; see also pp 163-64.
33 Bede Nairn, *ADB*, Vol 8, p 515 (Act No 41, 1919).

his town-planning colleagues, armed with their new brand of reformist liberalism, had attempted to attach themselves to a 'frail political centre' which had collapsed by 1920.[34] With one or two exceptions — Charles Reade in South Australia, for example, who at any rate was to leave Australia frustrated in his attempts at planning in 1921 — 'professional' planners were kept at arm's length by the state. Working outside institutions, they were sometimes called upon to advise in extraordinary circumstances.[35] But their advice was seldom heeded. This was also true of organisations such as the Town Planning Association of New South Wales which was on occasion, and sometimes for good reason, derided for some rather unfortunate suggestions.[36]

As far as broadly controlling growth in the City of Sydney went, town planning was left to plead its case to any influential individuals or organisation, whether in public or private enterprise, that would listen. In the early 1920s, many were attentive to the possibilities of town planning. But little more than lip-service was paid to planning advocates and practitioners.

Towards the end of his career, Fitzgerald was to regret that the 'usefulness of the town planner's mission is not yet clearly recognised in Australia'. The 'evil consequences of a bad City environment', which the 'reformer sees and deplores', had not been put right. Nor, as a result, had 'the conscience of the reformer' been satisfied. Much wealth had been generated through the City as an entrepôt, but its distribution was grossly uneven and the spatial and urban outcomes often unpalatable. Despite at times 'keen and strenuous controversy . . . [and] radical differences of opinion' between members of the planning fraternity, however, Fitzgerald felt assured of the ultimate consensus which would reign among those who had, 'year in and year out', devoted themselves unselfishly to the scrutiny of the 'many complex problems in connection with the planning of Sydney'.[37] Aiming a broadside at the City Council and, in particular, its pompous Town Clerk, Fitzgerald lambasted the 'many stupid methods . . . [to which Sydney's] own civic experts were still clinging'. These so-called experts, Fitzgerald sneered, were 'stay-at-homes, who have never been further than Balmain [and who have] poured ridicule on men of my

34 Tim Rowse, *Australian Liberalism and National Character*, op cit, p 27.
35 TC 1651/18 (Sulman to Town Clerk, 18 September 1918). See also the debate on the Town-Planning Bill, *NSWPD*, Ser 2, Vol 75, pp 548-61.
36 For example, see TCR, 1919, p 186; 1921, pp 86-87.
37 J. D. Fitzgerald, 'New Cities for Old', in *The Property Owner*, Vol 3, No 240, 11 April 1921, pp 1-2.

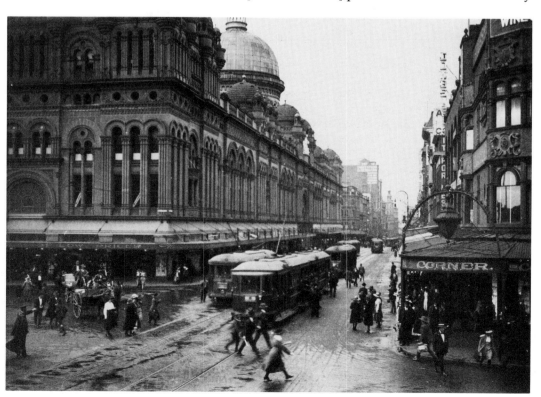

George Street (looking north with the Queen Victoria Building on the left) in 1922. Sydney's first tram, which ran in 1861, was horse drawn. Steam trams came into service from late 1879 and over the next two decades Sydney acquired 39.5 miles of tramways. In 1898, a decision was made to electrify the tramways. In the 1930s, however, yet another decision was made by the Department of Tramways and Road Transport to substitute buses for trams. From the mid 1950s, tramlines were significantly reduced. Sydneysiders took their last tram ride on 25 February 1961 from the City to Maroubra Beach. Unlike Sydney, the City of Melbourne wisely retained its trams (ML SPF)

type because we chose to conform to the standards of London and Paris'.[38]

Sydney's City Council continued to do what it had been doing since 1906: widening and straightening streets, banishing blind alleys, importing trees into the inner City and planting annuals. High land values, weak municipal powers and entrenched, powerful property interests limited the possibility of achieving a comprehensive City plan, although there were some attempts to create one. This is not to say that the City Council was devoid of town-planning enthusiasts. Sir Charles Rosenthal, an eminent Sydney architect and a City Alderman between 1921 and 1924, put a motion to the Council in 1922,

> that in view of the urgent necessity for a comprehensive plan in dealing with the future development of Sydney and Greater Sydney, this Council decides to seek the best Town Planning advice available in the Empire, by means of a competition, allotting a sum of £10,000 to be supplied as may be decided in first, second and third premiums.[39]

Lacking adequate support, the motion was eventually withdrawn. Sir Charles' proposal to redevelop Woolloomooloo as a magnificent seat of federal, state and local government also came to nothing.[40] This would undoubtedly have been too much for Macquarie Street which found it difficult enough to share a City with the Council.

J. D. Fitzgerald died of cancer in July 1922. Town planning in Sydney had lost one of its most ardent advocates, but it had also lost the battle to establish itself in freewheeling 1920s Sydney. Nowhere was this more apparent than in the fate of Fitzgerald's pet project, Greater Sydney.

On 29 November 1922, five months after Fitzgerald's death, a sumptuous nine-course dinner, featuring French cuisine, was held at the Australia Hotel to raise financial and moral support for the preparation of a regional planning scheme for Sydney.[41] (The idea may have been influenced by early discussions about regional planning in the United States, although the Regional Planning Association of America was not formed until the following year.) When the members of the organising committee were choosing a title for their project they had purposefully rejected the term 'Greater Sydney'; it had on occasion in the past 'been used by those advocating the submergence of Suburban Councils' from which they strenuously distanced their scheme. They decided on the title 'The Sydney Regional Plan Conference'. The Conference brought together a body of 'technical men' with some of the richest men in the State. Lord Mayor William McElhone, MBE, was its president and originator. McElhone, a Sydney booster and improver, had suggested such a forum during a meeting with a deputation protesting over the extension of Martin Place. They had persuasively asserted that it was senseless 'going on with such expensive improvements until there was a comprehensive plan to work to'.[42]

Lieutenant Governor Sir William Cullen formally opened the plush and pleasant proceedings of the conference's first meeting with a loyal toast. He was followed by Governor Sir Walter Davidson, William McElhone and a troop of experts, including John Sulman, who spoke on 'Why Sydney Requires a Plan'. W. F. Foster, wealthy building contractor and an alderman on the Woollahra Council, was entrusted with the evening's most important duty: to appeal to 'the greatest gathering of intellectuals, merchant princes, and captains of industry . . . ever seen in the City' for material support. Foster noted that they, including himself, had all 'done well' and owed 'a great deal to this City'.[43] Rewards, too, would flow from a Sydney Regional Plan: it would guarantee continued progress by fostering financial, physical, economic, moral and intellectual efficiency.[44]

Though the formal structure of the Sydney Regional Plan Conference was to experience labyrinthine expansion, its objectives were not to be achieved. From the end of February 1924, a week-long, town-planning exhibition was held in Sydney and half a dozen lunch-time lectures were delivered in Farmer's Exhibition Hall by Sulman, R. Keith Harris (Lecturer in Town Planning at the University of Sydney),

38 Ibid, p 2.
39 *PC*, 1922, p 314.
40 A. J. Hill, *ADB*, Vol 11, pp 452-53.
41 Sydney Regional Plan Conference, *Record of the Speeches*, Sydney 1922 (MLQ710/S). See also Robert Freestone, 'The Sydney Regional Plan Convention: A 1920s Experiment in Metropolitan Planning', *Planner*, Vol 3, No 9, 1989, pp 7-13.
42 TCR, 1922, p 121.
43 Sydney Regional Plan Conference, op cit, pp 28-9.
44 Ibid, see cover design; see also Sydney Regional Plan Conference, *The First Brochure of the Sydney Regional Plan*, (Sydney, 1922), np.

Norman Weekes (the Sydney Council's City Surveyor) and other experts.[45] But little more than the transcript of its inaugural dinner and a few brochures came out of the Regional Plan Conference's short existence, during which time Sydney had been 'feverishly rebuilding'.[46] Dead by the end of 1924, the Conference's passing was noted by the *Sydney Morning Herald* in March the following year.[47]

Content to see the State's capital expenditure on infrastructure expand without a commensurate expansion of State regulation in the built environment, Sydney's captains of industry had failed to heed the planner's call. Whether town planner or moral economist, or both, these consensual reformers had misread their situation: 'Businessmen and politicians, to whom they appealed for support and security, were not interested in their schemes and allowed them only a soapbox from which to preach "efficiency"'.[48] At the Sydney Town Hall, planners were even denied that temporary platform.

Talk of town planning led 'improvers' on the City Council to put up a motion in October 1923, which was successful, to include a planning section in the City Surveyor's Department as part of a general departmental reorganisation.[49] Alderman Edward Milner Stephen, who had served continuously on the Council since 1900 and who was by then Chairman of the Citizens Reform Association (later retitled Civic Reform), was the driving force behind this innovation. Deeply imbued with a 'sense of civic responsibility' and a member of the Town Planning Association of New South Wales, Milner Stephen detested ad hoc street improvements. His views on the necessity to properly plan the City were strengthened by an overseas trip from which he had only just returned. He had been particularly impressed with the results of modern planning in London, Paris and Los Angeles.[50]

Tree planting in Hyde Park, October 1931. Planting trees and annuals, along with piecemeal road widenings and resumptions, constituted the City Council's primary commitment to 'planning' (CCS CRS 57/117)

Milner Stephen's moves to give town planning a formal foothold in the City Council were obstructed for some time by an industrially orientated Labor majority and an increasingly uninterested City Surveyor, Norman Weekes, who was later dismissed by the Council.[51] Stephen, nonetheless, persisted in encouraging outside bodies such as the Town Planning Association to press the issue of the need for a town-planning department, and by 1926 an officer of Council was carrying out town-planning functions.[52] Moreover, the City Council had decided to insist that 'all building applications, especially those affecting corner allotments, should be returned to the City Architect and Building Surveyor and the City Engineer and City Surveyor . . . [to determine whether they would] affect any town planning scheme suitable for the Council to carry out'.[53] In effect, however, the Council wanted mainly to be able to splay corners and make other improvements to accommodate the increasing numbers of motor cars and trucks which were using City streets.

The Council's Works Committee, perhaps inspired by planning's new toehold on Council, determined to recommend the appointment of a sub-committee to investigate the inauguration of 'a comprehensive scheme for the remodelling of the City'.[54] Within days of this decision — and weeks before its approval by the Council — members of Sydney's planning push rallied in support. Charles Rosenthal, ex-chairman of the Works Committee, wrote as President of the General Council of the Australian Institute of Architects to Sydney's Town Clerk seeking a place for a representative from the Institute and expressing 'the hope that the proposed remodelling scheme . . . [would] be thrown open to a world wide competition'.[55] John Sulman, still active and aged seventy-eight, must have let his mind wander back to the 1909 *Royal Commission into the Improvement of Sydney and its Suburbs*, while drafting a Minute in 1927, which he sent for approval to the Chairman of the Works

45 Sydney Regional Plan Conference, *Sydney's Need: Being the Second Brochure of the . . .*, (Farmer & Co., Sydney, 1924), np.
46 Rose Publicity Services, *Hotel Macquarie*, (Sydney, 1923), p 15.
47 Freestone, 'The Sydney Regional Plan . . .', op cit, p 12.
48 Rowse, op cit, p 27.
49 *PC*, 1923, p 619; TC 4286/23.
50 TC 5200/24.
51 Ibid.
52 *PC*, 1925, p 184; 1926, p 248.
53 TC 280/26 (29 July 1926).
54 TC 4322/27.
55 Ibid.

Committee, Alderman Frank Green. Sulman was to tell Alderman Green almost exactly what he had told the Royal Commissioners nearly twenty years before: 'Town Planning Sydney [was] . . . essentially a job for a man on the spot with experience in Town Planning, embracing Engineering, Surveying, Architecture and Economics, and a Knowledge of local Conditions'. The 'most experienced man should be obtained. I claim, to be that man'.[56]

Sulman was to redirect this Minute to John Garlick, now Chairman of the Main Roads Board, at the end of the year. A special committee had been appointed in September 1927 by the City Council to examine the best means of preparing a comprehensive plan for Sydney. But two months later the Council was sacked by the Bavin National-Country Party State Government. In light of the Council's demise, Sulman wondered whether, 'when Greater Sydney is installed, the Commission Manager form of government may be adopted?' He asked Garlick to consider an idea he had previously floated with the Town Planning Association after his return from a trip to the United States and Europe in 1924: namely, the 'Position of City Manager at £5000 per an[num]'. Whatever the financial arrangements, Sulman was ready to begin work on 'the Town Planning of Greater Sydney', and willing to do so for nothing save the glory. Sulman's only real condition was that he would have to 'act as sole Town Planning Commissioner for the City of Sydney'.[57]

Essentially Sulman was proposing to conduct a 'survey' of the immediate Sydney region, a service which he had specifically offered to the City Council in 1926. Garlick marked Sulman's correspondence to the attention of his Chief Commissioner of Main Roads, noting that he 'should provide a sum to enable this work to be begun' in the departmental estimates for the following financial year.[58] Little, however, could have been much further from Premier Thomas Bavin's mind or more abhorrent to his thoughts about the Council than the appointment of an independent, elderly, non-politically-aligned individual to the position of the City's supreme Town Planning Commissioner.

THE GENTLE SPIRIT OF TRAFFIC CONGESTION

*He won't be happy till every mudguard in the
Commonwealth has a dent in it*
Source: Finey, *Smith's Weekly,* 1928

Legitimate charges of major corruption among some Labor aldermen over the construction of Bunnerong Power Station on Botany Bay, as well as rife nepotism, prompted Bavin to make the dismissal of the City Council an election promise for 1927. Bavin's coalition team won office on 8 October of that year. But the complex web of political machinations and manoeuvres reveal political ends rather than an attempt to promote honest, effective local government in the City.[59]

Under the Labor government-sponsored Sydney Corporation Amendment Act of 1924, adult franchise was achieved in practice, transforming Civic Reform — the conservative force in the City's local politics — into a minority party. Shortly after coming to power, the conservative Bavin Government presented the Sydney Corporation (Commissioners) Bill to Parliament which assented to the legislation on 28 November 1927. Coupled with the vow to sack the City Council had been the government's stated intention to simultaneously pass a Greater Sydney Bill. Indeed, the rule of the Commissioners was supposed only to have been an interim measure in the transition to a regionalised form of local government.[60] The Bavin government's seemingly radical version of 'Greater Sydney', however, contained a restricted franchise which sought to tip the balance of power back to City property owners. Moreover, there were plenty of observers who doubted the government's sincerity as

56 Ibid.
57 Ibid.
58 Ibid.
59 See Fitzgerald, *Sydney 1842–1992,* op cit, pp 132, 182, 202, 235, and 244; and F. A. Larcombe, *The Advancement of Local Government in New South Wales 1906 to the Present,* (SUP, Sydney, 1978), pp 39-55.
60 D. Bennet Dobson, 'Proposal Re Greater Sydney Bill . . .', TC 4322/27.

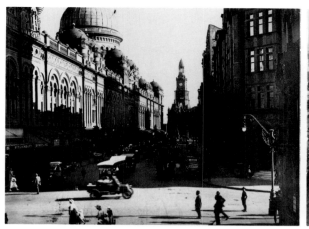
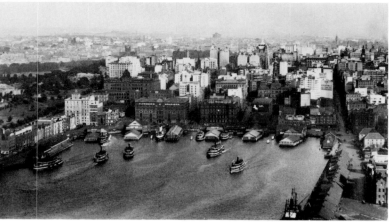

to a Greater Sydney, and with good reason. Thomas Shannon, MLA for Surry Hills and a soon-to-be-sacked City Labor alderman, noted with foresight based on past experience that, in moving the motion before the House to appoint three Civic Commissioners, Carl Glasgow, National member for Waverley,

> [had] told us it was a temporary measure, to stand until the Greater Sydney Scheme had passed. Mr Bavin told us the same thing this afternoon. The Greater Sydney proposal has been before this House and the country for twenty-five years, and Mr Glasgow must be an optimist of the first water if he thinks he is going to get the Greater Sydney Bill [passed] during the life of this Parliament. I know that the strings will be pulled by suburban aldermen to stop any attempt of that sort. I see a number of them on the government side of the House — some suburban mayors, too.

The Bavin Government did not introduce a Greater Sydney Bill. The Commission's term in office was also to be extended by six months to 30 June 1930.[61]

With his vast knowledge of local government, John Garlick was appointed a City Commissioner as was Henry Morton, Melbourne's City Engineer and Building Surveyor. Edmund Fleming, a Member of the Federal Migration and Development Commission, was chosen a little later to chair the Commission. His sudden death in October 1928 saw Garlick take up the chairmanship. Brigadier-General H. Gordon Bennett, a businessman, was appointed in Fleming's place.

Although Garlick alerted his colleagues to the advisability of arranging 'for a comprehensive study of the City plan to be made with a view to laying down an orderly scheme of [City] improvement', the Commission's subsequent restructuring of the Council's administration provided only a marginal place for town planning.[62] Preoccupied with investigating inefficiencies and malpractices, as well as overseeing the Council's day-to-day operations, the Commission was to put town planning's questions to one side. Subsequent administrative reorganisation, however, was to highlight town planning's at very best marginal place in the affairs of the Council of the City of Sydney.[63]

Early in 1929, the City Commissioners amalgamated all Council departments 'of an engineering character' under one head to eliminate administrative duplications. Now the City Engineering and Surveying Department, the City Cleansing Department, the City Architect and City Building Surveyor's Department, along with three other departments, were merged into a single operational unit, the City Engineering and Building Surveyor's Department. A. H. Garnsey, an engineer who had been an acting departmental head, was placed in control of the new department. He was to carry out the duties of City Engineer, City Surveyor and City Building Surveyor.[64]

The 1929 reshuffle did not provide for any town planning section or specialist planning staff. That an engineer was appointed to head the newly created department also indicated ongoing professional rivalry between engineers and architects which frustrated the would-be planner's mission. The Commissioners had observed

Left, *York Street, 1920, looking south to the Sydney Town Hall. Cars, seen here, were to cause growing traffic problems in the City. Across the country, the number of commercial and private motor vehicles was to rise from 87,000 in 1921 to almost 550,000 by the end of that decade. By the end of World War II, this figure had doubled. Cars were concentrated in metropolitan areas and urban centres* (ML SPF)

Above, *An aerial view of Circular Quay with the City stretching out behind in 1931. The wool and bond stores on the left and the monumental Farmers and Graziers building fronting the Quay symbolised a British-orientated, isolated society with a dominant rural economy. Within three decades high-rise would start to replace these nineteenth-century structures, while other cultures and economies were to more significantly influence Australia* (ML SPF)

61 *VPLA*, Vol 134, 8 September 1932, p 99 ff.
62 Minute, 12 January 1928, TC 4322/27.
63 First Report of the Commissioners, *PC*, 1928, p 11.
64 Second Report of the Commissioners, *PC*, 1929, p 16.

City Engineer, A. H. Garnsey in 1938
(CCS CRS 71/290)

Sydney, 1933, showing the Pyrmont Bridge on the left, Pyrmont and Ultimo in the background and Martin Place in the centre. Even with its art deco additions, 1930s Sydney retained a human scale (CCS CRS 80/34)

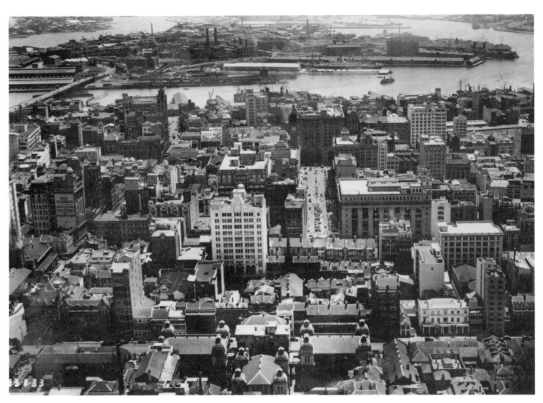

that engineers presided over the 'work [which] most closely affects the individual citizen'; in their opinion the City Engineering Department was at the coalface of municipal endeavour.[65] The engineers agreed. Their profession had drawn up the blue prints and supervised the miraculous industrial revolution which had changed so much about the world. Town planning, on the other hand, was primarily the concern of architects.

Architect professor Leslie Wilkinson of the University of Sydney, another patrician member of the planning fraternity who specialised in architectural design and history and who was also a member of the Town Planning Association of New South Wales, gave a paper on relations between the two professions in 1930.[66] He regretted that 'few engineers appreciate[d] the aims and ideals of the architect' which could, for the untrained eye, 'be difficult to see, much less to appreciate'. By the very nature of their work, engineers were in a far better position:

> The engineer by his practical achievements, obvious to all — ignorant and cultured alike — has been placed in power by authority, and architecture has been made to take second place . . . for many years architecture in Government departments has been usually subservient — a branch of a Works Department with an engineer in charge.[67]

This was certainly the case with the City Council.

Pleading for a closer collaboration between engineers and architects, Wilkinson looked forward to the day when 'our architecture, while losing nothing of beauty, may be more skilful, and our engineering, already civil, and losing nothing of its practicality, may be more polite'.[68] But that day was a long way off. In control were practical men the like of engineer-surveyor John H. Packard, who almost forty years earlier had savaged Sulman's paper on 'The Laying Out of Towns' as 'inconsistent and Utopian'. Packard had warned Sulman that 'important considerations would not . . . be sacrificed at the shrine of beauty' or that of some utopianism.[69] In this he was proved right.

As the City Commission's work proceeded, it was observed that a good portion

65 Second Report, p 16.
66 Leslie Wilkinson, 'The Collaboration of the Architect and Engineers', Australian and New Zealand Association for the Advancement of Science, *Proceedings*, Vol 20, 1930, pp 324-30.
67 Ibid, p 326.
68 Ibid, p 330.
69 John H. Packard, 'Comments . . . upon Mr Sulman's Paper . . .', Australasian Association for the Advancement of Science, *Report of the Fifth Meeting*, (Adelaide, 1894), p 583.

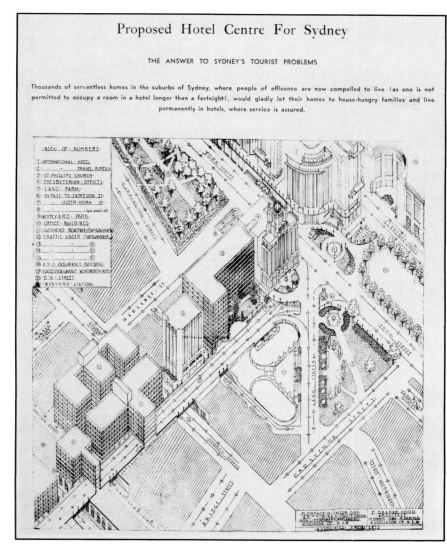

Proposed Hotel Centre For Sydney

THE ANSWER TO SYDNEY'S TOURIST PROBLEMS

Thousands of servantless homes in the suburbs of Sydney, where people of affluence are now compelled to live (as one is not permitted to occupy a room in a hotel longer than a fortnight), would gladly let their homes to house-hungry families and live permanently in hotels, where service is assured.

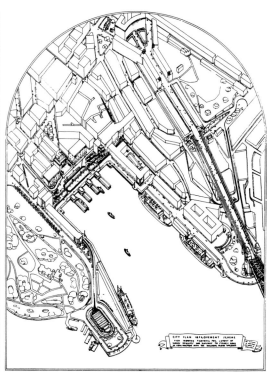

Above, 'City Plan Improvement Scheme . . . Showing a proposal for . . . Sydney Cove in conjunction with the Harbour Bridge Approach', 1932, by W. Hayward Morris for the Board of Architects and the Institute of Architects (*Architecture*, May 1932, p. 110)

Florence Taylor and Graham Hood's elitist and eccentric plan to 'answer . . . Sydney's tourist problem' as well as the 'servant problem'. This serviced hotel complex was to accommodate wealthy tourists and rich residents of Sydney whose homes could then be let to 'house-hungry families' (J. M. Giles, *50 Years of Town Planning with Florence Taylor*, Building, Sydney, 1959)

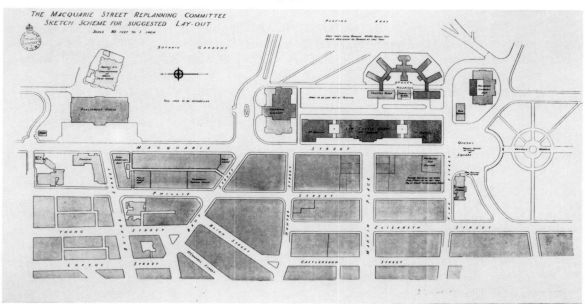

A layout for a redeveloped Macquarie Street suggested by the State Government-appointed Macquarie Street Replanning Committee, 1935 (CCS)

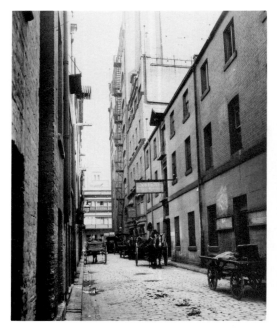

Above, *Wynyard Lane,
Sydney, 1912. During much
of the nineteenth century and
well into the twentieth
century, fire was a real danger
in many parts of the City.
Though the building near the
end of the Lane on the right is
equipped with a fire escape,
these hazards were often the
product of faulty interiors*
(ML SPF)

Right, *Wynyard Park
(looking south) in 1939. Until
the construction of Sydney's
first high-rise buildings in the
late 1950s and early 1960s,
the Amalgamated Wireless
Australasia (AWA) Tower
(pictured here on the right) at
twelve storeys and
approximately 330 feet high
was the tallest building in the
City* (CCS CRS 71/442)

70 *First Report*, 1928, p 33.
71 Larcombe, op cit, p 64.
72 See *Labor Daily*, 30 July 1930;
Guardian, 30 July 1930; *Sun*,
31 July 1930; *News*, 14 August
1930.
73 No 58, 1932.
74 No 9, 1934; the new Part was
effective from 1 January 1935. See
TCR, 1934, pp 50-51, 1936,
pp 60-63.

of the Council's administrative difficulties were not of their own making. The Commissioners noted the serious deficiencies in the City Council's enabling legislation. A Sydney Corporation (Consolidation) Bill which had been prepared by the Council needed, in the Commission's opinion, to be passed into law and made the basis of a Sydney Corporation (Amending) Bill which the Commission was in the process of preparing. As for the City of Sydney Improvement Act — the City Council's building Act — it was said to be almost 'archaic'. Modelled on earlier City Council attempts, the Commission was also drafting a Building Bill to give Sydney Council the same powers that suburban councils were granted under the 1919 Local Government Act.[70]

An election for a new City Council was held on 25 October 1930. While the Nationalist State Government was to lose power to the Lang Labor Government during the following month, it had succeeded in manipulating the City wards in a way that ensured the return of a Civic Reform City Council for the next six triennial elections. Depite the passing in 1929 of a Sydney Corporation Amendment Act which in part alleviated a few problems connected with the alteration of existing buildings, the in-coming Council 'began its term with powers and functions no better endowed than its predecessor'.[71] This situation was highlighted in the middle of 1930 when a caretaker's wife and daughter, having been trapped on the floor where they lived due to inadequate fire escapes, died in a fire which broke out in Vauxhall House, Bathurst Street.[72]

Economic depression, Town Hall wrangles and the usual maelstroms which emanated from Macquarie Street were to mean that the Sydney Corporation (Consolidation) Act was not approved by State Parliament until 1932.[73] Another two years were to pass, during which time much correspondence was exchanged between the City Council and the Department of Local Government about the need for better legislation, before the Sydney Corporation (Amendment) Act gained parliamentary assent.[74] This legislation gave the Council powers to control and regulate the erection, demolition, use and occupation of buildings in the City and to make by-laws governing these matters. Proper fire escapes and automatic sprinkling systems were mandatory in all buildings. The most significant feature of the amendment Act, however, was its bestowal of powers on the City Council to declare, alter or abolish residential districts within its boundaries. But compared with the schemes envisaged by planners such as Sulman — who had died on 18 August 1934, a week after the building provisions had been incorporated into the Corporation's Act — any concessions to town planning were extremely narrow. Whether or not additional

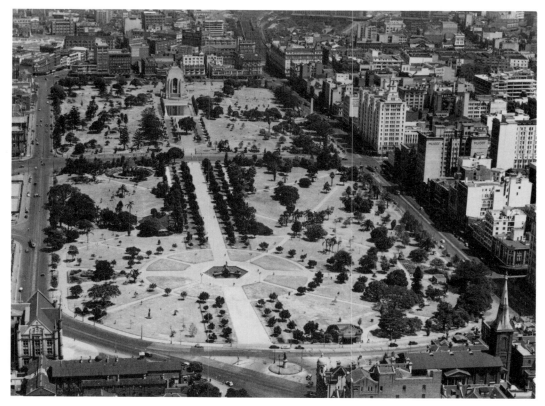

Hyde Park, Sydney, in the mid 1930s. Underground railway works in the Park had commenced in the early 1920s and had been completed in 1925, thus the new plantings and other works
(CCS CRS 71/450)

planning powers would have been brought properly into play was another matter altogether.

Late in 1935, the City Council adopted a Town Planning By-law (number 20): its main purpose was to set down a procedure for processing subdivision applications; its main concerns were with the adequate provision of roads and 'the planning of corners to facilitate the flow of traffic'.[75] It was not until June 1936 that a 'City Planning and Improvement Committee', proposed under the Sydney Corporation (Amendment) Act by Alderman Norman Nock, was established by the Council. Though the committee was prompt in expressing a desire to see the 'inauguration and preparation of a comprehensive plan of City remodelling and suggested improvements with a view to exerting a well-considered control of the future development of the City of Sydney', it was left to deal with minuscule rearrangements, ad hoc improvements and embellishments and a muddle of real-estate subdivisions which entailed the slicing up of the remnants of Sydney's grand estates.[76] From 1938, fourteen years after the position had been suggested, a Town Planning Assistant — Dugald McKenzie McLaghlan — was appointed to the Council. A comprehensive survey and plan, however, was not forthcoming: Sydney's Council lacked the political will.

Effective from the first day of January in 1935, the Sydney Corporation (Amendment) Act's 'planning' provisions did little more than lend the weight of law to activities which the City Council had been pursuing with varying degrees of success since 1906. Resumptions (thirty-seven of which were on the Council's books for work pending in 1935) and tree plantings (513 in 1936) remained the order of the day.[77] It was ironic, too, that 1935 was to see the State government transfer the City Corporation's Electrical Undertaking to the Sydney County Council.[78] Though another world war was to intervene, this signified the beginning of a long period which was to see the diminution of City Council's powers vis-à-vis those exercised by the State.

75 TC 1964/35.
76 TC 1152/36; TCR, 1936, pp 14-15.
77 TCR, 1934, pp 101-03; 1936, pp 71-2.
78 G. F. Anderson, *Fifty Years of Electricity Supply: The Story of Sydney's Electricity Undertaking*, (SCC, Sydney, 1955).

4

'A race between planning and chaos':[1] *Post-war Reconstruction*

> The need for adequate town and country planning machinery is now so insistent, having regard to the need for the orderly regulation of post-war development and for the correction of the evils of the largely haphazard and uncontrolled development of our cities, towns and villages in the past, that satisfaction of these needs can no longer be denied.[2]

War-time requirements initially saw Sydney Council's City Planning and Improvement Committee relegated to a 'state of inactivity'. Having proceeded unsatisfactorily in fits and starts, work on a guiding plan for the remodelling of the City was suspended from July 1940 when the Town Planning Assistant, Dugald McLaghlan, was directed to undertake National Emergency Services tasks. Questions, however, of planning for the City of Sydney were to emerge during discussions surrounding post-war reconstruction.

Late in 1941, the McKell Labor Government established the New South Wales Reconstruction Advisory Committee. Though a Commonwealth Ministry for Post-war Reconstruction was not set up until 1943, planning-minded members of the City Council began agitating in 1942 for the preparation of a 'master plan' for post-war Sydney. Anxious about an apparent lack of support from the City Engineer's Department in developing a 'concrete plan' and the continual interruptions to this important work, some aldermen began to reassert that Sydney could no longer afford to remain a City without a plan. Ashley Buckingham, Civic Reform Alderman and Vice-Chairman of the City Planning and Improvement Committee, alerted his committee colleagues to a new and, in his view, pressing need for a broad scheme to deal with post-war reconstruction. He noted in a minute of July 1942 that:

> At the cessation of hostilities, this Council, together with all other municipal and government bodies, will have to play a very important part in absorbing the men released from industry and the services — irrespective of financial consideration — for failure to do this will bring violent reaction, which may well become uncontrolled . . . It is towards long range thinking, therefore, [that] this committee be asked to recommend to Council that the plan in its broader outlines be proceeded with, and that by so doing we shall be able to commence with work, according to this plan, when the need arises.[3]

1 Paul Oppermann, 'Principal Address', The Fifth Town Planning Conference, 18 August 1958, in 'Tapis', 'Town and Country Planning', *The Shire and Municipal Record*, 28 September 1958, p 457.
2 J. J. Cahill, NSW Minister for Local Government, *NSWPD*, Vol 176 (1945), p 1720.
3 7 July 1942, in TC 1152/36.

Buckingham's concerns were passed on to the Acting City Engineer, E. G. Stimson, who rigorously defended both his Department and his own position. Apart from staff shortages and wartime exigencies, much preparatory work was needed before commencing with such a project. At the outbreak of war, the City even lacked an up-to-date and accurate plan of development. Indeed, Stimson informed the Town Clerk, only recently — after a 'tremendous amount of work' — twenty-four sheets (measuring twelve by thirteen feet in all) had been prepared by his staff. These were to form a base map for future planning initiatives. The latter, however, depended upon carrying out various preliminary surveys and studies to obtain essential data.[4]

A month after Stimpson's correspondence with the Town Clerk, A. H. Garnsey, the City Engineer, returned to the Council from active service. As a result of his reconnaissance of civic planning matters, Garnsey delivered an address to Sydney Council aldermen on the nature of 'Master Plans' to diffuse criticism of his department and reassure his elected superiors that work was well in hand. 'The Master Plan', he told the meeting, 'while promoting beauty and aesthetic effects, aims primarily at utilising the land area of a City along *sound engineering lines*, so that the citizens may find it a better and more attractive place in which to live, work and play'.[5] Garnsey regretted that, in Sydney's case, it could 'only be a partial plan because of the advanced state of development of the City, but the underlying principles of planning', he emphasised, 'must still be observed'.

Garnsey's blueprint for the City of Sydney contained the usual array of re-modelling elements employed by the Council. New and improved major thoroughfares were to be a main feature. 'Decadent Areas' were to be zealously rehabilitated; yet more resumptions and housing schemes, whether public or private, implemented. Adequate parks and playgrounds were to be provided for healthful recreation, and civic and cultural 'focal points' put in place to foster aesthetic development and, as a result, higher feelings among the citizenry. Zoning, albeit rudimentary, was also central to Garnsey's vision of a master plan for Sydney. Hinting perhaps at the tendency of aldermen to intervene in such matters on their constituents' behalf, he further stressed that City zoning needed to 'be comprehensive and not discriminatory'.

All this, Colonel Garnsey thought, should properly be controlled by local government. The realisation of such a master plan in the City of Sydney, however,

4 Minute, 24 September 1942, in TC 1152/36.
5 TC 1156/36, my emphasis. (The following detail is taken from a three-page summary of this address in this file).

Below left, *The south-western corner of Kettle Street (and Morehead Street), Redfern, 13 January 1958. City Engineer A. H. Garnsey would have described this Sydney spot as a 'decadent area', but for a number of people this was home* (CCS CRS 48/729)

Below, *An ornamental iron fountain in Loftus Street, Sydney, photographed in 1956. Attention by the City Council to detail such as this was not matched by the Council's attention to overall planning schemes and devices* (CCS CRS 118/58)

would depend on current inadequate legal machinery being overhauled and new and extended powers obtained by the City Council. He further warned that carrying out the plan would also require courage on the part of City Government, for radical departures from it . . . [could] result in promoting just such disorder and uncertainty as it . . . [was] designed to prevent'. Dispensing with the dangers of an unplanned City, Garnsey ended his pithy dissertation on a positive note. He concluded that 'much had recently been heard of a "New Order" to be established after the present turmoil subsides. What better foundation could there be for this "New Order", than a remodelled City based on the principles outlined'.

Colonel Garnsey was to return to war, leaving his replacement to plod along as ever. Whether empty rhetoric or otherwise, Garnsey's views on planning and the 'New Order' were moot. He was a powerful individual within the City Council. During an administrative reshuffle in 1936 his pre-eminent department was expanded and he became responsible for the City Council's most important committees, including that for Works. Garnsey's influence extended well outside the City Council to State departments and professional bodies. But vital decisions regarding any new order or legislative or political solutions to old, narking civic disorders were to be made later and elsewhere.

Council-initiated proposals for a City master plan lost momentum in the face of hostilities. Garnsey's rather lacklustre proposal for a two-dimensional zoning scheme also fell by the wayside. Nevertheless, during this period of general reassessment, town planning per se once again attained a high profile in both public and official eyes due to its perceived potential to contribute to the establishment of the 'New Order', despite the continuation of all of the old disorders.[6]

For Sydney Council's City Planning and Improvement Committee, war, which had brought building and development in the City to a standstill due to emergency restrictions, afforded an opportunity to examine more closely the City's urban problems and their immediate causes. Many City regulations were found to be far less stringent than their suburban counterparts, a situation that had been exacerbated by long delays in gazettals of new laws and amendments. (Building control remained based on the City Council adopting draft by-laws as a Building Code.) Height provisions were also assessed as being too generous, allowing as they did one hundred per cent site coverage up to 150 feet irrespective of street width.[7] (Melbourne, in comparison, had a maximum building height of 130 feet with a thirty-three per cent coverage).

Questions surrounding inner-city housing for working-class residents posed special problems for the Planning and Improvement Committee. Pre-war resumptions of residential areas for commercial and light industrial developments and resultant rises in land values had engendered a housing shortage and residential overcrowding in the City of Sydney. Committee members viewed with alarm demographic figures from the *New South Wales Statistical Register*. According to the most recent figures available in 1942, population density for the City of Sydney — 27.41 people per acre — was three-and-a-half times greater than the metropolitan average. The City's death rate was fifty per cent higher than the metropolitan average; its infant mortality twenty-five per cent higher; and its birth rate a third lower. Euthenic postulations regarding the connection between wickedness and a degraded living environment were also confirmed, apparently, by the statistics: the instances of ex-nuptial births were more than twice the metropolitan norm.[8] Inner-city figures were inevitably skewed by the presence of major institutions such as hospitals and refuges, but the figures nevertheless provided ready evidence for would-be reformers.

Convinced that housing schemes involving slum eradication would be a plank in the policy platform of whatever post-war federal government was in power, the small band of reformers on the Planning and Improvement Committee continued

6 See Commonwealth Housing Commission, *First Interim Report*, (Government Printer, Canberra, 1943) and C. E. W. Bean, *War Aims of a Plain Australian*, (Angus & Robertson, Sydney, 1943), ch 13.
7 CPICM, 15/2, pp 21-2.
8 Ibid, p 22.

unsuccessfully to urge the City Council to prepare planning schemes which would address these and other urban 'problems'. The Committee, too, was intent on being seen to be carrying out or at least actively considering planning functions which might otherwise be taken out of the Council's hands. Thus when the City Council moved to approach the Commonwealth Housing Commission (established in April 1943) regarding post-war housing proposals, the Planning and Improvement Committee argued for much more than a simple offer of general assistance then being contemplated. Alderman Buckingham insisted that the Council should place before the new commission 'defined and well prepared plans'. Not only would these blueprints aid in the removal of 'dark spots' from the City, while providing employment: 'Constructive and thoughtful planning', Buckingham contended, would 'indicate, also, that this City is alive to the necessity of planning now for post-war reconstruction, and that we are desirous of collaborating with the Commission appointed to deal with these matters'.[9]

Premier William McKell (CCS)

It was for similar reasons that Sydney's Lord Mayor, R. F. Bartley , the Town Clerk, Roy Hendy, and Citizens Reform Alderman, patriot and Planning and Improvement Committee Vice-Chairman, Stanley Crick, visited the State Premier, William McKell, on the morning of 18 August 1943. The appointment with Premier McKell had been made ostensibly to deal with tentative State proposals for a civic centre which involved the utilisation of Council lands. But during this meeting the Lord Mayor indicated a greater desire to discuss the role the Council could play in post-war works, particularly in 'relation to civic improvements'.[10] McKell was accommodating. He noted that several post-war reconstruction committees had already been formed. But he was only too glad to create a further Sub-Committee consisting of State and Council representatives.[11]

A Sub-Committee of the Public Buildings Advisory Committee was duly appointed in February 1944. Comprising H. E. Street (Under-Secretary of the Department of Local Government and Housing), Cobden Parkes (Government Architect), S. A. Giraud (Valuer-General), Colonel Garnsey and the Town Clerk, the Sub-Committee held six conferences to consider major redevelopments of Macquarie Street and its environs, the Observatory Hill resumption area, Circular Quay, Missenden Road and the Brisbane Street-Goulburn Street precinct. Submitted on 30 March 1944, the majority report included recommendations which entailed the demolition of Sydney Hospital and the old Law Courts as well as the possible removal of the Hyde Park Barracks to make way for a new parliamentary centre. Every sub-committee member was in favour of a grand seat for State and Federal government; all fancied the idea of a State opera house at the King Street end of Macquarie Street to complement such a centre; and most saw merit in developing Circular Quay and the area around Bridge Street for State and Federal administrative buildings (with the proviso that the new structures would not exceed one hundred feet in height).[12] But the conferences and their broad-brush recommendations were to come to nothing. Perhaps they were never meant to.

Other decisions regarding the shape and administration of the City were to be made with little or no initial reference to the Council of the City of Sydney. When a State Labor government was elected to office in 1941, Premier McKell signalled his intention to reintroduce the Greater Sydney Bill. Essentially aimed at amalgamating a number of Labor municipalities adjoining the City to remove the long entrenched Citizens Reform Council, this tactic was abandoned due to both heated protests and the entry of Japan into the war. A subsequent proposal to extend the City's boundaries led to a Bill being framed by the State government, copies of which were not made available to the Council. Although the Citizens Reform party had been given a not dissimilar leg-up into the City's seat of government through adjustments

9 Ashley Buckingham to Town Clerk, 20 July 1943, TC 1511/43 (No 11); CPICM, 15/2, 4 August 1943, pp 35-6.
10 TC Minute, 18 August 1943, TC 3160/43.
11 Ibid.
12 Ibid (see Town Clerk Minute, 12 February 1945).

to the ward boundaries and the franchise, R. J. Bartley, Sydney's Lord Mayor, was infuriated. He contended that such amalgamations would compound the serious urban problems then facing the City and hamper effective planning. Bartley, a member of the Planning and Improvement Committee, advocated instead a metropolitan umbrella authority with local councils in control at the grassroots, though the City Council was by no means united on any one view. [13]

Partially clothing the issue in the garb of post-war reconstruction and planning requirements, McKell was to inform the Local Government Association of New South Wales in July 1944 that he intended to bring down 'legislation at an early date with respect to the question of the extension of the boundaries of the City of Sydney and the Union of Areas in the County of Cumberland'. [14] Protests and debate again flared throughout the metropolis. Sydney's City Council eventually adopted the attitude, based on the recommendation of its Planning and Improvement Committee and in line with many other Councils and the Local Government Association, that the State Government would have to appoint a Committee or a Commission to investigate this vitally important matter. The City Council also pressed for a place for its Town Clerk on such a body. [15]

The Royal Commission on Local Government Boundaries was appointed in June 1945. Its three Commissioners — Stanley Haviland (Assistant Under-Secretary for Local Government), Ronald Storey (Chief Clerk in Equity) and Chairman Justice John Clancy — were to agree to the need for change. But they were to draw three different conclusions concerning the extent to which the City of Sydney should be expanded and the manner in which metropolitan local government boundaries elsewhere were to be rearranged. [16]

Despite the fracas which at times surrounded the inquiry and a campaign of opposition, the Commissioner's general concurrence as to the advisability of amalgamating some surrounding local Councils with the City of Sydney promoted legislative action. Compromise legislation, overseen by John Cahill, Minister for Local Government, was drafted, redrafted and finally passed by Parliament in 1948. Alexandria, Darlington, Erskineville, Glebe, Newtown, Paddington, Redfern and Waterloo municipalities were absorbed into the City of Sydney, raising its area to eleven square miles, and an election was set down for 4 December 1948. Ensuring a Labor victory in the election, [17] the passing of the 1948 Local Government (Areas) Act ushered in a long period of Labor-dominated City Councils. Almost twenty years of parochial, municipal laborism in the City was to stifle any real attempts at planning in Sydney. But it was also to contribute significantly to the preservation of a good deal of inner-city, working-class residential areas.

During the final year of the war, the McKell Government was to place on the statute books a piece of legislation concerned with metropolitan planning which involved the City. Appropriating the language and 'science' of town planning as the State legislatively retooled itself for post-war restructuring, J. J. Cahill presented a Local Government (Town and Country Planning) Amendment Bill to parliament early in 1945. [18] Addressing the legislative Assembly, Cahill told his colleagues that the 'need for some well-directed system of town-planning . . . [was] obvious'. [19] All were in agreement on that point. But given the apparent confusion in the minds of many people as to what 'planning' actually meant, [20] Cahill went to some length to define the now lauded discipline.

Essentially, Cahill observed, planning was 'scientific development' or, in the unfortunate case of unplanned cities such as Sydney, scientific 'redevelopment'. Quelling concerns about overly centralist government and possible socialist schemes — communism being the greatest political bogey in Australia from 1945 into the 1950s — the Minister remarked that 'we must not allow ourselves to believe that we are doing anything revolutionary, but merely attempting to get the right perspective on modern needs'. [21] Conditions had to be adjusted for post-war industrialisation.

13 *PC*, 1943, pp 299-300. Detailed discussion is to be found in F. A. Larcombe, *The Advancement of Local Government in New South Wales 1906 to the Present*, (SUP, Sydney, 1978), pp 112-15.
14 Quoted in J. D. B. Miller, 'Greater Sydney, 1892-1952', *Public Administration*, Vol 13, No 2, June 1954, pp 118-19.
15 CPICM, 15/2, 15 November 1944, p.77; *PC*, 1945, pp 143-48.
16 See F. A. Bland, 'Some Aspects of Greater Sydney', *The Shire and Municipal Record*, 28 January 1947, p 467.
17 This was reinforced via disunity within Citizens Reform. See Larcombe, op cit, p 124-25.
18 For a detailed discussion see Murray R. Wilcox, *The Law of Land Development in New South Wales*, (The Law Book Company, Sydney, 1967), pp 189-202.
19 *NSWPD*, Vol 176, p 1767.
20 Ibid, Vol 177, p 2597.
21 Ibid, Vol 176, p 1769.

Town planning's precarious place in the consciousness of politicians and its extreme susceptibility to political opportunism, however, became evident during the second reading of this landmark piece of legislation. Partially severing the still nascent discipline from any specific professional corpus, Cahill cast planning as a political 'magic pudding'.[22] He declared that 'Town and country planning [was] the democratic right of all citizens, and must not become a close preserve for professional planners, although the expert knowledge and guidance of the engineer, the architect, the surveyor and the administrator must be used as a basis'.[23] In working to regulate in advance the orderly arrangement and use of land, planning had to be flexible. In the end, however, it would be controlled by the State. An amendment to the Bill in the Legislative Council was to keep ultimate power over local and regional planning in Macquarie Street.[24]

The Local Government (Town and Country Planning) Amendment Act gained parliamentary assent on 5 April 1945. Though complicated and hard to follow, this legislation was rightly hailed 'as the most powerful [planning] instrument which had ever been placed in the hands of local government' in New South Wales.[25] Under its provisions the Cumberland County Council was created.[26] This body was charged with producing a broad county plan within three years — it took six due to inadequate resourcing — and overseeing the preparation of schemes for local government areas. Local planning schemes were the responsibility of shire and municipal councils; they were obliged to provide detail for the county master plan.

The steps for undertaking a local plan were clearly prescribed in the Act. Councils had first to pass a resolution to prepare a scheme. A planning committee then had to be appointed which would in turn nominate an individual with suitable qualifications in town and county planning to *assist* in the scheme's preparation. Places were also allowed on the planning committees for public-spirited private citizens, but most Councils seem not to have invited input from outsiders.

After being prepared and adopted by a Council, a local planning scheme had to be submitted to the Minister for Local Government as draft ordinances. These were then referred to an Advisory Committee which made recommendations to the Minister who could vary, revoke, approve or, in dire cases, take over responsibility for both preparing and enforcing the scheme. In the event of ministerial approbation, the local scheme would subsequently have to gain the Governor's approval and pass through both houses of parliament. Between a scheme's adoption by local government and its coming into force, interim development was to be controlled by draft ordinances. Variation to both draft and gazetted ordinances could be approved by local government or the Minister, the latter having the final power of determination.[27]

Unlike previous local government legislation with planning import, the City of Sydney was included under the 1945 Amendment Act; official nomenclature designated it the County Centre. Sydney's municipal Council, however, was slow to react to its mandate to prepare a scheme, as was every other shire or municipal Council in the State.

During 1948, the City Council completed its first plan for interim development control and resolved to finalise the work through its City Planning and Improvement Committee, which had been investigating such matters since the end of the war.[28] Aspersions as to the government stroke setting the pace in the Town Hall held some water. Not until 18 October 1948 was formal approval given by the Council for the creation of a Town Planning Branch in the City Engineer's Department, and even then it was to exist as a weak appendage to that department with at first only one senior planning assistant (McLaghlan), an assistant analyst and A. H. Garnsey, City Engineer, as the nominal town planner.[29] Sydney's City boundary, however, was uncertain until the mid-year passing of the Local Government (Areas) Act. Repealing the Sydney Corporation Act, this new legislation brought the City Council under the Local Government Act of 1919, effective within the City from the first day of 1949.

22 The Magic Pudding was the central character in a children's story of that name by Norman Lindsay. Thieves were constantly capturing the pudding and using it for their own ends. The pudding, too, was able to remould and reconstitute itself no matter who dipped into or controlled it.
23 Ibid, p 1768.
24 Ibid, Vol 177, pp 2598, 2607.
25 Cumberland County Council, *Circular*, No 7, in TC 1943/45 (Box 1). See also A. G. Coleman, 'The Post-war Planning Activities of the Sydney City Council, 1945-1970', MA Pass History Essay, University of Sydney, December 1978, p 1 (held in the Sydney Council Archives Theses Collection).
26 See 'Chronology' for 1945.
27 TC 1943/45 (Box 1).
28 TC 1985/47, no 28 (Box 4).
29 TC 2201/48; Nigel Ashton interviewed by Paul Ashton, 2 January 1992, in *PS*, p 3.

Future developments in the immediate post-war period were to confirm the views of municipal sceptics: the City Council's general disregard for progressive planning was to prove as glaring as the Cumberland County Council's overall failure.[30] In the late 1940s, however, it looked to many as if the long felt need for adequate planning in the City and its hinterland was on the verge of finally being satisfied. Slowness on the City Council's part to respond to statutory planning requirements was also put down, with some justification, to the administrative and functional complexity which surrounded the county centre.

While recognising the urgent need for action in the City, the Cumberland County Council did not need to be convinced that planning in the county centre was much more than a local problem. Leaving aside the much discussed but yet unrealised civic survey for Sydney, the County Council appreciated the lack of a 'clear-cut division between the functions of the City as the principal centre of the County, the State capital and the largest distributing centre and port of the Commonwealth'. City land uses were also scattered and intermingled, being based almost exclusively on 'convenience and habit'. The Cumberland County Council also strove to encourage the City Council in good planning habits, such as undertaking detailed surveys prior to making plans. It noted with approval the City of Sydney's first interim development control plan of 1948, which sought to check the infiltration of industry into living areas while simultaneously stopping the economically 'unsound redevelopment of many obsolete areas'. Time and time again the County authority emphasised that a planning scheme for the City of Sydney would have to cater for 'flexible adjustment to changing trends and conditions'. This would entail a lengthy and complex planning task, the burden of which rested with the City Council.[31]

Differences were to emerge rapidly between the City and County Councils, despite generally polite relations in public. Sydney's City Council, and in particular its nominal town planner, A. H. Garnsey, took a rather concrete view of planning. Since the late 1930s, the Council's Engineering Department, largely at aldermanic behest,[32] had been declaring residential districts in various wards (there were twenty by 1950) and otherwise 'zoning' parts of the City. This work partially culminated, on 13 October 1947, with the City Engineer's submission of a Land Use Zoning Scheme to the Sydney Council for final approval.[33] During the following year, this scheme was put forward by the Sydney Council for incorporation into the Cumberland County Plan.

Sidney L. Luker, the Cumberland Council's chief county planner, was both perplexed and disappointed with the City's unexpected 'planning' scheme. On 22 March 1948, only two months before the City Council submitted this land-use scheme, the nature of the County plan and the requisite local planning devices had been formally explained to City aldermen and senior Council staff (including City Engineer Garnsey). Agreement, or so Luker thought, had been reached between county planners and the City Engineer as to zoning being nothing more than a means for interim development control and a starting place for more detailed work. City planning, Luker reported to his Chairman, called 'for very comprehensive study and determination' and therefore he was unable to recommend the incorporation of a detailed zoning plan into the county scheme.[34]

While members of the City Council's tiny Town Planning Branch were reluctantly forced back to their drawing boards, the 1948 Local Government (Areas) Act significantly expanded the area for which the City Council was responsible and set a two-year deadline from the beginning of 1949 for the completion of a scheme. Despite the engagement of a few additional staff and occasional amendments to the draft scheme,[35] delays in preparing a detailed plan for the City of Sydney remained chronic. Excuses were exchanged and blame was shifted from the City Council's door to the County's and back again. Skirmishes over civic powers, too, broke out from time to time, the City Council not infrequently protesting about the 'unnecessary

30 Apart from a number of piecemeal achievements, such as the acquisition of some parts of Sydney Harbour's foreshores (eg Caraba Point), by 1967, three years after the Council's demise, only four local schemes were operating in the Cumberland County. See Wilcox, op cit, p 192.

31 *County of Cumberland Planning Scheme Report*, (Cumberland County Council, Sydney, 1948), pp 118, 106.

32 For example, in the case of Pyrmont, see CPICM, 15/3, p 102.

33 TC 3808/47. The scheme was approved on 31 May 1948. See TC 1943/45 (Box 1).

34 Chief County Planner's Report No M.94, in TC 1943/45 (Box 1).

35 In June 1950, for example, a Labor City Council resolved to alter the zoning of Pyrmont, Ultimo and Chippendale from largely non-residential to primarily residential. This affected 8500 people. See TC 1943/45 (Box 1, item 24). See also TC 2784/47 for Surry Hills.

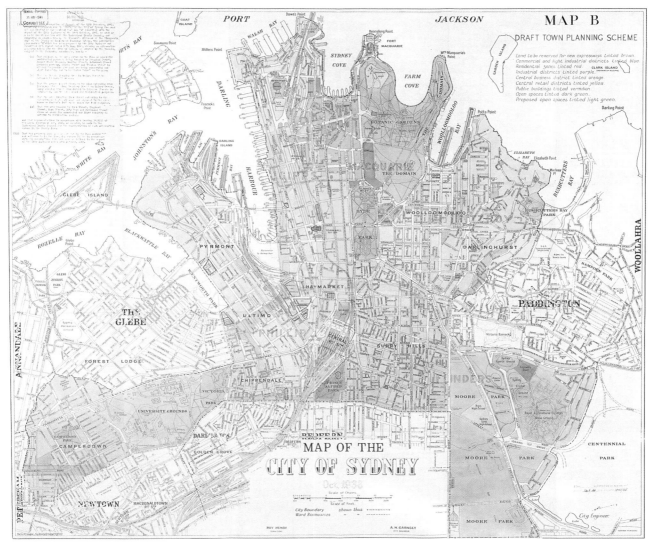

The scheme represented on this map was prepared by the Council of the City of Sydney in the late 1940s, and modified in the early 1950s, in response to the Cumberland County's requirement that local government bodies prepare detailed planning schemes for their own areas. The base map was prepared earlier by Council in 1938. The scheme, however, is essentially a rudimentary zoning plan. It was finally rejected by the City Council after much debate about a number of working-class residential areas being zoned largely for industrial purposes (shaded mauve). Under this proposed scheme, Pyrmont, Ultimo and Chippendale were zoned almost exclusively industrial

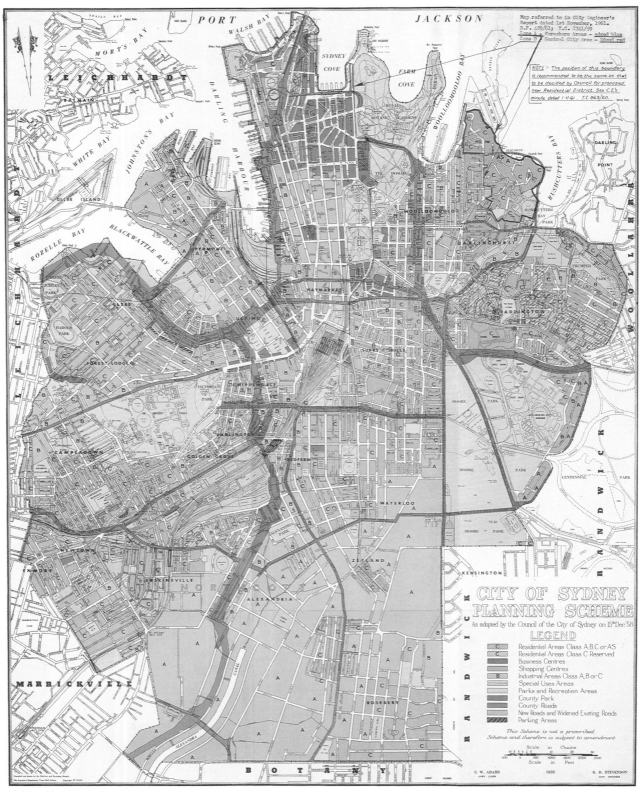

This City of Sydney Planning Scheme was adopted by the City Council on 15 December 1958, though it was not to be approved by the Minister for Local Government, after years of politicking and numerous amendents, until 1971. When this map was prepared, the boundaries of the City of Sydney included the area today administered by South Sydney Council

On 30 May 1951, Sydney Council's City Planning and Improvement Committee approved this local replanning scheme for the inner-city suburb of Paddington. Under this extensive scheme, the entire area, made up of nineteenth-century housing stock, was to be razed and replaced with medium density, two- to three-storey flats

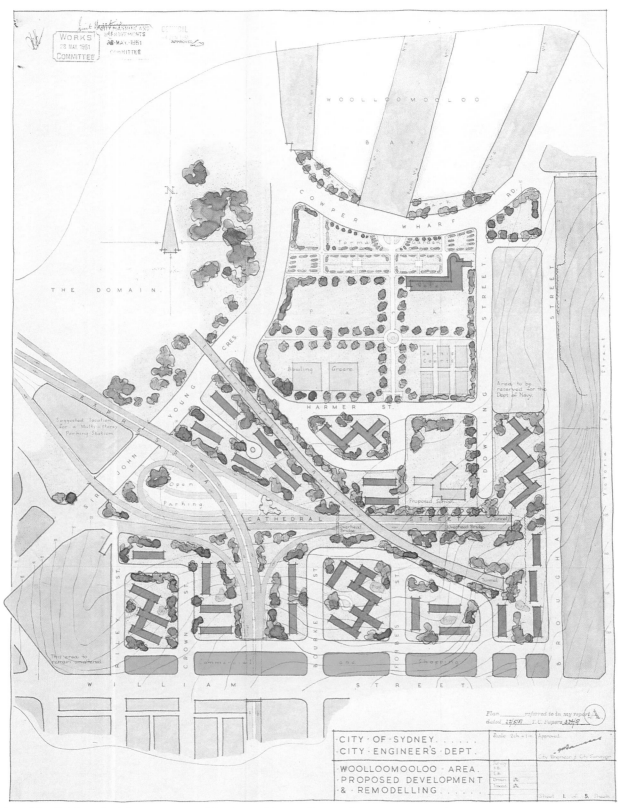

As with all 'planning' documents at this time, this Woolloomooloo Area Proposed Development and Remodelling' scheme was prepared by Sydney Council's City Engineer's Department. (It is signed by City Engineer, A. H. Garnsey, and dated 28 May 1951.) This plan entailed the complete redevelopment of the area and the combination of elevated expressways and high-rise, austere blocks of flats for displaced residents. The scheme did not go ahead because of conflicting needs between different levels of government

interference with the powers of local government' as the County Council attempted to carve out a role in the City.[36]

Having made little headway with its statutory planning scheme, the City Council agreed to form a joint committee with the Cumberland County Council to address planning problems in Sydney. The primary outcome of the committee's deliberations, which began in March 1950, was a ministerial extension of the deadline for the scheme until New Year's Eve, 1952.

Close to retirement, City Engineer Garnsey laid a plan consisting of a six-sheet scheme map and a scheme ordinance, with other supplementary maps, before the City Council on 19 August 1952. By way of background, Garnsey explained that the Council was 'planning for order'. Housing shortages in and around the City were gradually being redressed. But commercial and industrial development had made little progress since the start of the war. 'When building controls are lifted and labour and materials become more plentiful', he forecast correctly, 'there is likely to be considerably increased building activity, particularly in the business centre'.[37] Master plans, however, had to be treated with caution, particularly those akin to the more 'elaborate and beautiful' overseas ones which, created in a reconstructionist euphoria, had subsequently vanished 'because of a more realistic approach to the planning problem'. 'Idealism', Garnsey wrote, 'must be subordinated to practical considerations'. Order was to be achieved by means of piecemeal compromise and rudimentary zoning.

Adopted by the City Council on 13 October 1952, Sydney's new Planning Scheme was placed on public exhibition in the Town Hall for three months from 3 November 1952. Affecting 210,000 residents, the principal features of the scheme included a traffic distributor system, linked with the County scheme which had five expressways converging on the City's CBD. Off-street parking stations were tied to the distributor roads. Parking meters were planned for the CBD while provision for parking areas outside the City centre were intended to relieve inner-city traffic congestion.

Far more imagination and a good deal of civic pride and self-importance had been put into a proposed civic centre. For some time, different suggestions had been floated concerning the transformation of the area round Sydney's Town Hall and the Queen Victoria Building into a seat of municipal government and cultural activity. Now plans were being put forward to erect an extensive civic centre around the three sides of Hyde Park south. Incorporating the already existing Australian Museum and the Sydney Grammar School, the complex included new municipal offices, a grand concert hall, a technical museum, a medical centre and a municipal library.[38]

Other areas in the City received detailed planning treatment, though the overall emphasis was still on zoning. Some localities, although zoned, were left for later deliberations since to which authority charge of their redevelopment would be given was uncertain. Extensive remodelling, A. H. Garnsey thought, would undoubtedly take place in areas such as Paddington, Surry Hills, Waterloo, Glebe and Newtown. But he was unwilling to proceed with detailed schemes until such uncertainty had been removed.[39]

For many who had welcomed post-war planning initiatives as a vehicle for a new lease on chaotic City life, the experience in Sydney, so far, was not encouraging. Seven years had elapsed since the war's end and the status and future of town planning in the City was as unsure as ever. In his 1951 'Foreword' to an Australian textbook entitled *Town and Country Planning*, Sir Patrick Abercrombie, doyen of the British planning movement, noted that this text appeared 'at an opportune moment, when great changes are taking place and when in some parts of Australia the primrose path of *Laissez-faire* still seems to satisfy'.[40] The path of laissez faire was certainly well trodden in the City of Sydney. But the complex web of power relations which inevitably surrounded this approach ensured the State's domination in the control and development of the City.

Sir Patrick Abercrombie
(Town and Country Planning Institute of Australia, *Bulletin*, January 1949)

36 See TC 1943/45 (Box 1).
37 Garnsey to Town Clerk, 19 August 1952, in TC 1985/47 (Box 3, Attachments).
38 See *Civic Development*, January 1953, no 10, p 1. See also TC 1597/46.
39 TC 1985/47 (Box 3).
40 'Foreword', in A. J. Brown and H. M. Sherrard, *Town and Country Planning*, (MUP, Melbourne, 1951), p viii. Abercrombie had visited Australia late in 1948.

Bemoaning the failure of the Greater Sydney movement and the fragmented administration of the City of Sydney, J. D. B. Miller, a contemporary observer, noted that by the close of 1952, the year in which Sydney Council's planning scheme had gone on public exhibition, 'the City was as much in the hands of "irresponsible boards" [harking back to the nineteenth century] as ever, and that, if anything, the hand of the State Government in running Sydney's affairs had been strengthened'.[41] The Electricity Commission, the Board of Fire Commissioners, the Maritime Services Board, the Main Roads Department, the Railways Department, the Housing Commission, the Department of Road Transport and Tramways, the Metropolitan Water, Sewerage and Drainage Board as well as various minor boards all made decisions about the life of the City and its physical development.

The Cumberland County Council added not only itself to this list but a number of its creations, including the City Roadways Planning Conference which was set up in 1946 and comprised representatives from most of the major departments, commissions and boards.[42] Things had also gone awry with the County Council and 1952 was no exception. In that year the County Clerk, H. E. Maiden, noted in his Council's *Annual Report* that the 'Town and Country Planning Legislation and the County Scheme Ordinance are fraught with administrative and legal difficulties. New problems are encountered almost daily'.[43] By the mid 1950s, around twenty-two thousand claims for 'injurious affection' resulting from County zoning also weighed heavily on the Cumberland Council. A test-case decision in the New South Wales Land and Valuations Court on 17 December 1954, though finding in favour of the County Council on a technicality, clearly indicated that the final question of compensation would largely be a matter of 'How much?'.[44]

Strong opposition in the form of 1540 representations from property owners and other interested parties was also directed towards the City Council's exhibited planning scheme. Powerful private organisations based in the City were especially antagonistic to any potential restrictions which altruistic planning might have on fresh development.

Supported by the Sydney Chamber of Commerce, the Retail Traders' Association of New South Wales successfully lobbied the City Council to extend its deadline for submissions on the scheme until 3 November 1953.[45] The Association's position regarding both planning in the City of Sydney and planning in general was made abundantly clear by one of its councillors, S. E. Wilson, in an address delivered to the Sydney Division and the Australian Planning Institute in May 1953.

Published as a paper entitled 'Is Planning Stifling Development?', Wilson's speech commenced with the assertion that 'the business man must not be regarded as a supporter of disorganised chaos' who is 'simply opposed to any form of planning'.[46] In what he thought the unfortunate instance of the City planning scheme, however, Wilson was quick to point out that 'many business men believe the Plan will have disastrous economic consequences': it was claimed that its implementation would 'seriously retard development and . . . impose the most discriminatory and unfair burdens on individual property owners without any compensation whatever'. If development was to be encouraged and the economy expanded, business required nothing more nor less than (a) the chance of success and a fair reward, (b) suitability of area in relation to production and distribution, (c) security, (d) freedom from disturbance, and (e) opportunities to expand. Thus, for the City of Sydney, Wilson put it on behalf of his colleagues, 'We believe that a guiding principle should be, as far as possible, to leave an established City undisturbed. Accept it as it is, but call in the engineers to give it the services it requires'.[47]

For the Retailers' Association, planning would be best concentrated 'outside the City parameter to direct development and relieve City pressure'. Within the City of Sydney, the Association contended, intervention should be directed at sub-standard buildings and slum areas. This direction, however, was already being pursued by

41 J. D. B. Miller, 'Greater Sydney, 1892-1952', *Public Administration*, Vol 14, September 1954, p 192.
42 For Minutes, see TC 4576/46.
43 Memo No 77, in TC 1943/45 (Box 1).
44 'The Bingham Case', *The Shire and Municipal Record*, 28 February 1955, pp 627-28; *Local Government Reports*, Vol 20, 1955-56, pp 1-34.
45 TC 1985/47 (Box 2, items 12ff).
46 S. E. Wilson, *Is Planning Stifling Development?*, (Shepherd & Newman, Sydney, 1953), p 1, in TC 1985/47 (Box 4).
47 Ibid, pp 2, 4.

the City Council and other authorities, such as the Housing Commission. Between 1947 and 1954, the City of Sydney's residential population was to fall from 214,000 to 193,000, a decrease of just under ten per cent.[48] Some commentators have subsequently, though without foundation, viewed this as 'indicative of a change in the attitude of the City's residents towards the desirability of living in the City and an implicit condemnation of the City Council's failure to introduce necessary developmental changes'.[49] Rather, residential depopulation was the product of the erosion of traditional working-class areas due to slum clearances and ongoing resumptions accompanied by all the attendant middle-class moralising.[50]

Part Four of the City Council's draft local planning scheme ordinance, a floor-space ratio for the central business district, gave rise to more protests and representations than any other feature of the scheme. (A floor-space ratio theoretically regulates the amount of floor space a building can have in proportion to the size of the block it is on.) Based on guidelines in the British Ministry of Town and Country Planning's 1947 *Advisory Handbook on the Redevelopment of Central Areas*, the City Council's index put forward ratios of six-to-one for class B industrial areas; eight-to-one for City shopping centres; and ten-to-one for the business centre.[51] Further investigations were undertaken and considerations weighed in the aftermath of vigorous criticisms. By mid April 1954, acting and soon-to-be City Engineer, R. D. Stevenson, indicated that the methods of control suggested in the index would, if implemented, indeed lead to economic 'hardships and anomalies'. Duplication of State and local government regulations in regard to a floor-space index, however, was eventually to see the City Council abandon this proposed planning tool.

Regulations relating to the physical limitations of development in the City were to be relaxed a little under the Height of Building (Amendment) Act of 1952. More importantly, control over buildings exceeding eighty feet in height had from that year to be approved by both the Chief Secretary and the Council of the City of Sydney. Previously, the State had only intervened in the approval of buildings over one hundred feet tall.[52]

Protest after protest emanated from the Town Clerk's office over changes to the Act. In the City Council's view, 'dual control in respect of the erection of buildings [was] . . . most undesirable' and it recommended that immediate steps be taken to repeal the Amendment Act, in so far as the City was concerned.

Undesirable or not, this situation persisted into the mid 1950s only to be exacerbated by a Ministerial decision in 1956 to reassess statutory limitations on the height of buildings in the City with a view to increasing the limit. Approaches from the Commonwealth Government (concerning major new administrative buildings on the corner of Elizabeth and Bent streets in the City) and from a private developer, D. J. Collings-Power Proprietary Limited for a Kent Street development, had sparked the minister's action.[53]

Reporting in March 1956 on the State government's proposed floor-space index, City Engineer Stevenson pointed to the inconsistencies between the Council and the Minister's indexes and their respective likely impacts on the City. Council's proposed floor-space index would allow maximum useable floor space in Sydney to be increased from 956 acres, as it then was, to 1628 acres, taking the existing index from approximately five to an average of 8.5 in the business and retail centre. If the City Council's suggested index were abandoned, Stevenson calculated,

> the useable floor space could eventually increase to a point giving a floor space index of 15.0 on all buildings being built to a height of 15 storeys as against today's average of five.
> If, as is proposed in certain quarters, the existing height limit of 150 feet is abolished an even greater floor space index would result.[54]

Stephenson speculated grimly that a boom in the height and bulk of City buildings

48 P. N. Troy (ed), *Urban Redevelopment in Australia*, (ANUP, Canberra, 1967), p 88.
49 Coleman, op cit, pp 12-13.
50 TCR 1955, p 9; see also Caroline Alport, 'Towards Waterloo: Inner-City Habitat and Urban Reform in Modern Sydney', unpub mss, City Council Archives.
51 TC 1293/54.
52 TC 1043/52.
53 Ibid.
54 Ibid, 12 March 1956.

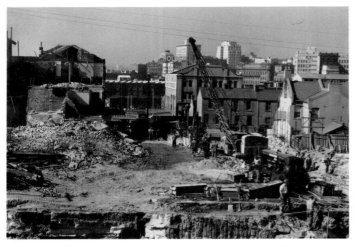 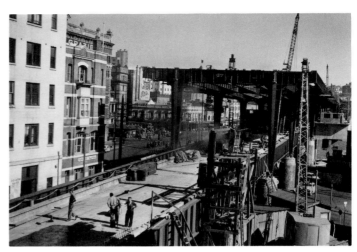

Above, *York Street North (foreground), 19 August 1955, showing demolitions and excavations for the Cahill Expressway* (CCS CRS 48/311)

Right, *Circular Quay overhead railway construction looking west — the 'master stroke of vandalism'* (CCS CRS 48/298)

eventually would generate enough additional traffic to thoroughly clog Sydney's already chaotic streets.

State-Council communications teetered as usual, the City Council learning perhaps more regarding possible legislative amendments from press reports than from the Chief Secretary's Department.[55] Amid the shambles, an Advisory Committee was appointed by the State Government to recommend appropriate changes to the Act. By October 1956 the Committee had furnished the Chief Secretary with a report. Though still uncertain, it appeared that the old maximum building height was to be rescinded and that the Minister would be empowered to approve buildings over 150 feet pending advice from a permanent Height of Buildings Advisory Committee which would lay down general design and safety conditions. These recommendations were to provide the basis of the 1957 Height of Buildings (Amendment) Act.

Despite more of the same as far as planning in Sydney was concerned, the mid 1950s was a watershed in the City's planning history. Symbolically, 1956 saw the completion of the Circular Quay overhead railway — a 'master stroke of vandalism'[56] — which proclaimed the State Government's commitment to cold functionalism and crude engineering approaches in the face of complex planning problems (not to mention deplorable technocratic aesthetic sensibilities). It was plain to many that Sydney was on the brink of a colossal urban boom. Yet again the City was to undergo a period of 'remorseless development', as one journalist-observer put it earlier in the decade.[57] But the question as to whether development in the City was to be sensitively controlled or left to anarchic market forces and political expediencies still remained unanswered.

This is not to say that the question went begging. Sydney planners, though small in number and often working independently of major bureaucracy, used various forums to promote the need to plan. George Clarke, a young and enthusiastic Sydney architect who had been a planning officer with the Cumberland County Council since 1954, penned a critical piece for a 1956 issue of the *Voice*. He was en route to Italy on a scholarship to study 'Urbanistica' when his article was published. In his article Clarke argued that the strain on scarce capital resources resulting from increasingly rapid development had engendered a situation where there was

> little opportunity or inclination in this country at present for City planning that embraces either English conscientiousness, Continental aestheticism, or American technological exuberance. What goes under the name of City planning in Australia today [he rightly claimed] is a merely two-dimensional affair of 'land-use' zoning. The present planning task is mainly negative or conservative.[58]

Clarke contended that if planners were given the necessary authority and resources, and if they used aesthetic, functional, moral and social criteria they could 'bring efficiency, convenience and beauty' to Australian cities, particularly long-suffering Sydney. As practised in Australia, however, City planning aimed merely 'at the

55 TC 1293/54.
56 'The Master Vandalism: Quay Railway — Roadway . . .', *The Shire and Municipal Record*, 28 September 1948, p 331.
57 *Sun*, 18 January 1951.
58 George Clarke, 'City Planning in Australia . . .', *Voice*, April 1956, Vol 4, No 7, p 26.

maximum long-range conservation of development opportunities and the capital represented by land'. Confounding this situation, planning administration was bogged down in attempts to 'co-ordinate the conflicting and chaotic energies of many different kinds of developers and constructing authorities'.[59]

Young zealots such as Clarke represented an up-and-coming generation of planners who would strive to capture the public imagination, while attempting to convert decision makers and ruling elites to planning. There was not a little of the old evangelical zeal evident at this time. It had only been a few years since Sir Patrick Abercrombie had said to Australian teachers and students of planning that the 'watchword is devotion, for town planning is not only a profession but a vocation'.[60] And the 'word' was still alive. Having just been offered a position with the Cumberland County Council, Clarke remembered his professor,

Denis Winston, professor of town planning, University of Sydney (CRS 62)

> Denis Winston, took me aside at the planning school that night and said, 'It's wonderful George, that you've joined the greater crusade'. And that was the way in which I and Denis Winston regarded it — we were utopian crusaders out to change the world. But first of all we tried to understand it . . .[61]

As a result of that process, Clarke believed, they were to eventually become 'Sydney realists'.[62]

Clarke's academic mentor, Denis Winston, was the founding professor of Town Planning at the University of Sydney (from 1948) and a constant contributor to debates on urban development and policy in the City. On 19 October 1956, Winston delivered the inaugural Sidney Luker Memorial Lecture, an annual talk which had been established to honour the Cumberland County Council's recently deceased Chief Planner. Focusing on the question 'Where have we got to with Planning Today?', Winston told an attentive audience gathered at History House that as far as the City of Sydney was concerned,

> our inheritance in planning from the immediate past is the tradition of keeping watch on what people are doing and trying to stop them if possible; because practically everything that people wanted to do as regards building development was either unsanitary, unsafe, or deplorably ugly.[63]

For Winston, however, what the central part of the City of Sydney needed most pressingly was firm 'control [of] building height and bulk to ensure proper light and air' and to curb overcrowding and serious traffic congestion.[64]

Keeping watch was to remain one of the primary roles of academic planners in the City of Sydney, though the effect of their vigilance was scant. Hardly a week passed by for some considerable time without untoward comment in Sydney's daily press about intolerable traffic conditions in the City.[65] Indeed, one Friday in December 1956 was dubbed 'Black Friday' after the worst recorded traffic jam in Sydney to that date held up peak-hour motorists in some parts of the City for forty minutes.[66]

Winston's concerns over building height and bulk in Sydney were shared by many others, including some professional employees and aldermen on the City Council. These concerns were to be addressed more promptly by the State government by means of the Height of Buildings (Amendment) Act which passed through Parliament early in 1957. As foreshadowed by previous ministerial moves, the Amendment Act took off any absolute limit to building heights in the City. Under the new provisions, all building and development applications for structures over eighty feet in height had to be referred to the Height of Building Advisory Committee, as well as the City Council. Comprised of a broad range of representatives from government departments (for example, Police and Civil Defence) and, professional bodies (for example, Architecture, Planning and Local Government), and including the Sydney Council's City Building Surveyor, John Rankin, the committee exercised considerable power over major building projects in the City. Critical to its decisions was a paragraph in the Amendment Act which, as an ex-City planner recalled,

59 Ibid, p 27.
60 'Foreword', in Brown and Sherrard, op cit, p viii.
61 George Clarke interviewed by Paul Ashton, 2 Feb 1992, in PS, p 19.
62 Ibid.
63 Australian Planning Institute Bulletin, December 1956, p 4.
64 Ibid, p 6.
65 TC 1043, 52.
66 See note 63.

prescribed that 'a building over one hundred and fifty feet should not have any more floor space than a building under a hundred and fifty feet could have had. That . . . set the mark at around about fourteen-to-one if you were clever enough to get that high'.[67] This, in effect, introduced a quasi floor-space index for the City of Sydney.

Adding another powerful symbol to Sydney's Circular Quay, an insurance company, the Australian Mutual Provident Society, was to avail itself of the relatively generous new provisions. Razing the nineteenth-century Farmers and Graziers Building in 1957, the Society proceeded to erect Sydney's first skyscraper on an island block fronting 1-3 Phillip Street: finance capital was conspicuously supplanting pastoral capital. Proposed initially to have twenty-two storeys, the AMP Building was erected to a height of twenty-six storeys.[68] Sydney's first building boom to follow World War II was on the way. Between 1956 and 1964, the value of new building stock in the City of Sydney, most of which was commercial, soared from around three million pounds to just under fifty-one million pounds.[69]

Confusion as to the precise nature and workings of the floor-space ratio in the Height of Buildings (Amendment) Act led a deputation of City aldermen, headed by Labor Lord Mayor Harry Jensen, to wait upon the Chief Secretary, Christopher Kelly, on 3 April 1957. Kelly was to assure the City Council that it would be represented on the Advisory Committee by its City Building Surveyor. But apart from indicating that the control mechanism was in effect 'a modified floor space index' ('modified' seeming to mean 'flexible'), the Minister could shed no further light on the matter for the bewildered deputation.[70]

After extensive debates between the various interest groups, the Height of Buildings Advisory Committee was to set a floor-space ratio of twelve-to-one. As development control, however, the floor-space ratio is an extremely crude instrument. According to one expert,

> it does not properly control the size of buildings because it does not control the height between floors for one thing; It does not properly control the population in a building because it applies to different uses — the floor space in one building can be quite different to another for the same population. It does not do anything exactly, its a very broad brush instrument. But the thing it does do is enable the development industry to have a known expectation of development, and if you like, shares the cake. It makes sure that everybody gets the same share of the floor space that might be available and there is no argument as to favouritism for one development over another.[71]

Arguments, however, flared over the measurement of floor space. Should internal or external building measurements be taken? Would lifts and other non-lettable spaces be included in calculations?

While the Advisory Committee, chaired for some time by Gerry Kingsmill, Under-Secretary of the Chief Secretary's Department, proceeded to establish its ground rules, the City Council continued to grapple with its own floor-space index. Actual ratios and methodological considerations formed but one of a set of questions surrounding this problematic device for the Council. Several aldermen feared that such an index might 'have a tendency to drive [property] owners from the City' if precluded from 'obtaining the maximum use of . . . land'.[72] This, of course, could mean a decrease in rate revenue which had to be strenuously resisted. To counter disincentives to develop the City, a hardship clause was proposed after months of discussion to relax or waive any provisions of the draft floor-space index. But at least one alderman was vehemently against this proposal. In favour of a floor-space index, Labor Alderman T. Wright wrote to the Town Clerk that he did 'not like the proposed reference to "hardship" in the draft clause . . . It should be on the basis of what is considered appropriate from the viewpoint of City planning and needs'.[73] This was the crux of the matter: City planning in Sydney was to take a back seat to the needs of capital. Played on a political field, the rules of town planning were supremely

67 John Doran interviewed by Paul Ashton, *PS*, p 70.
68 TC 1043/52 (18 January 1957). The block was bounded by Phillip Alfred and Young streets and Goldsbrough Lane.
69 Ray W. Archer, 'Market factors in the Development of the Central Business District Area of Sydney, 1957-1966', in Troy, op cit, p 274.
70 TC 1043/52.
71 John Doran interviewed by Paul Ashton, *PS*, p 78.
72 TC 1043/52 (minutes of meeting with Minister Kelly, 3 April 1957).
73 TC 1985/47 (Box 1, letter, 30 June 1958).

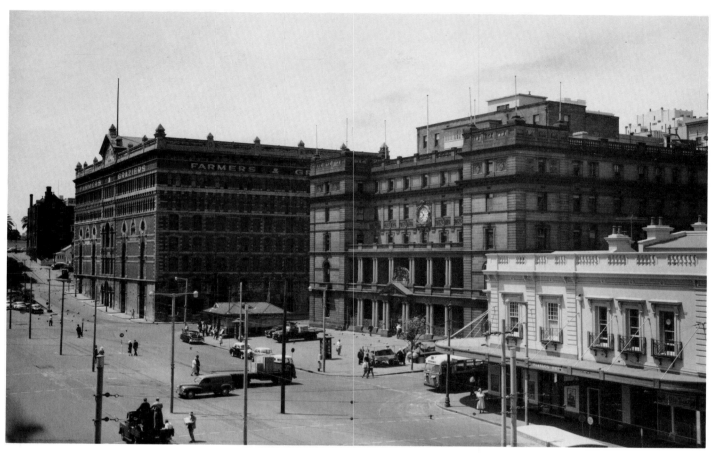

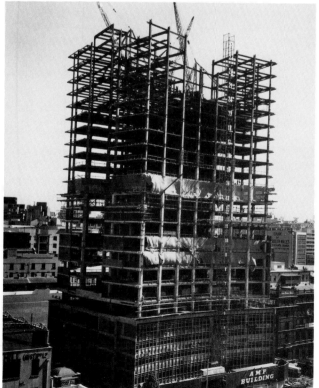

The AMP building, Sydney's first skyscraper, under construction around 1960. The building was officially opened in 1962 (CCS CRS 48/1394)

The Farmers and Graziers building, Circular Quay, in 1957 just prior to its demolition (CCS CRS 47/1405)

The Cahill Expressway nearing completion. This photograph was taken from the roof of the ICI building on 25 October 1957 (CCS CRS 48/700)

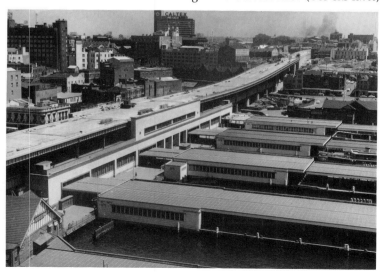

mutable and the goal posts, often numerous, were eminently moveable. Indeed entire teams, several of which might be playing at once, could be sent off without warning, and referees, also numerous, replaced.

Uncertainty flowing from the tottering County of Cumberland Plan continued to hamper the City Council's attempts to bring its plan to completion. Legal advice had confirmed the experience, without proffering remedies, that many difficulties surrounded the preparation of the local planning scheme. Serious doubts, too, had emerged as to the Council's power to zone land. This was all the more disturbing since zoning was the mainspring of the Council's planning document. Recent amendments to the Cumberland scheme had also 'been seized upon by many developers as a means of circumventing Council's wishes regarding the development of the City', in particular a change which allowed development or extensions on property purchased before 27 June 1951.[74]

Turning to the Department of Local Government for guidance, City Engineer Stevenson was to discover that, while 'the Department would view with alarm any wholesale disregard for the County Scheme', it looked to local government to right the scheme's overall defects. Thus, he informed the Town Clerk, it appeared that the County of Cumberland Scheme was

> a draft scheme and just as the Cumberland County Council has seen fit to move County Roads to positions that will be practical from topographical as well as financial considerations it is equally competent and proper for any Local Council to vary zones to meet existing conditions and to procure desirable development . . .[75]

'Desirable development' was not defined. Leaving aside questions as to the dubious basis of the original country scheme, this was flexible planning in the extreme.

Faced with the beginning of a building boom, the City Council sought from March 1958 to finalise its long overdue planning scheme as a matter of urgency. Unable to resolve these various dilemmas, a conference of Council's most senior staff, in seeming desperation, recommended that the planning scheme be submitted to the Department of Local Government in its current form. 'Any doubts,' the conference contended, 'as to the powers of the Council to "zone" land could then be resolved by the Minister'.[76]

A few months prior to the City Council's adoption of a planning scheme for Sydney on 15 December 1958, City Engineer Stevenson presented a final defence for the inclusion of a floor-space index in the Council's draft ordinance. The majority of aldermen, however, were not swayed by his opinions and arguments, despite their advocacy by eminent town planners, among them Professor Denis Winston, Professor Brian Lewis (of Melbourne), Professor Gordon Stephenson (who applied the maximum floor-space index of five in his Perth Planning Scheme) and Sir William Holford.[77] Rather, Council voted to delete the floor-space index from the ordinance.

A few years later the City Council was to adopt a code, though far less demanding than that of the Height of Buildings Advisory Committee, which placed limitations on the floor area and facade width of buildings exceeding the 150 feet height limit. The formulation of the code, however, had been rather eccentric. Known as 'Rankin's rules' (after the City Building Surveyor, John Rankin, who oversaw their creation), the regulations were based on a study undertaken at the Commonwealth Experimental Building Station. As an ex-City Planner recalled with some amusement,

> this study was as scientific as they could do it in those days with an artificial sky and models of buildings. O'Connell Street [in the City] was chosen as a street with suitable light levels and then they modelled tall buildings and short buildings and measured the light levels under this artificial sky. They arrived at the decision that if the buildings were twice the width of the street on each side then O'Connell Street was pretty well matched. If the buildings went taller than

74 TC 1985/47 (Box 1, item 23, 14 March 1958).
75 Ibid.
76 Ibid.
77 Ibid, 15 September 1958.

that the light level would be reduced so therefore there should be some restriction on the width of these tall buildings.

.When they did their measurements, it came out to something like only a quarter of the buildings could be taller than a hundred and fifty feet or you would have some diminution of light levels. Having looked at that figure as being rather restrictive, they then decided after all this research, that that was too much to expect and probably only every second building would be built up anyway, so they said half the width of the street instead of a quarter. That's the way it was written.[78]

John Rankin, City Building Surveyor, pictured here in 1938 (CCS CRS 72/251)

On New Year's Eve 1958, E. W. Adams, the City Council's Town Clerk, submitted his Council's draft planning scheme for approval to J. B. Renshaw, the Minister for Local Government. The Minister's Department, however, did not take formal receipt of the scheme for another eight months after the City Council fulfilled a number of outstanding requirements. More than two years later, Adams was to make formal inquiries as to whether the Minister was yet in a position to furnish any information concerning the City of Sydney Planning Scheme. The Minister was not.[79]

Renshaw, or at least his advisers, may have been dissatisfied with the City Council's planning scheme. But the Minister was also alive to the serious urban problems confronting the City of Sydney. In his opening address to the Fifth Australian Planning Congress, held on 18 August 1958 at Sydney's Hotel Metropole, Renshaw had noted that 'Unplanned development had . . . created a series of most complex problems [in Sydney], the solution to which had to be found'.[80] 'Administration of the Planning Scheme,' he admitted, 'was a difficult job and a doubtful honour'. Further, Australia's record expansion since the war had hampered planners and financial policy had also 'prevented them tackling problems as they should be tackled'. What planners needed to do, however, was 'to take the public into their confidence', to educate the public mind as to all aspects of planning and to involve all sections of the community. But this was passing the buck.

Late in October 1959, Professor Denis Winston, chairman of the Fifth Planning Conference, wrote to his ex-student, George Clarke, who was then working as a city planner with I. M. Pei & Associates in New York. 'My dear George,' he commenced,

Sydney seems to be just getting around to *thinking* of the possibility of urban renewal, so when you get back there should be ample scope for you to demonstrate how it really should be done; which reminds me to hope that you are coming back some day. No, I don't think Sydney is likely to suffer from the U.S. defect of 'projectisis'; I agree that these lead to all sorts of difficulties if not harmonised within an overall scheme: but we have the opposite defect, that is to say good overall planning but no projects — so the planning never really becomes visible to the naked eye and people begin to wonder whether there is any planning or, if there is, what it does and is it worth it.

Congratulations on all your good work in Providence. I am still a bit sceptical about 'citizen participation' in planning because it is very hard for people to be in favour of something that they have never seen and can therefore hardly imagine, but I agree that the public relations side of the business is highly important. But I still think the planner must make the decisions and should be able to do much better than any citizen group could think out for themselves.

Yes, it is true that there seems to be a genuine and growing awareness in Sydney of some of the planning and design problems we have been talking about for so long, and we are just beginning to see the first positive actions following all the talk. The next few years here should be very exciting indeed.[81]

78 John Doran, op cit, *PS*, pp 70-71.
79 1985/47 (Box 1, letters, 31 December 1958; 20 November 1961; 3 January 1962).
80 'TAPIS', 'The Fifth Australian Planning Congress', *The Shire and Municipal Record*, 28 September 1958, p 453.
81 Winston to Clarke, 27 October 1959, from George Clarke, personal correspondence file 1957-1960, Clarke private papers.

5

Generating 'political steam':[1]
Participatory Democracy and
Strategic Planning

1 Edmund N. Bacon, 'Planning as a Viable Democratic Process', paper presented at the Australian Planning Institute Congress 1966, (Sydney, 22 August 1966), p 3 (ML Q309.26/32r).
2 George Clarke, 'Report on Urban Development as seen from the South East Pylon of the Sydney Harbour Bridge', Town Planning 1 Essay, University of Sydney, 8 June 1954, p 32 (George Clarke private papers).
3 The same was true for metropolitan and country planning. See for example J. H. Shaw, 'Selling Town Planning', *Journal of the Australian Planning Institute*, December 1960, pp 23-5.
4 G. Clarke to D. Winston, 18 March 1963 (George Clarke personal papers).
5 See Peter Webber (ed), *The Design of Sydney: Three Decades of Change in the City Centre*, (The Law Book Company, Sydney, 1988), chs 4 and 5.
6 George Clarke interviewed by Paul Ashton, PS, pp 32-3.
7 *SMH*, 5 December 1962. George Clarke, among others, had called for the 'preparation of a three-dimensional comprehensive City plan' in a paper to the 1962 ANZAAS Conference. See W. G. Clarke, 'The organisation of urban renewal', *Architecture in Australia*, December 1962, pp 96-8.

The truth is that people will get that kind of town planning, and as much of it, as they want or deserve. Theories of town planning values must spring from the ruling set of ideas of a ruling social class; it is an examination of the changing motivations and constitution of the ruling social classes that is of value in understanding the urban development of Sydney . . .

If the future is to be tackled with an adherence to 'pure' principles of town planning, then the leading set of ideas held by the community in general must be changed.[2]

Ignited among other factors by Sydney's emergent boom and by political directives and decisions, a burst of promotional activity was evident within Sydney's planning fraternity from the beginning of the 1960s. Sydney practitioners, as with their colleagues elsewhere in Australia and overseas, were out to sell town planning.[3]

Established groups such as the Royal Australian Planning Institute and the Royal Australian Institute of Architects postured and published on Sydney's urban problems. Attempts were also made by some individuals to form lobby groups — for example, an eventually abortive Civic Trust and Master Plan Advisory Committee which sought to agitate and educate for effective, overall planning in the City of Sydney.[4] Specific proposals were put forward for particular areas of the City.[5] For the most part, however, the energies of town planning theorists and promoters were expended on rallying politicians and bureaucrats to the planning cause. The exercise was to prove both difficult and for a time greatly discouraging.

A few Sydney politicians flirted with planning ideas, or at least the props and jargon of planning. Alderman Harry Jensen, Sydney's Lord Mayor between 1957 and 1965 ('headline Harry' to his critics and opponents) was sufficiently impressed by the planner's paraphernalia to invite architect-planner George Clarke to address a Council ALP caucus conference held in a Katoomba guesthouse one weekend in 1962. Though an entirely unsatisfying experience for Clarke,[6] part of Jensen's policy speech for the Lord Mayoral elections was to include a proposal for a 'three-dimensional plan' for the City of Sydney. This plan, he publically claimed, would 'firmly establish the shape of Sydney for the next century'.[7] No details, however, let alone a plan, were

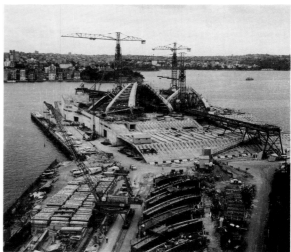

forthcoming.

Reactions to Jensen's announcement were justifiably sceptical. Such a plan, the *Sun* editorialised, would constitute 'a miracle'. Nothing short of some super-natural marvel, it suggested, would be able to overcome the multiple authorities and fragmented planning mechanisms that regretfully had brought about 'the unstable and rather unhappy position that exists as our City approaches its 175th anniversary'.[8]

Jensen's rhetoric also belied party-political and bureaucratic realities in the City Council. Most aldermen, whether Labor or Civic Reform, were uninterested in, if not hostile to, planning. Entrenched bureaucracies also continued as in the past to work against the implementation of broadly conceived planning strategies.

Only a year before Jensen's almost fanciful speech was roundly attacked, internal enquiries had been made as to the need to administratively upgrade the City Council's planning functions. A report from the Engineer's Department earnestly discouraged any such move. The planning branch, then comprising sixteen staff members in all (one of which held the statutorily required planning qualifications) did not, the report concluded, 'qualify for the status of a Department'. Further, planning was narrowly perceived and most planning functions were split between the City Engineer's and the City Building Surveyor's departments.[9] Problems, however, existed with this arrangement. Statutory planning was conducted through the City Building Surveyor's Department, much to the chagrin of the then Chief Planner, Dugald McLaghlan, who worked in the City Engineer's Department. Traffic, zoning and general minutiae preoccupied planning work, and Council staff undertook 'no forward planning whatsoever except for writing a few . . . rules such as height codes'.[10]

Any ideas, serious or otherwise, which Council aldermen may have had about a comprehensive planning scheme remained open to the vagaries of Sydney's political economy. Cavalier treatment of City planning legislation by the State government further emasculated Sydney Council's control over the City's development. On occasions, in particular places, fundamental Council powers were entirely removed to the State arena.

During the early 1960s much public and private attention was focussed on and around Sydney Cove and Circular Quay. Construction of the Sydney Opera House on Bennelong Point was then underway; the Overseas Passenger Terminal was completed in 1961; the Cahill overpasss which cut across the Quay was finished in 1962; and the area already featured a growing number of high-rise buildings, including those constructed for the AMP and MLC insurance companies.

Above left, *Demolitions on the western side of Sydney Cove in about 1960. Sydney's overseas terminus was to be opened on this site in 1961* (CCS CRS 47/1404)

Above, *Sydney's Opera House under construction in 1964. Two years after this photograph was taken, Joern Utzon, the building's architect, resigned after a decade of chaos and controversy over the project. The drama — recorded in Michael Baume's book,* The Sydney Opera House Affair — *in many ways reflected broader planning problems in the City* (CCS CRS 48/3924)

8 *Sun*, 5 December 1962.
9 TC 1595/61.
10 John Doran interviewed by Paul Ashton, *PS*, p 70.

Portrait of a City Engineers Department theodolite, 1960. Used for measuring horizontal and vertical angles, the theodolite was perhaps the City's main 'planning' instrument
(CCS CRS 48/997)

Particular interest was taken in the area fronting Sydney Cove by a number of large corporations with land holdings there. In 1961, the heads of Lend Lease, AMP, British Tobacco and other large organisations formed themselves into the 'Sydney Cove Improvements Committee' and commissioned Professor Denis Winston to assemble a team to prepare a scheme for a precinct fronting the Cove.[11]

Plans were duly drawn up and a model made, as well as a proposal, which was subsequently submitted to the City Council on 5 March 1962. By this time, however, this was merely a courtesy since the Council was no longer in a position to make any legally enforceable determinations about the scheme. Council's powers over the area at Circular Quay bounded by Bridge, George and Macquarie streets had been ministerially suspended late in February to allow the private proposal to be assessed without any chance of Council meddling.

The official reasons for taking control of this precinct were set out by Pat Hills, Labor Minister for Local Government, Engineer and ex-Lord Mayor of Sydney, in May 1962 in a long letter written to Harry Jensen. Hills stressed that the area was

> particularly ripe for redevelopment and it would be tragic to allow development to take place in a haphazard unplanned manner, without regard to the development taking place or about to take place elsewhere around Sydney Cove.
>
> It was having regard to these [and other] considerations . . . that action was taken by me recently [on 23 February 1962] to suspend the provisions of the County of Cumberland Planning Scheme in respect of the land generally in the vicinity of Sydney Cove and to direct that interim development applications be referred to me for decision . . .[12]

The City Council's failure to prepare an adequate planning scheme for Sydney, Hills contended, was the primary reason for his sudden action and he urged the Council to proceed quickly with this desperately needed work. The Minister, however, was also bereft of any overall scheme. Rather, it would appear that his intervention flowed from immediate wishes of private property interests. Chaos, however, prevailed; pressure from other property owners opposed to the plan and pointed hostility from the powerful Department of Government Transport were to sink the Quay proposal.[13]

Ministerial interference with the City Council's powers under the County of Cumberland Planning Scheme did not seem to perturb the Council's Labor majority aldermen. Lord Mayor Jensen, who was to enter State politics a few years later, wholeheartedly agreed with his well-placed State Labor colleague that Sydney's charm and reputation would be 'enhanced by wise and carefully planned development'. In fact, his Council was at that very moment looking into this matter. 'As perhaps you are aware,' he wrote to Hills in May 1962, indicating a less than perfect grasp of planning terminology, 'the Council has under consideration at present, a third-dimensional planning proposal for the City and the establishment of a Citizens' Committee to lend assistance'.[14] These considerations, which were to form the basis of Jensen's Lord Mayoral Speech, which was roundly attacked at the close of the year, would only enhance the City Council's ability to 'cooperate and assist the Government in any way possible'.[15]

While amended from time to time, the City Council's draft planning scheme was to remain largely, as it always had been, a land-zoning document. The few aldermen with an interest in planning, and the political clout to realise their ideas, showed little concern for most of the non-residential parts of the City. Labor constituents, for example, had not been directly affected by the proposed redevelopment at the head of Circular Quay, thus the City Council's silence in terms of any formal protest. Similarly, when the American firm De Leuw, Cather & Company's report on five proposed expressways into and round the City was presented by P. D. Hills, as the Minister for Highways, at a conference in December 1961, few objections were raised by Council aldermen. Leaving aside technical comments from Council officers,

11 John Toon, 'Sydney Cove – a Proposal for Urban Redevelopment', *Australian Planning Institute Journal*, October 1962, p 75.
12 P. D. Hills to H. F. Jensen, 8 May 1962, in TC 3153/62.
13 See Don Gazzard, ' "The Peoples' Promenade": Martin Place 1860-1985', in Webber, op cit, p 80.
14 H. F. Jensen to P. D. Hills, 21 May 1962 in TC 3153/62.
15 Ibid.

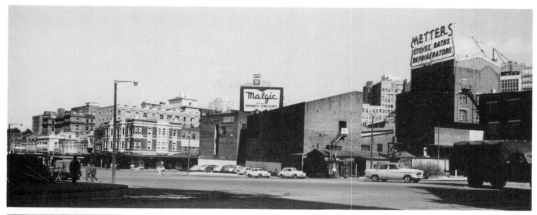

George Street looking down Alfred Street to Pitt Street at the Quay in 1960. Over the next decade, the skyline was to change dramatically (CCS CRS 47/1751)

George Street looking down Alfred Street to Pitt Street, 1992 (Paul Ashton)

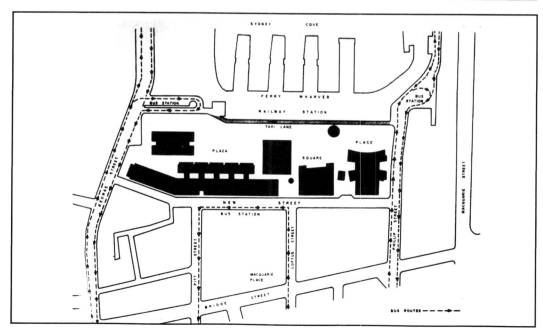

A plan for the area behind Circular Quay prepared between 1961 and 1962 for the private Sydney Cove Improvements Committee (Australian Planning Institute Journal, 1962)

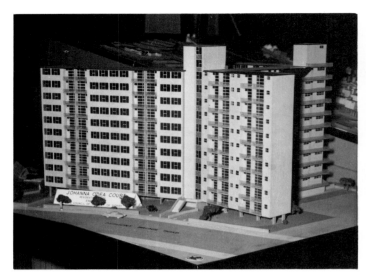

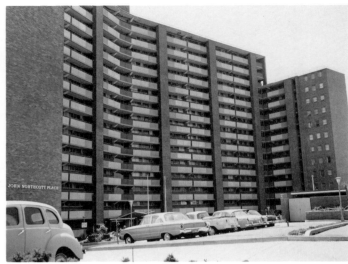

Above, A City Council model for the Johanna O'Dea Court, Camperdown, housing project around 1960
(CCS CRS 48/1892)

One end result of the 'slum clearance' programs underway after World War II — the John Northcott Place Housing Commission flats. This complex, incorporating 428 flats, was opened in 1961
(ML GPO 2 25638)

aldermanic concerns were centred on encroachments on inner-city residential areas.[16]

Whether motivated by a deep sense of social justice or the ballot box, or both, the maintenance of traditional inner-city, working-class populations and the provision of 'modern', low-income housing preoccupied the thoughts and activities of a number of Labor aldermen. Alderman Reginald Murphy for one was keenly interested in slum clearances. Indeed, he wanted to see eradicated an estimated five hundred acres of slums, made up primarily of terrace and semi-detached houses in the inner-city areas of Woolloomooloo, Paddington, Surry Hills, Waterloo, Newtown, Erskineville and Pyrmont. In the process, people were not to be replaced by commerce or light industry. Already by 1960 major flat projects had been completed by the City Council in Camperdown (the Johanna O'Dea Flats) and Glebe (the John Byrne Flats). Murphy now wanted his Council to 'pursue a more practical and aggressive policy in connection with the slum clearances and re-building of its own City'. In co-operation with building societies, the City Council, he hoped, would surge forth and provide 'decent' housing for a further 200,000 people.[17]

Large-scale housing projects were not to prove feasible for the City Council; they required the acquisition of expensive inner-city land. Further, the federal government had opted to support State governments in the provision of public housing. Though the Council did acquire a substantial number of multiple-dwelling buildings over the next decade or so, this represented only a small proportion of public housing. In total, however, public housing projects in the City of Sydney did not reverse the twentieth-century trend of inner-city population decline.[18]

Other matters loomed larger in the City's planning. Signalling an end to the drawn-out demise of the Cumberland County Council, the 1962 Local Government (Town and Country Planning) Amendment Act transferred many of the County Council's powers to local government.[19] During the following year, a Bill was introduced into Parliament by Local Government Minister, Pat Hills, to establish a State Planning Authority. Chaired by Nigel Ashton, former Chief Town Planner of the Department of Local Government, the Authority was formally appointed on 2 March 1964. Three months later it took over all the remaining powers and responsibilities (as well as many of the problems) of the by then defunct Cumberland County Council. Partly alluding to the difficulties faced in the past by public service planners, the Authority's deputy chairman, Ronald Thomson, hoped that its temporary premises, previously a ballroom, would not turn again into 'a place for side-stepping and going around in circles with one's head in the clouds'.[20]

16 TC 1652/60; 1985/47, Box 5.
17 Reginald Murphy, 'Slum Clearance: A Plan for Re-building in Sydney', *The Shire and Municipal Record*, 28 December 1960, p 734.
18 See Fitzgerald, *Sydney 1842–1992*, op cit, pp 230-32.
19 For details, see Wilcox, op cit, and J. G. Starke, *Starke's Town and Country Planning in New South Wales*, (Butterworths Conveyancing Service, Sydney, 1966).
20 Quoted in F. A. Larcombe, *The Advancement of Local Government in New South Wales 1906 to the Present*, (SUP, Sydney, 1978), p 340.

Central to the work of the new State Planning Authority was the assessment of local government planning schemes, the procedure for which remained unchanged. Due, perhaps, to being generally resented by local government,[21] the authority was to receive few schemes for examination during the 1960s. Extraordinary circumstances, however, were to surround the City Council's draft scheme which had been passed to the Authority for comment in mid October 1964.[22]

Having been lodged with the Department of Local Government for six years, Sydney's draft planning scheme was to be unexpectedly approved at the end of 1964. At 2.00 p.m. on 30 December 1964 a letter was delivered by hand from the State Planning Authority to Sydney's Town Clerk, Jack Luscombe, advising the City Council that the Minister had decided to proceed with its draft scheme given 'certain alterations' which, in substance, entailed major amendments.[23] The scheme was to be placed on public exhibition the following day and objections were to be received until 3 May 1965.

As was the case with much to do with planning in the City, the timing of these decisions was tied to political considerations. With a convincing Liberal-Country Party victory at the federal level fresh in his memory and a cocky State opposition intimating at every opportunity its intention to remove the City Council if elected to office, Labor Minister Hills had moved to finalise a plan for the City before the State government elections in May of the following year. His premonition, too, about electoral uncertainty proved correct. State Labor lost office in 1965. Within weeks of the Council's statutory planning scheme's gazettal, over 1100 objections and inquiries — a number of which came from several government departments and authorities — had flooded into the Sydney Town Hall.[24] No individual or organisation, however, protested louder or longer about the gazetted scheme than the City Council, or at least a sizeable portion of its aldermen. Though a steadfast Labor man, Lord Mayor Harry Jensen was doubly incensed by the entire proceedings. Not only had the Government's new creature, the State Planning Authority, poached Council prerogatives and powers as a result of changes to the scheme, some residential parts of the City had been adversely affected by the scheme proposed by the Minister.

At a long and special meeting of the City Council's General Purposes Committee in March 1965, consideration was given to the objections which the Council would raise regarding Ministerial alterations to the City's draft scheme. Concern, however, was almost exclusively focussed on the impact of expressways (proposed by DeLeuw, Cather and Co), street widenings and zoning alterations to the Council's scheme on resident populations. Adopting a conciliatory tone, the minister, it was agreed, should be urged to give his 'earnest consideration' to avoiding where practicable the loss of homes or, alternatively, providing for new, affordable housing in affected areas so that resident populations would be maintained.[25]

Individual Labor aldermen, too, came forward — and rightly so, from their

21 Ibid.
22 TC 1985/47, Box 2 (atts).
23 TC 1985/47, Box 1; John Doran interviewed by Paul Ashton, PS, p 72.
24 TC 1985/47, Box 1.
25 TC 1985/47, Box 5.

Below left, *A model, photographed in 1962, of the City Council's proposed Goulburn Street parking station. This unsightly facility was opened in the mid 1960s*
(CCS CRS 48/2778)

Below, *Queen Square, with Macquarie Street in the background, in 1960. The tram lines and associated overhead wires would soon be removed. The structure behind the light coloured building is the Barracks. It was built in 1817 during Macquarie's governorship. Though questions about the Barracks' demolition were raised from time to time, this was one of the lucky twenty-eight buildings which were placed on the Cumberland County Council's Register of Historic Buildings in 1963*
(CCS CRS 47/1945)

constituent's point of view — to defend their particular wards from partial or total devastation. Alderman Gil Roper of Phillip Ward was strenuous in his attempts to spare elevated portions of Surry Hills from being zoned for industrial purposes. These areas, he asserted, enjoyed 'natural ventilation and salubrious climate' which rendered them 'highly suitable for retention as residential areas'. Representing the residents of Ultimo and Pyrmont, Alderman Sid Fegan objected to the 'Minister's Plan' which condemned the already scarred and abused peninsula to extensive industrialisation.[26] It was indicative, however, of the general attitude towards planning in the City Council that, apart from legalistic questions, it became a matter of urgency 'that the various aspects of the City of Sydney Planning Scheme as altered by the Minister for Local Government be considered by the Ward Alderman on a Ward basis'.[27]

For a time, political machinations in Macquarie Street were to deflect civic attention from the City Council's hijacked planning scheme. Immediately after its electoral victory in May 1965, the Askin Liberal-Country Party State government appointed a Boundaries Commission to investigate the City's wards with a view to having them substantially reformed. It was the government's intention to use boundary readjustments to dislodge the long entrenched Labor majority Council. But to the government's great disappointment, the Commission, which was appointed as a Royal Commission, found the City's limits and electoral divisions to be adequate and thus recommended their retention.[28]

Rejecting the Commission's deliberations and findings, the Askin Government *directed* the Boundaries Commission to choose new limits for a smaller City of Sydney. This task was duly carried out and the Commission tabled its report in Parliament on 30 March 1966. Though attacked by Labor politicians for, among other evils, breeching 'every tenet of modern town planning' the report was received.[29] One political commentator, noting what any astute onlooker would have been well aware of, forecast that such a 'drastic cut' in the City's size would mean that Labor 'would almost certainly lose its long-standing control' of the City Council.[30]

Cynical observers of City planning and politics undoubtedly would have been having a field day. That the State government restricted the Royal Commission's terms of reference to secure, in effect, a gerrymander in the City was one thing. But the City Council, too, was to be upbraided for deficiencies, stemming from political considerations, in its approach to town planning in Sydney.

Only days before the Boundaries Commission submitted its report, a public inquiry into objections to the City of Sydney Planning Scheme — that is, the 'Minister's Plan' — commenced in the Sydney Town Hall. Conducted by A. I. Davis, then the State Planning Authority's solicitor, on behalf of the Department of Local Government, the inquiry ran for just over ten weeks. Its long duration was largely attributed to the fact that, with a few minor exceptions, neither the Council nor any other body had surveyed the scheme area for land use since 1952.[31]

In his report on the inquiry, Commissioner Davis pointedly remarked that, of the Council's 109 objections, few were 'based on technical considerations', which Davis erroneously believed were value-free. Indeed, the Commissioner noted that most criticisms 'emanated from the Council itself or, in some cases, from the Ward Aldermen'. Particularly damning, however, was Davis' summation of the City Council's principal 'planning' thrust.

During his numerous site inspections, necessitated by outdated land-use surveys, Davis had seen many instances of residential redevelopments going ahead on what he considered to be substandard allotments. Newtown, Erskineville, Redfern and Woolloomooloo, all working-class areas, seemed to the Commissioner to be the main localities where these and other developments not 'in accordance with modern town planning principles' were flourishing. Worse still, the City Council was engaging in unco-ordinated development activities, a situation which he felt duty-bound to

26 Ibid (both letters dated 15 March 1965 to Town Clerk).
27 Ibid (Town Clerk memo, 1 April 1965).
28 Larcombe, op cit, p 139.
29 *SMH*, 1 April 1966.
30 *SMH*, 31 March 1966.
31 J. Davis, 'City of Sydney Planning Scheme: Report of Inquiry into Objections', 20 January 1967, in TC 1985/47, Box 2, p 3. Davis was later to become the Assistant Director of the EPA.

expose. Davis informed the new Minister for Local Government:

> One can only assume that the Council is deliberately embarking upon re-development projects, in areas where they fear zonings other than residential, and that the projects are carried out as a means of forcing the issue. For example . . . the Council proposes to build flats on land owned by Hardie Rubber Co. Ltd, in Paddington, which is within an Industrial Zone but in respect of which the Council seeks a re-zoning to residential. It has also recently erected a small block of flats in Woolloomooloo despite uncertainty as to the future of the area.
>
> I have also been informed that the Council has encouraged private developers to build flats in areas where the future zoning could easily be industrial.[32]

Despite one vitriolic attack by a representative of private interests on Davis' credibility as a Commissioner (he was an officer of the State Planning Authority), most in attendance found him to be 'impartial'. At any rate, that was the opinion of Dugald McLaghlan, the City Council's Principal Planning Officer. Nonetheless, Davis did bring to the inquiry a particular set of values. Though keen to uphold the 'principles of town planning', which were never articulated, clearly he felt a need to recognise 'existing conditions, financial implications and individual hardships' as major considerations in planning decisions. (These interests, by and large, were those of the constitutents and supporters of political parties other than Labor.) Davis also attached a stigma to certain areas and buildings. For example, he could see no reason to alter a special commercial zoning applied to half of Ultimo and Pyrmont since, in his opinion, there were 'no residences in the whole of the area worth keeping'.[33]

Nonetheless, Davis listened attentively to the various submissions. He heard the middle-class Paddington Society's objections to a major thoroughfare being driven through their area and the monstrous losses, historically and architecturally, which redevelopment would entail. Similar arguments were made by a representative of the 'Save Woolloomooloo Campaign Committee' regarding the working-class 'Loo being rezoned as a 'comprehensive redevelopment area', though Davis disallowed the zoning category, imposed by the Minister, since it was not recognised under the Local Government Act. Special note was taken of submissions from the Australian Planning Institute (Sydney Division) and the Royal Australian Institute of Architects, Davis concurring with their arguments as to an optimum floor-space index and height of buildings provisions. (The floor-space index, it was thought, should be five-to-one or six-to-one in the City centre with bonus provisions allowing a maximum of ten-to-one or twelve-to-one.) Even political parties were allowed a voice. The Civic Reform Association asked the Commissioner whether the entire scheme could be deferred and a fresh one prepared by 'some technical authority' (an authority, one presumes, without links to the New South Wales branch of the Australian Labor Party).

Of the City Council's 109 objections, Commissioner Davis allowed fifty-four. Private objectors fared slightly better with 648 submissions recommended in full and 91 in part out of a total of 1111. After initial stormy reactions, however, private interests now appeared relaxed about Sydney's draft planning scheme. Demonstrating either a great use of understatement, or political naivety, Davis found it 'surprising that comparatively few of the private objectors appeared in support of their objections although each and every . . . [one] was informed in writing of his right to appear'.[34] Perhaps their sense of urgency had been soothed by the recent election of the Askin State Government and its commissioned City boundaries report which clearly indicated that the days of a Labor-dominated City Council, with its commitment to maintaining residential areas, once again were numbered.

Professional planners outside State and local authorities viewed with alarm the rude and rudderless acceleration of Sydney's growth. Planners had failed to capture the popular imagination or significantly influence the relevant political decision-making processes. In a paper presented to the Thirty-Second Summer School of the

32 Ibid, p 31.
33 Ibid, p 8.
34 Ibid, p 2.

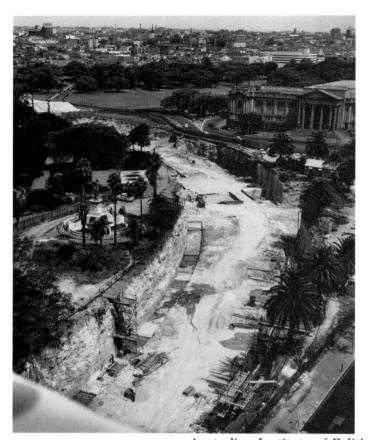

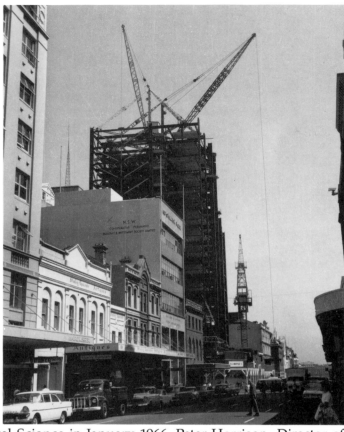

Above, The Eastern distributor, photographed here on 28 January 1960, cut a swath through Sydney's Domain, separating it from the Botanic Gardens. The resultant hole was eventually covered over though it was originally intended to leave the cutting open (CCS CRS 48/1018)

Right, The Metropolitan Water, Sewerage and Drainage Board's Bathurst Street offices under construction in about 1964 (CCS CRS 48/3946)

35 Peter Harrison, 'City Planning in Australia: What Went Wrong?', in Denis Winston et al, *Australian Cities: Chaos or Planned Growth?*, (Angus & Robertson, Sydney, 1966), pp 60-87.
36 Planning Research Centre, *Urban Redevelopment in Inner City Areas*, (James Bennett, Collaroy, 1966), pp 39, 40.

Australian Institute of Political Science in January 1966, Peter Harrison, Director of Town Planning with the National Capital Development Commission, conducted a 'post-mortem' on City planning in Australia.[35] Despite a 'hopeful period' in the wake of World War II which saw 'a good deal of intelligent optimism about reconstruction', particularly in Sydney, planning had executed little influence over post-war expansion or urban problems in general. Private, speculative investment continued apace, serviced, as it traditionally was, by public authorities.

In Harrison's opinion, planning was in dire need of renewed promotion. Public relations would have to be developed and the 'question of community participation' seriously explored. There was general agreement on this strategy. In another contemporary and well-attended forum provided by the newly established (1964) Planning Research Centre at the University of Sydney, a similar view was endorsed. The scarcity of planned redevelopment in centres such as Sydney would only be redressed if the numbers were right. Denis Winston summed up the forum's feeling on this point: 'In our democratic society', he claimed, 'there has to be a fairly clear consensus of opinion before ideas can be turned into political acts'. Grassroots participation, however, was far from the professor's mind. What planning required were 'missionaries — industrialists, financiers and economists — who will spread the realisation of the importance of the City in the national economy' to influential people, preferably politicians.[36]

Political support for town planning in Sydney was to be forthcoming from what could well have been considered an unlikely source. In the mid 1960s regulatory mechanisms controlling growth in the City remained crude. Planning was negative, in that it forbade certain development rather than encouraging excellence in form and design, and permissive, in as much as statutory planning at the local level of government was optional in practise. City Council planning staff continued to focus almost exclusively on the processing of individual building and development

applications. Poor regulation of growth in a period of largely sustained boom led to talk of an urban crisis in the City.

Out of power since 1948, the City's Civic Reform Association — which had an affinity, if not a direct affiliation with the political Liberal Party — looked forward to the Askin Government's implementation of its official policy and objective (since 21 September 1965) to 'reform' the City Council. As a political party, Civic Reform had no philosophical or other commitment to planning: its primary constituency was the City's financial, manufacturing and retailing interests. Two of the Association's newest members, however, were to persuade the Civic Reform Executive to adopt planning and urban renewal as part of its platform. They were Engineer Leo Port and Architect Andrew Briger.[37]

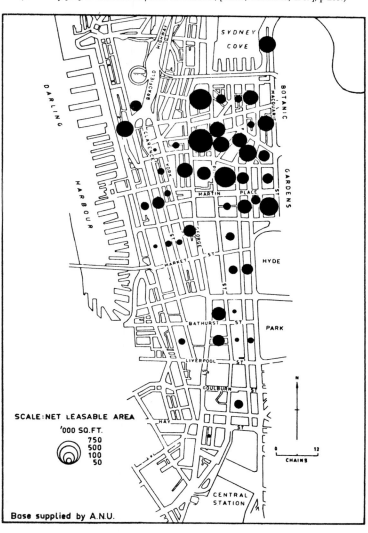

Office space completed in Sydney, 1954–1967, by Street Block
(P. N. Troy [ed], *Urban Redevelopment in Australia*, [RSSS, Canberra, 1967], p 263.)

During 1966, Port and Briger, partly through their training and persistence, succeeded in having Civic Reform commission architect and town planner, James Colman, produce a document regarding the preparation of a plan for Sydney.

Colman's lengthy report was submitted to the Association's executive in April 1967. Outlining the general 'civic delinquency' which had brought Sydney to the 'greatest crisis in its history', Colman emphasised the need to look beyond the City boundaries and to possible federal involvement in Sydney's problems. But for the most part, he concentrated on the ways in which a City Council, controlled by Civic Reform, might be restructured to implement a new scheme for Sydney. Essential to a successful planning scheme, Colman further insisted, would be a parallel public relations program. High-quality graphics would also be required to lend 'the stamp of authority' to promotional material.[38]

Civic Reform was sufficiently impressed with Colman's report to establish a Planning Committee in 1967 with Port as Chairman and Briger as Vice-Chairman. Much political capital, Colman had stressed, could be made out of conscientious planning which was, in essence, he thought, altruistic and apolitical; it was pure. Indeed, Colman had undertaken the study, and for small remuneration, given a 'primary concern . . . with City planning, not City politics'. With this in mind, he advised the Association that it 'should "play up" the planning, but "play down" the politics', lest Civic Reform alienate the many individuals and groups deeply interested in this vital urban process. Though other consultants were to later advise the Association, Port and Briger began a tentative campaign for City planning based on Colman's report. Civic Reform left the running to its planning exponents, backing them, at least, while the boom lasted.

Neither the growing agitation for comprehensive planning nor open attacks on the still unapproved Sydney planning scheme had any visible impact on the Labor City Council.[39] Developers, too, seemed generally content with planning arrangements in Sydney. The City Council had not placed any obstacles in the way of

37 For a personal account, see Andrew Briger, 'The Politics of Planning: The 1971 City of Sydney Strategic Plan', in Peter Webber, op cit, pp 40ff.
38 James Colman, 'A Plan for Sydney: A New Approach to Planning the Metropolis', (Sydney, April 1967); see also Summary.
39 Council was severely criticised in the editorial of the *Australian Planning Institute Journal*, July 1967, pp 55-6.

redevelopment in the central business district, as evinced in the staggering growth over the half-dozen years which had transformed the City's skyline. Nor did it appear likely that the Council would hamper future expansion (providing that it did not upset or displace resident voters). Reassurance in this regard was to be found in the Council's evidence to the Royal Commission of Inquiry into Rating, Valuation and Local Government Finance. Answering the Commission's question as to what constituted full development in the City, F. D. O'Grady, the City Council's Assessment Officer, replied

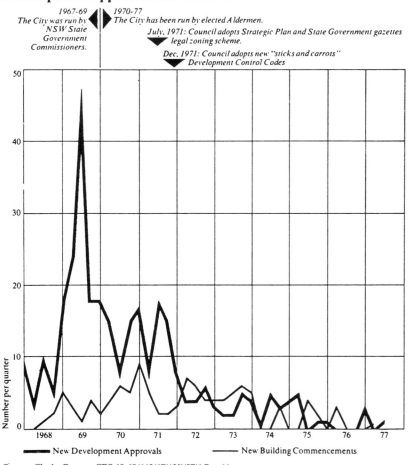

New buildings in the Central Business District 1968-77: Development Approvals and Commencements.

1967-69
The City was run by
NSW State
Government
Commissioners.

1970-77
The City has been run by elected Aldermen.

July, 1971: Council adopts Strategic Plan and State Government gazettes legal zoning scheme.

Dec. 1971: Council adopts new "sticks and carrots" Development Control Codes

Number per quarter

■ New Development Approvals ▬ New Building Commencements

George Clarke Papers, CRS 69-69/113/174/ V4/27/1 Box 11.

that at no point of time can the City be said to be at its maximum development, so that I think the only way we can define 'full development' is to say that whatever is regarded as the maximum at the present time is full development, but tomorrow it might be different.[40]

Planning matters, however, were to be taken entirely out of the City Council's hands. On 13 September 1967, the Askin Government's Local Government (City of Sydney) Boundaries Bill was introduced into Parliament by Pat Morton, Minister for Local Government and Highways ('Morton the Mortician' to the Labor Opposition); it passed into law in November of that year.[41] The Council was removed from office; three Commissioners — Vernon Treatt (former Liberal Party Leader), William Pettingell (businessman) and John Shaw (an ex-Commissioner for Main Roads) — were installed; the City's area was reduced from 11 to 5.2 square miles; its residential population fell from 171,000 to 68,500; and the new municipality of South Sydney was created.

For the twenty-two-month life of the Commission, Sydney's 'planning' entered fully into the realms of absurdity. Meetings of the City Planning and Improvement Committee, now attended by the State-appointed Commissioners, were conducted in record times over the next two years: an average meeting ran between two to three minutes.[42]

Development applications of greatly varying quality poured into the City Council during the third reign of commissioners. Sydney's draft planning scheme contained a basic floor-space ratio for the City centre of ten-to-one, with a maximum of twelve-to-one. Following Commissioner Davis's recommendations, the State Planning Authority was to suggest in 1968 to the Minister for Local Government that the minimum ratio be lowered. News of the possible reduction struck panic into the development industry: the Commissioners were rushed with development applications which were all passed, although applications did not necessarily imply actual projects. Property owners aimed mainly to maximise on paper their ability to exploit City land given more generous draft interim planning allowances. Discussion in the press in March 1969 about reducing the floor-space ratio led to a further deluge of applications, as well as a barrage of criticism from groups such as the Building Owners and Managers Association, which did not want

40 *Royal Commission into Rating, Valuation, and Local Government Finance,* (Government Printer, Sydney, May 1967), para 11277.
41 *VPLA,* Vol 68, pp 1140-157 ff; Vol 69, pp 1651-652; 2392.
42 CRS 15 15/8-15/9, Box 3.

'All this is public park, Madam. You can recognize it from the bench.'

(Courtesy of George Molnar, *Sydney Morning Herald*, 30 August 1966)

Excavations for Australia Square. Opened in 1968, this skyscraper was to be Sydney's tallest building for more than a decade (CCS CRS 48/4041)

The [third set of] Commissioners who were three in number were appointed in 1967. Vernon Treatt was the Chief Commissioner. He was an ex-politician. Bill Pettingell was another Commissioner who was at that time General Manager of the Australian Gas Light Company and a very well-known and respected businessman. The third member of the team, who was virtually given the sole right to all planning and building matters, was John Shaw who was an ex-commissioner of Main Roads. He was what would be called in the old days a martinet . . . he had virtually sole control over all planning matters — all development application matters — because the other two left him to it. He was the Planning Committee because there was only one of him. And whatever he recommended, the others seemed to go along with. I didn't hear any arguments in Council meetings. If you got there after the bell stopped reverberating you missed the meeting, because that's about how long it took. They'd ring the bell, say the prayer, adopt a paper and close the meeting and walk out. Anything over thirty seconds was a long meeting.

John Shaw had personal hates about buildings. He didn't like black buildings. So people quickly learnt to put in light-coloured buildings. That was the sort of measure of the planning expertise that was around at that time. It was mostly personal ideas.

John Doran in *PS*, p 80

additional restrictions on their members' ability to build. On this occasion, the Commission received and approved development applications for a total of thirteen million square feet (1.214 million square metres) of gross office accommodation. These were subsequently passed on to the Height of Buildings Advisory Committee, which also had to plough through the mass of paperwork.[43] Consents issued by the Commissioners were to conflict with new codes adopted by the City Council in the early 1970s and contribute to a later, massive oversupply of office space in Sydney.[44]

Other 'planning decisions' made during the interregnum were to have long-lasting legal consequences. A scheme for Woolloomooloo, undertaken from 1968 by the State Planning Authority on behalf of the City Commissioners, was eventually to land both the Authority's heirs and the City Council in Court. Legal proceedings were to drag on until the 1990s. By then, the origin and meanings of this urban debacle had been buried by the passage of time.[45]

While the Commissioners remained in control of the City, the Civic Reform Association's new planning committee set about laying the foundations for its fresh strategy. Just prior to the sacking of the City Council in 1967, Civic Reform had sponsored a planning exhibition in the Kings Cross area — 'Kings X Tomorrow-Today' — which attracted considerable, positive public attention. George Clarke, then a principal of Clarke, Gazzard and Partners, a successful and ambitious firm of architects and planners, had been particularly taken with the response to the display.

In a letter to Andrew Briger, Clarke congratulated the new-look committee on their praiseworthy and 'effective outreach for citizen participation in the planning process', an essential ingredient, he noted, in modern City planning. After numerous approaches to Lord Mayor Jensen, Clarke had given up on the Council, convinced that 'nothing useful would be done for as long as the Sydney Town Hall remained under the control of Tammany Hall and the local decadent leagues of the ALP'. But while the Council was still controlled by the City Commissioners, it was clear that things were to change, given Premier Askin's manoeuvres to replace the ALP with Civic Reform and its leagues. In order to 'further develop . . . [Briger's] already outstanding leadership', Clarke forwarded to him a sizeable collection of literature on the 'twin concepts' of comprehensive planning and popular participation. Clarke, Gazzard and Partners already had implemented a scheme for the Hobart City Council which Clarke claimed had transformed town planning into its 'greatest political asset'. He hoped that his firm might sooner rather than later be able to work with Civic Reform towards a comprehensive plan for the City of Sydney.[46]

Andrew Briger did not reply to Clarke's lengthy correspondence until mid March of the following year. Briger then confided in Clarke, telling him that 'up to date the activities of the [Civic Reform Planning] Committee have been somewhat confined'. A little uncertainty surrounding the 1968 State Government elections had prompted a wait-and-see approach. But the waiting was over. Briger confidently told Clarke, 'Now with the [Liberal] Government confirmed in Office this will ensure the implementation of the legislation relating to the City boundaries which leaves the path clear for action on our part'.[47] Clarke's correspondence and ideas were to be put to the Civic Reform Planning Committee, which found his political acumen especially appealing. Clarke also had his own agenda: he was out to change 'the leading set of ideas'.[48]

Shortly after the Council election in September 1969, which featured planning as a major issue and new, State-imposed wards,[49] George Clarke wrote again to Andrew Briger, this time beaming over Civic Reform's recent victory at the polls. Enclosed with his congratulatory letter was a copy of a scheme his practice had recently completed for the Queensland Gold Coast. Drawing on innovative overseas planning methods and impressive nomenclature, it was a 'strategic plan'. Clarke earnestly recommended that Civic Reform move quickly to prepare a strategic plan for the City of Sydney, beset as it was with 'terrible problems raised by the conventional approaches

43 CRS 62 (George Clarke Papers). See also M. T. Daly, *Sydney Boom, Sydney Bust*, (George Allen & Unwin, Sydney 1982, ch 2.
44 CCS, *The Sydney City Council's Strategic Plan: Objectives and Action 1977–80*, Annexures, (The Council, Sydney, 1979), p A9.
45 This case is discussed in ch 6.
46 G. Clarke to A. Briger, 17 October 1967, Clarke Personal Papers.
47 A. Briger to G. Clarke, 15 March 1968, Clarke Personal Papers.
48 See note 2.
49 Briger, op cit, p 48.

of statutory planning'.[50] Perhaps more importantly, if planning was going to have any significant, long-term environmental impact, which was predicated on scoring political points, a plan would have to be commissioned, designed, approved, initially implemented and tentatively assessed within the triennial period of office. There was little fear that the so-called 'local decadent leagues of the ALP' would regain power without the boon of a favourable change to City boundaries. Rather, planning as a plank in civic political platforms had yet to be nailed down.

Over the following month, Clarke prepared a report on a strategic plan for Sydney. Briger was to present this to the Sydney Council's City Development Committee (a revamp of the City Planning and Improvement Committee) on the first day of December 1969. Statutory planning schemes, the report explained, were nothing more than an assemblage of broad and simple land-use regulations which legally attempted to prevent the worst sort of development being undertaken. Strategic plans were far more complex mechanisms: they were policy documents that expressed 'the highest objectives which can be attained for an area, and described the plans, performance standards and programs which must be implemented to attain those objectives'.[51]

In Sydney's case, both a statutory scheme and a strategic plan would be operative, given the City Council's approval of the latter. While illustrating desired land-use patterns and defining programs of work, the detail for which would be developed in separate action plans, the strategic plan would provide the means to assess whether development applications under the statutory scheme were compatible with long-term objectives and the City's overall fabric.

Again public participation was stressed as being essential to the success of such a plan, though in the end the nature of this participation was to be limited. Instead, participation was aimed at securing the support of decision makers and power brokers. Due to the many limitations on the City Council's powers and its complete lack of control over some vital civic matters, the report on Sydney's strategic plan concluded that the Council urgently needed to seek 'the respect of statutory bodies and Government departments'.

On 15 December 1969, the City Council formally resolved to commission a 'strategic master plan' for Sydney. George Clarke subsequently prepared a consultant's brief at the request of Aldermen Andrew Briger and Leo Port and a month later the appointment was internationally advertised.[52] 'Meanwhile', Clarke remembers, his firm 'obtained an indication from . . . Port and Briger . . . as to how much money the Civic Reform Aldermen thought might be worth investing on this strange new idea.'[53] This knowledge, combined with what was undeniably a sound submission, secured Urban Systems Corporation Pty Ltd and associated companies, under the direction of Clarke, the commission. A contract to prepare a strategic plan for Sydney in no more than thirty-six weeks was signed on 10 August 1970.

Announced on 20 July 1971 and published the following day, Sydney's Strategic Plan had the immediate impact of finally spurring the Minister for Local Government

50 Clarke to Briger, 9 October 1969, Clarke Personal Papers.
51 CRS 15/10, Box 3.
52 See *SMH*, 13 January 1970.
53 George Clarke interviewed by Paul Ashton, *PS*, pp 39-40.

To a considerable degree, Sir John Sulman and the Royal Commission of 1908 created and defined the subject matter of urban planning for Sydney. When I later came to look for my predecessors I found them in Sir John Sulman and the 1908 Royal Commission. Previous to that the only people I remember finding were Lachlan Macquarie and Francis Greenway, Colonel William Light, Sir Thomas Mitchell, Walter Burley Griffin and a few other surveyors and architects, and a few of the 'post-war reconstruction' public servants, like Grenfell Rudduck and David Wilmoth's father. So I've always said that my Strategic Plan of 1971 (updated by me in 1974 and 1977 and by others in 1980 and 1983), was the third strategic plan for the City of Sydney. Macquarie and Greenway had done the first before 1815; Sulman and the 1908 Royal Commission had done the second; and I, through the agency of Port and Briger and Civic Reform, had done the third. I think that's entirely legitimate and realistic. But that's for history to judge.

George Clarke in *PS*, pp 21-2

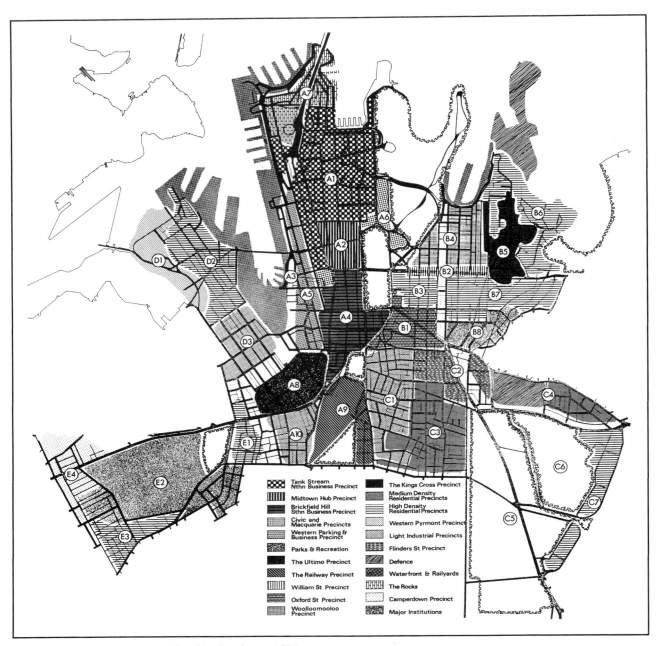

▦	Tank Stream Nthn Business Precinct	■	The Kings Cross Precinct
▥	Midtown Hub Precinct	▨	Medium Density Residential Precincts
▤	Brickfield Hill Sthn Business Precinct	▨	High Density Residential Precincts
▦	Civic and Macquarie Precincts	▦	Western Pyrmont Precinct
▨	Western Parking & Business Precinct	▨	Light Industrial Precincts
▨	Parks & Recreation	▦	Flinders St Precinct
■	The Ultimo Precinct	▨	Defence
▨	The Railway Precinct	▨	Waterfront & Railyards
▥	William St Precinct	▦	The Rocks
▤	Oxford St Precinct	▨	Camperdown Precinct
▦	Woolloomooloo Precinct	▨	Major Institutions

The City Precincts, 1971 (CCS, *Strategic Plan*, the Council, Sydney, 1971)

[From 1967 to 1969 the commissioners had presided over total laissez faire, the policy favoured by Askin and seemingly also by Morton.]

I remember one day mentioning to Mr Pat Morton, the then Minister for Local Government and for Planning, how enormously difficult his job must have been because of all the small, individual cases, Interim Development Orders and statutory planning scheme ordinances which he had to decide and sign, because so many particular detailed matters were under the discretion and control of the Minister. I said to him that I often wondered how he coped and that there must be enormous stacks of paper piling up on his desk because, under the then planning system of New South Wales, any little matter — even a back fence — could depend upon the decision of the Minister. He looked at me and he smiled and opened his palms out wide and said: 'Oh!', he said, 'I love it. I love being able to do favours for people. I love being able to help people.' And it suddenly struck me that, within the limited comprehension of an ordinary man who could be made Minister, the thrill that he could actually personally decide this matter — whether it be the matter of the height of a fence somewhere that had to be referred to the Minister or whether it was a major matter such as getting rid of the Labor voters in Woolloomooloo by adopting some fancy piece of planning stuff cooked up by the state bureaucrats — obviously it was a heady prospect for a normally simple man.

George Clarke in *PS*, p 46

to gazette the statutory City of Sydney Planning Scheme.[54] The Strategic Plan consisted of sixteen major policies: on administration, city structure incentives and contributions, finance, public transport, roads, parking, pedestrians, residential life, retailing and tourism, community services, leisure and learning, preservation, urban design, open space, and pollution control. These entailed a plethora of formidable, long-term objectives. But few of these were to be achieved: while the statutory plan, controlled by the Minister, had legal weight (though no detailed objectives or instruments) the strategic plan's efficacy was dependent on the political goodwill of the State government. Initial goals and much activity, however, generated enormous hope and enthusiasm.

Adopted promptly by the City Council, the Strategic Plan set up a hierarchy of priorities with related work schedules. A public relations campaign, launched with the plan's announcement, was to be vigorously pursued. Planning functions in the Council also had to be up-graded and a Planning Department created. These and other initiatives were aimed at facilitating another high priority, that of giving the Council the perceived ability to exercise effectively City government functions and to assert afresh its right to do so.[55]

Another set of priorities sought to approach the City as five distinct districts, with thirty-two precincts and other sub-areas, for the management of development and urban renewal programs on various scales. Action plans were to be prepared and implemented for each City precinct. Pilot projects at prominent spots such as Martin Place, Fitzroy Gardens in Kings Cross (part of Alderman Briger's Ward) and William Street would simultaneously contribute to the public relations campaign. Looking forward, the Strategic Plan aimed significantly to concentrate the highest density of commercial life in Sydney's central spine or 'core'. This was a term developed by American planners Horwood and Boyce in 1958 for the metropolitan zenith of activity characterised by 'people, paperwork and parcels', with highly developed internal linkages and a limited horizontal scale.[56] The idea was to encourage the redevelopment of 'a strong, concentrated linear core, so as to maximise the benefits from existing and future investment in public services and facilities, and to create a relatively compact, rather than a scattered, central business district'.[57]

Control of the dimensions of redevelopment in the City was intended to be achieved through a new floor-space ratio code which was suggested in the Strategic Plan. Reference to such a ratio had been made in the statutory planning scheme, leaving the Height of Buildings Advisory Committee, which continued to advise the Minister, and, theoretically, the City Council with responsibility for determining acceptable development in this regard. A proposed floor-space ratio was announced by the City Council at the unveiling of its Strategic Plan: it varied ratios from precinct to precinct, allowing a minimum of two-to-one and a maximum, in the Tank Stream precinct, of fourteen-to-one after all bonuses (including ones for public space, theatres and child-minding facilities) were taken into account. Adopted by the Sydney Council on 6 December 1971, this floor-space ratio lowered the basic index for the City from ten-to-one to six-to-one. Appeals, however, could be made to a tribunal. In practice, too, the Height of Buildings Advisory Committee, given Ministerial

54 Government Gazette no 78, 16 July 1971, pp 2589-638; NSWPD, Vol 92, pp 512; 2169.
55 CCS, City of Sydney Strategic Plan, (The Council, Sydney, 1971), p 6.
56 See R. W. Archer, 'The Efficiency of the Sydney Central Business District: The Public Authority Contribution', Australian Planning Institute Journal, July 1964, p 65.
57 Strategic Plan, p 82.

One of the hundreds of public comments on the City Council's proposed William Street Action Plan, 1972 (CCS CRS 34 1985/47 Box 2)

support, was to ultimately control City development in excess of eighty feet in height.

Media responses to the City Council's Strategic Plan were welcoming and lavish. Editorials gushed with praise for the plan which, they observed, would shore up the flagging spirits of the many citizens concerned about the redevelopment of the inner City.[58] With its clear advocacy of a better, more human environment, pedestrian and residential rights and public participation and its considered floor-space code, the Strategic Plan appeared armed to reverse the trends which were turning the City into 'a dead heart of concrete office blocks'.

Not all commentary was positive. Architect Harry Seidler thought the new-fangled master plan 'something of a toothless tiger'; he also wanted to see developers afforded far greater incentives in the form of bonuses to fill the City with plaza-studded, soaring developments.[59] Hundreds of private objections to the plan were also to flood into the City Council in due course from developers and other interested groups, some of which were reported in the tabloid press. The President of the Building Owners and Managers Association, while essentially defending his members' rights to make money any way they could, spuriously and incorrectly alerted Sydneysiders to the danger that 'a great deal of architectural expression of buildings' would be entirely dictated by the codes proposed in the plan.[60]

Public acclaim for the document, however, was almost universal. This was boosted with the permanent closure of Martin Place between George and Pitt streets on 10 September 1971, after being trialled for one year. (Clarke and his partner Don Gazzard had suggested the transformation of part of Martin Place into a pedestrian mall during the third Sydney Commission, an idea which had been made an election promise by Civic Reform in the 1969 elections.) On the day, two hundred officials guests and thousands of spectators attended a lunch-hour ceremony which included live music, hydrogen-filled balloons, floral gifts and an allegorical theatre piece written by actor Michael Boddy and entitled 'Carbon Monoxide Thwarted or the Triumph of Strategy Over Ad-Hockery'.[61]

Reactions to Sydney's Strategic Plan were so good that Civic Reform adopted it as its banner in the Council election which was held a few weeks after the closure of Martin Place. Civic Reform's victory was clear-cut, if inevitable, and its commitment to sane City planning never publically stronger.[62] Planning advocates had generated a full head of political steam at the local level of City government. This was a time of economic buoyancy and popular protest — the first moratorium demonstrations on Australia's involvement in Vietnam had been held in May 1970 while much dissent was being voiced over years of conservative government. Despite the euphoria, however, cool observers noted the old traps. The conservative *Sydney Morning Herald* adopted a more cautious tone. Sydney's Strategic Plan, it commented,

> if implemented, could make Sydney one of the most exciting cities of the world. It could also make Sydney a very pleasant and convenient City for its citizens, an attribute it has lost with the advent of post-war motor vehicle congestion and the more recent hurly-burly of redevelopment. But before the public becomes too enthusiastic it should be remembered that this is no more than a guideline plan.[63]

Political steam in the Council of the City of Sydney had yet to be transformed into positive action.

58 *SMH, Australian,* 21 July 1971; *Bulletin,* 24 July 1971, pp 17-19; see also *SMH* editorial, 2 December 1970.
59 *SMH,* 29 July 1971.
60 Ibid.
61 *Daily Telegraph,* 9 September 1971.
62 *SMH,* 20 September 1971.
63 *SMH,* 21 July 1971.

6

'Losing ground':[1] *Post-boom Planning*

On the first anniversary of the City Council's adoption of the Strategic Plan, ten men gathered around a table in the map room of the State Planning Authority's Castlereagh Street offices. They remained in conference for three hours. The meeting, which involved representatives from the State Planning Authority and the City Council, had been called to discuss various conflicts which had emerged between the Sydney Region Outline Plan, the City of Sydney Planning Scheme and the City of Sydney Strategic Plan. Of particular concern to the gathering were the embarrassing differences surrounding the methods used by the Authority and the Council to calculate floor space in the City for 'density-control' purposes. Equally embarrassing was a controversy over redevelopment proposals for Woolloomooloo which had recently attracted substantial media coverage.[2]

The outcomes of this meeting were scant. Due to intervention by the federal government, there was little that could be done for the time being regarding Woolloomooloo's redevelopment, though the controversy was to flare up again in the not-too-distant future. Floor-space ratios were discussed at length and it was generally agreed that these needed to be consistent. But negotiations went little further than that. Other problems surrounding the application of the City Council's Strategic Plan remained unresolved.

A few weeks after this 'anniversary' meeting, the *Sydney Morning Herald* was to reflect on the progress of Sydney's Strategic Plan.[3] In a number of ways, the *Herald* noted, the plan had been an outstanding success. As a piece of propaganda, the plan had markedly educated public opinion and made interest-groups, as well as individuals, more aware of the complexities of City growth and its control. From the outset, however, applying the scheme had proved a 'tortuous game' for the Council's new Planning Department and its consultants. Planning decisions made by the City Council remained dependent on official approvals elsewhere. During May 1972, to take but one example, Council planning policies were overruled by the State Planning Authority and the Height of Buildings Advisory Committee. These bodies allowed a fifteen million dollar development, which the Council had rejected as being too high, to go ahead in Liverpool Street.[4] After only a year the Strategic Plan seemed 'to be losing ground'.

1 *SMH*, 22 August 1972.
2 TC 2258/72 (meeting 2 August 1972).
3 *SMH*, 22 August 1972.
4 *SMH*, 16 May 1972.

Sydney's Tallest Buildings Chronologically

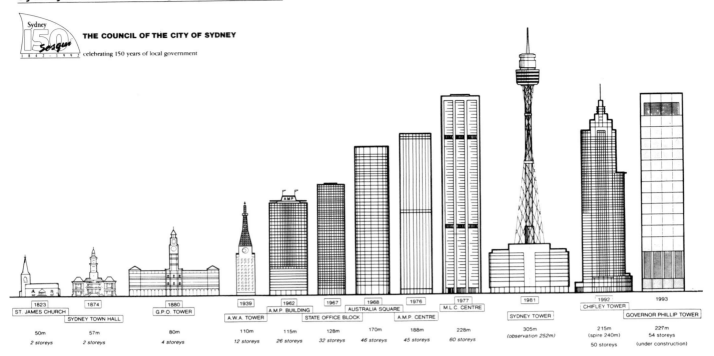

THE COUNCIL OF THE CITY OF SYDNEY

Sydney 150 Sesqui 1842–1992 celebrating 150 years of local government

1823	1874	1880	1939	1962	1967	1968	1976	1977	1981	1992	1993
ST. JAMES CHURCH	SYDNEY TOWN HALL	G.P.O. TOWER	A.W.A. TOWER	A.M.P. BUILDING	STATE OFFICE BLOCK	AUSTRALIA SQUARE	A.M.P. CENTRE	M.L.C. CENTRE	SYDNEY TOWER	CHIFLEY TOWER	GOVERNOR PHILLIP TOWER
50m	57m	80m	110m	115m	128m	170m	188m	228m	305m (observation 252m)	215m (spire 240m)	227m
2 storeys	2 storeys	4 storeys	12 storeys	26 storeys	32 storeys	46 storeys	45 storeys	60 storeys		50 storeys	54 storeys (under construction)

With the compliments of the Council
L.P. CARTER, O.B.E., TOWN CLERK

(CCS CRS Planning Department)

Part of the Martin Place pedestrian precinct Action Plan (No 24) (CCS CRS 75/1/8)

George Clarke, the Director of the City Council's consultant planning team, did not agree with the *Herald*'s assessment. Some adjustments to the plan would, of course, be required — workforce projections, for example, had been significantly overestimated, but these could be revised. The misconception that the Strategic Plan was a detailed specification for every square inch of Sydney also needed to be banished. What the City was witnessing, Clarke told the *Herald*, was 'the beginning of a continuing process of City planning'. Time, Clarke also emphasised to the *Herald* reporter, would be needed for the relevant authorities to assess the plan and 'rationalise the development approval process to give more power to the City Council'.[5]

Optimism such as this was characteristic of many middle-class urban reformers during this period of change and hope. There was a growing mood of discontent among many Sydneysiders, both working- and middle-class. Green bans (the first of which occurred in 1971), protests about the demolition of inner-city terrace houses, and demonstrations against encroachments on City parks dramatically indicated the new environmental awareness.[6] The rhetoric of liberalism was bankrupt; it had failed to deliver a better inner-city urban environment after years of relentless development. Indeed, the Strategic Plan was itself a product of these circumstances.

Conservative commentators were attuned to this shift in sentiment, though one noted the slowness of some prominent State politicians to recognise the changing standards. The *Financial Review* dubbed New South Wales' State Premier Sir Robert Askin along with Victorian Premier Sir Henry Bolte 'unreconstructed bricks and mortar traditionalists'. Local government, too, had its share of politicians who were still mouthing old, uncomplicated attitudes towards urban redevelopment. Civic Reform Alderman John Harris, Chairman of the City Council's Works Committee, in glowing defence of the plan to allow the massive redevelopment of Woolloomooloo, only recently had said that there was 'a constant stream of development applications from people who visualise Sydney in the years to come as one of the world's greatest Cities'.[7] Such sentiments belied Civic Reform's otherwise publicly vocal commitment to sound, humane planning, while indirectly indicating the precarious position of that party's minority, would-be urban reformers.

Many planners working for or with the City Council remained optimistic about Sydney's planning future, despite continued difficulties. As action plans began to be implemented, growing popular support also witnessed political commitment to the Strategic Plan. The Council's new Strategic Planning Branch, which was headed by the lately appointed Chief Planning Officer, Michael Llewellyn-Smith, was launched on this new wave of commitment. As part of the Council's Planning Department, the Branch operated with a considerable degree of independence. John Doran, the City Planner, fully supported the branch, but he interfered little in its functions — Doran 'wasn't into strategic planning'.[8] Other branches of the Planning Department tended also to leave the Strategic Branch to its own devices, particularly given that it was full of university graduates (and professional women on equal salaries with their male counterparts!) who had not worked their way up and who could not be comfortably accommodated into the long-established Council culture. The Strategic Branch was there largely to implement and service the plan which had brought it into existence, and its first priority was the implementation of action plans to indicate to observers and residents of the City that something was happening.

Kerry Nash, at that time an enthusiastic graduate planner who had joined the Strategic Planning Branch in mid 1972, recalled the example of Paddington. This area had been marked for destruction and redevelopment in the 1950s and 1960s, but in the early stages of strategic planning it was given priority for action planning. During the closing months of 1972, Council ideas for proposed terrace-house conservation, street closures to remove cars from the locality, and general improvements were placed on public exhibition. As Nash recalls, the plan

> The Floor Space Code [in the 1971 Strategic Plan] was something quite new for the City. It was a bonus system. The maximum of twelve-to-one was still obtainable. But the basic ratio was reduced down as low as three-and-a-half-to-one for some sites and you had to earn your way back to twelve by way of bonuses. Bonuses were obtainable for providing things like plazas, terraces, through site links and escalators; all the desirable things that people wanted to see in the City were bonus provisions.
>
> There is still a lot of argument about the benefits that it produced. It certainly produced a lot of features which are useless. It produced a lot of retail area which has never been any good for retail — it simply provided a bonus. It produced through site links which don't really go anywhere which are of no use to anybody. The harm, I think, it did was to produce uncoordinated spaces of setbacks here, there and everywhere and colonnades that were dead-ends and all this sort of thing.
>
> John Doran in *PS*, p 73

5 *SMH*, 22 August 1972.
6 See, for example, Paul Ashton and Kate Blackmore, *Centennial Park: A History*, (NSW University Press, Sydney 1988), pp 130-31.
7 *Financial Review*, 19 May 1992.
8 Kerry Nash interviewed by Paul Ashton in *PS*, p 171.

included a very detailed public participation program, and it culminated in late December 1972 with Paddington Town Hall being full with about three hundred residents and [us] getting a standing ovation with the stamping of feet and applause. That etched in the politicians' minds . . . that the . . . approach that we were taking was working . . .[9]

At first, the City Council adopted twenty-three action plans. As many as fourteen teams of consultants could be found working on some of these at any one time. Optimism, however, about broader features of the Strategic Plan was to gradually wane. And there were early threats to the Plan's integrity in a number of ways.

The William Street Boulevard was selected for the first of the Council's action plans. But as the then City Planner, John Doran, reluctantly though openly admitted, it was produced

> as a publicity stunt to give a boost to the [Strategic Plan]. Virtually the only research done on it was to look at William Street very loosely and [then it was] decided that it ought to be widened to look like the Champs-Élysées. Somebody over one weekend produced a perspective sketch which was reproduced in the newspapers. And that kicked the William Street Boulevard off.[10]

Perennial planning problems in the City of Sydney were to bring about the final demise of the William Street Boulevard. While parts of the street's northern side were developed in a piecemeal fashion, the southern side of William Street failed even to get off the ground. As Doran frankly remarked, 'the Department of Main Roads changed its mind about realignments'.

Outward optimism among progressive planners was mixed with not a little hard-headedness. Consultant planners outside bureaucracies who engaged vigorously with urban planning issues did not deceive themselves about the pragmatic process of modern town planning. At an Action Planning Forum conducted by the City Council in November 1972, which sought to iron out some of the worst difficulties surrounding the City's planning, George Clarke acknowledged the wide range of conflicting interests in Sydney. Planning, he contended, was a process which involved exposing conflicting values and interests with the aim of securing consensus, or, as he put it, 'some creative synthesis of a plurality of values and interests'. One of the key purposes of such a process, Clarke told his audience — comprised of politicians, developers, radical groups, such as the Surry Hills Planning for People Campaign and, of course, town planners — was to narrow conflicts down to their essentials so as to

9 Ibid, p 155.
10 John Doran interviewed by Paul Ashton in *PS*, pp 74–5.
11 George Clarke, 'Address given at the . . . Action Planning Forum, Wednesday, 22 November 1972 . . .', p 1, Clarke Personal Papers.

reconcile those of them that prove to be *unnecessary* conflicts.

> Those irreconcilable conflicts which *cannot* be reconciled through processes in which we mere employed professional planners . . . maintain, or attempt to maintain, the thin veneer of civilised behaviour that enables our society to change in any orderly fashion . . . ultimately go into the political arena where they are decided on the basis of political power.[11]

There are variations built into later planning instruments and LEPs. There was one requirement which said that if you provided any parking in excess of that which the Council required it had to be counted in floor space. This was alright in places where you didn't want parking. But it was an absolutely unnecessary restriction in areas where the Council wanted to see parking and the applicant was happy to provide parking in excess of the code but couldn't do so because he lost floor space. The Council got over that in a lot of cases simply by saying: 'Well, we require that many spaces'. Being required parking, it was not counted. That is why old decisions never seem to contain logic these days, they all look like they've just broken the code.

John Doran in *PS*, pp 77–8

Leaving aside Clarke's failure to relate this process of conflict management to any specific type of social system or to adequately theorise the state, there were enormous planning and urban conflicts in Sydney during the early 1970s. Nowhere in the City were these problems more starkly apparent than in Woolloomooloo.[12]

Situated in a harbourside valley between the Sydney Domain and Kings Cross, Woolloomooloo, a working-class, inner-city suburb, had led an uncertain existence since the close of World War II. Post-war reconstruction planning proposals put forward by the City Council included major redevelopment of the valley basin. With its harbour frontage and 'natural' features, the 'Loo was held up by some City aldermen as a potential place of national importance. Properly planned, Woolloomooloo they believed, could be transformed into 'a Gateway' to the City from overseas. As early as February 1951, two City aldermen, A. R. Sloss and W. W. Lewis, successfully moved in Council that any further industrial development be prohibited in the area bounded by Lincoln and Sir John Young crescents, Victoria and William streets and Woolloomooloo Bay. A joint committee of Council was subsequently set up to investigate this well-received idea and Council officers were directed to do costings and prepare schemes for the 'Loo.[13]

Le Corbusier, whose high-rise designs were austere, totalitarian and then fashionable in parts of Europe and America, may have been pleased with the planning schemes produced by the Council's engineers. Local residents and others, however, were not. Though the Council had made provision for eventually accommodating a substantial number of the area's 5,500 inhabitants, the new, depressing high-rise apartments meant the destruction of the 'Loo and a loss of traditional residents.

The Housewives Association of New South Wales — 'Non-Party: Non-Sectarian: Non-Communist' as their letterhead proclaimed — implored the Council not to exacerbate the current housing shortage by displacing residents, arguing that the Council was duty-bound to find homes for those destined to be turned out. The Association's Board thought a brand new housing settlement outside the City might provide a solution. One anonymous local, desirous of staying put, wrote to Sydney's Town Clerk, bitterly observing that while the Council crowed that it was 'out to make Woolloomooloo a picturesque front door to Sydney . . . [it] could have added and to make a doormat of the inhabitants'.[14]

Discussions regarding Woolloomooloo's redevelopment were pursued in earnest with the New South Wales Housing Commission. An estimated price tag of £14 million — a little more than half of which represented building costs, and the remainder expenditure on resumptions — did not pose any special problems. The recent purchase of an area of seven acres by the Department of the Interior for

Planned realignment of the Cowper Wharf roadway along the Woolloomooloo foreshore, c. 1974 (CCS CRS 312/21)

12 A case study of another area, The Rocks, is provided in Kate Blackmore, 'A Good Idea at the Time: The Development of The Rocks', in Peter Weber (ed), op cit, pp 120-29.
13 TC 324/51.
14 Ibid, letters, 5 June 1951 and 23 February 1952 respectively.

proposed central Naval Stores, however, led the Commonwealth government early in 1952 to lodge objections to wholesale redevelopment.[15] Logistic considerations indicated that naval stores should be scattered across Sydney to ensure the nation's security. In a season of cold war, defence requirements won out. But while this particular proposal was to be permanently shelved, the spectre of another 'Gateway' was to return to haunt residents towards the end of the following decade.

On 19 August 1969, a public planning exhibition was opened in the City's lower Town Hall by Chief Commissioner Vernon Treatt. Prepared by professional officers of the State Planning Authority, the plan had been undertaken to guide the complete and intensive, high-rise redevelopment of Woolloomooloo. Public authority involvement, the exhibition brochure emphasised, was to be minimal in the scheme's implementation. Action would be required on the City Council's part to facilitate site consolidation. But it was left to private enterprise to bring about such consolidation and make the plan — which contained 'a good deal of flexibility' — a reality.[16]

Pat Morton, Minister for Local Government, had verbally instructed the State Planning Authority to confer with the City Council Commissioners to draw up a scheme for the basin. It is uncertain as to whether Morton was motivated by a wish to get 'rid of the Labor voters in Woolloomooloo',[17] as some contemporary observers claim, or to appease the development industry, or both. Whichever, Morton's instructions were duly carried out by the Authority which suggested the formation of a Woolloomooloo Steering Committee to the City Council. Comprising Deputy Commissioner J. A. L. Shaw, Jack Luscombe (the Town Clerk), Nigel Ashton (Chairman of the State Planning Authority) and Peter Kacirek (the Authority's Deputy Chief Planner), this committee oversaw the preparation of the plan for Woolloomooloo.[18]

Developers, some of whom had pressed the Commissioners and the Steering Committee for a decision prior to the plan's completion, were delighted with the outcome, though a few would have preferred a larger floor-space ratio than the plan proposed (five-to-one, with bonuses for site consolidation allowing up to ten-to-one). Here, it seemed, was a virtual guide to making money. Unsurprisingly developers began buying land and options to buy property in Woolloomooloo.

Contradictions, however, were apparent between the Steering Committee's scheme and other planning documents pertaining to the City. During 1967 and 1968, the State Planning Authority had issued two publications concerning Sydney's planning future, *Prelude to a Plan* and the *Sydney Region Outline Plan 1970-2000 AD*,[19] in which the Authority's official position on the City's development was clearly stated. What Sydney required, the Authority asserted, was 'a detailed and comprehensive study of the problems of land use and movement in the City centre, followed by an imaginative plan to provide the guidance and context for developers'. What Woolloomooloo got, one witness later told a judge of the Supreme Court of New South Wales (who agreed with the testimony), was a plan which was

> brief (only 8,750 words), unquantified (no numerical research or analysis), and narrow in scope (being a 'civic design' exercise for a site of 90 acres, and devoid of any economic or transportation analysis or proper recognition and study of influences or ramifications beyond the restricted area of Woolloomooloo.[20]

Despite complaints from a few State authorities as to not having been consulted and legal advice that the City Council was not bound by the Commissioners' acceptance of the Woolloomooloo plan, the newly elected, Civic-Reform-controlled Council adopted this dubious study on 8 December 1969. A week later, the Council proceeded to commission its own strategic plan for the City. When this planning scheme was adopted by the City Council in August 1971, Woolloomooloo became subject to a further conflicting precinct plan, a ludicrous situation which attracted comment from the press.[21] The Strategic Plan decreed that for 'the future economic well-being of the

15 See TC 2257/48.
16 TC 568/68. The entire course of events to 1981 can be found in *San Sebastian Pty Ltd & Anon v. The Minister Administering the Environmental Planning and Assessment Act, 1979 & Anon*, No 5616 of 1976, (NSW Supreme Court findings 1981).
17 George Clarke interviewed by Paul Ashton in *PS*, p 22.
18 For details and an account of popular outcry and subsequent resident action see Shirley Fitzgerald, *Sydney 1842–1992*, (Hale & Iremonger, Sydney, 1992), pp 283-301.
19 State Planning Authority, Sydney (respectively) 1967, 1968.
20 *San Sebastian v The Minister Administering the Environmental Planning and Assessment Act*, op cit, p 52.
21 Supplement, *Australian*, 21 July 1971.

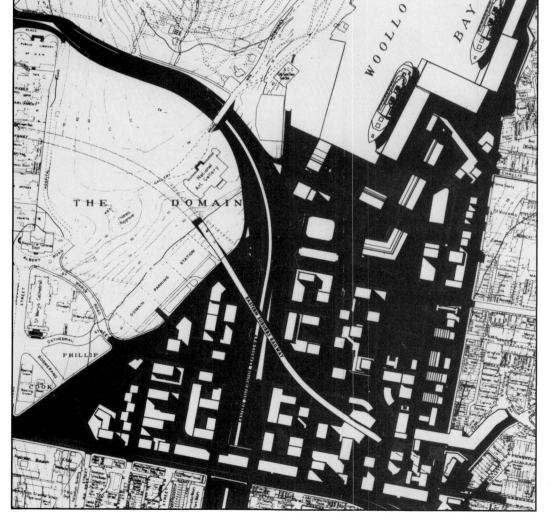

A model, photographed in 1951, of the City Council's proposed Woolloomooloo Housing Scheme. Le Corbusian in flavour, this project did not proceed (CCS CRS 48/1893)

Part of the NSW State Planning Authority's 1969 proposal for the redevelopment of Woolloomooloo (ML)

Gateway Developments Pty Ltd's 1971 plan for the redevelopment of Woolloomooloo (Eric White & Associates, *Wooloomooloo: Its Tomorrow*, Sydney, 1971)

City as a whole, the valley of the 'Loo, excluding the Boulevard frontages of the William Street Precinct, should be re-established as much as possible in predominantly residential uses'.[22] Only four months later, the City Council adopted a Development Control and Floor Space Code Ratio. Clause 8 of this instrument directed that the Council would 'administer development control [for Woolloomooloo] in the light of the Woolloomooloo Study prepared in 1969 by the professional staff of the State Planning Authority of New South Wales'.[23]

In the meantime, confident developers had gone on a real-estate spending spree in Woolloomooloo. Sidney Londish, a prominent developer, through one of his companies, Gateway Developments Pty Ltd, had managed to acquire eight and a half acres of land in the area, thus making Londish's company the largest private property owner in Woolloomooloo. Corporate confidence was buttressed by State government support for the area's redevelopment. Indeed, when in mid 1971 Gateway Developments unveiled its $400 million project for the 'Loo, which relied on maximum floor-space ratios of up to twelve-to-one,[24] Robert Askin, the Premier of New South Wales, officially presided over the ceremony. An enthusiastic booster of the Londish scheme, Premier Askin noted in his congratulatory opening speech that this project would help make Sydney a great city despite opposition to its going ahead. 'As always,' the Premier chided on this occasion, 'when you are dealing with progress and development you get a few critics about'.[25]

Londish's Gateway Company formally submitted a development application to the City Council on 20 October 1971 and the Council subsequently approved, in principle, a new street system for Woolloomooloo to allow for site consolidation. But apart from deep concerns expressed by proponents of the Strategic Plan, the Woolloomooloo redevelopment scheme attracted little if any criticism from official quarters until it was passed by the City Council on 8 May 1972.

Two weeks later, after a barrage of adverse media coverage and much public

22 CCS, *City of Sydney Strategic Plan*, (The Council, Sydney, 1971), p 89.
23 PC, 6 December 1971.
24 The project is described in Eric White (production), *The Woolloomooloo Redevelopment Project*, (Sydney, c1971).
25 *Financial Review* 16 October 1971, 10 May 1972.

protest, Council approval of the Gateway proposal was rescinded on a motion by Labor opposition aldermen. Some commentators noted of the Civic Reform majority that its acceptance of the Woolloomooloo scheme, which left the State Planning Authority and the Height of Buildings Advisory Committee with the last word, was 'an odd dereliction of responsibility by a council which claims it should have greater powers to govern the planning of the city'.[26] Attacks were also made on the seriously defective nature of the State Planning Authority's plan for the 'Loo, on the duplication of powers and on the gross overdevelopment which the Gateway proposal would inflict on the area. A. C. Strachan of the Civic Design Society, based at the University of New South Wales, wrote to the editor of the *Sydney Morning Herald*, condemning this situation. The SPA, he concluded,

> is caught on its own hook whilst the Council seems beholden to certain developers on the basis of a plan [prepared by the SPA] which the Council clearly had the power to repudiate and which plan is in conflict with the overall Strategic Plan which is supposedly the guiding light for the future. What a mess![27]

Adding an unexpected element to the controversy, Premier Askin successfully intervened for foreign finance on behalf of Londish and his Gateway Company — which was then leading the project for a consortium of companies — while travelling abroad in mid 1972. Though Sydney's development boom was not to peak until April-May 1973,[28] the news came back from overseas at a time when the market for office space in the City (as in other Australian capitals) was clearly heading towards a crisis of oversupply.[29] For some time, the Gateway proposal had been experiencing difficulties in obtaining adequate financial backing. But after talks with the Premier in Singapore, the manager of the recently established Singapore branch of the Moscow Narodny Bank established a line of credit of up to $37.5 million for Gateway developments.[30]

Sydney's tabloid press focussed even more sharply on the Woolloomooloo front as the 'battle of the office blocks' intensified. All seemed to concur with the

26 *SMH*, 11 May 1972, editorial.
27 *SMH*, 21 July 1972.
28 See M. T. Daly, *Sydney Boom, Sydney Bust*, (George Allen & Unwin, Sydney, 1982), p 13.
29 *Australian*, 10 May 1972.
30 *Financial Review*, 10 May and 11 May 1972.

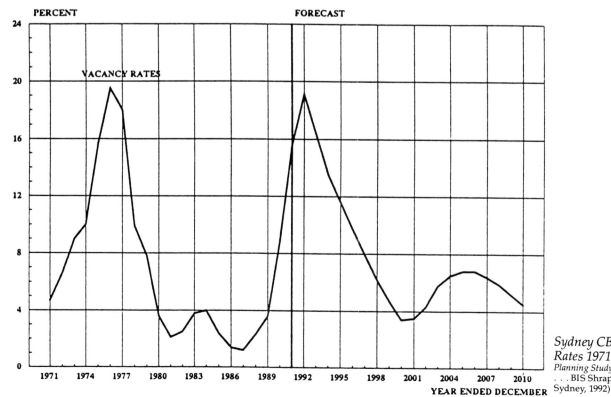

Sydney CBD Office Vacancy Rates 1971 to 2010 (from *Strategic Planning Study: Projections and forecasts . . .* BIS Shrapnel for the CSPC, Sydney, 1992)

sentiments expressed in an editorial in the *Sun*. Authorities, it claimed, and in particular the City Council, 'should be committed to what is best for Sydney . . . Big investors are already warning our cities about the office glut. The investors have only money to lose. The rest of us have a city at stake'.[31] Responding to the City Council's approval of the Gateway proposal and Askin's moves to attract foreign finance to the project, the Federal Labor Party Opposition pledged to intervene in the redevelopment scheme if elected to office. Tom Uren, Labor spokesperson for urban affairs, rightly noted that such a redevelopment would place intolerable pressures on transport and service systems: the City Council's consultants had previously arrived at a similar conclusion. A Federal Labor Government, Uren promised, would strive to achieve redevelopment on a similar scale to that existing in the area. Further, tentative and only recently announced plans to build a Commonwealth centre on the site once ear-marked for naval stores would be changed and the centre moved to Parramatta.[32]

Reflecting the City Council's lack of power and Civic Reform's ambivalence about the Strategic Plan, Sydney's Lord Mayor, Sir Emmet McDermott, publicly adopted a 'wait and see' approach to the bedlam which had engulfed the planning process in the City.[33] His Council continued in its strong desire to proceed with the Gateway Scheme.[34] The State Planning Authority, on the other hand, acted decisively. On 1 June 1972 it informed the City Council that it disapproved of the Gateway redevelopment. Not a few Council aldermen and planning staff were surprised by this since the Authority's decision contravened the spirit and intention, if not the precise details, of the 1969 plan for Woolloomooloo. Planning, it seemed, was a process of 'compromise . . . to get over some other problem'.[35]

Strategic planning staff in the City Council had been alive to the new public spirit which was having a potent influence on politicians at all levels of government. (They had also for some time been advising their political masters, as Michael Llewellyn-Smith had done in September 1972, of the extremely defective nature of the State Planning Authority's plan.)[36] With the Authority's change of attitude towards Woolloomooloo, the City Planner, John Doran, also began emphasising to Council aldermen the desirability of non-intensive development in the beleaguered valley basin.[37] Other broadly related events, however, were to determine the fate of the 'Loo.

Assertive resident action, the election of a Federal Labor Government on 2 December 1972, and the subsequent imposition of a green ban early in the following year by the Builders Labourers' Federation on any redevelopment in Woolloomooloo prompted the City Council to defer all decisions on development applications in the area until an action plan, based on the Strategic Plan, had been prepared for the 'Loo. Work on the action plan also ceased during 1973 pending the outcome of a meeting held on 20 December between Tom Uren (by then the Commonwealth Minister for Urban and Regional Development), the New South Wales Minister for Planning and Environment and the Lord Mayor of Sydney. At this meeting, Uren offered the City Council up to $20,000 to prepare a proposal for the redevelopment of Woolloomooloo. The offer was accepted and work recommenced on an action plan for the area. Eventually, a tripartite agreement was reached. The 'Loo was now to have low-cost, medium-density housing.[38]

After the media storm abated and the final agreement was signed, the battle for Woolloomooloo — a battle won partially for and by inner-city residents — was to be transformed into a legal saga. For more than a decade, State and federal courts were to hear the claims of a small development company, San Sebastian Pty Ltd, and associated companies against the State Planning Authority's successors (the Planning and Environment Commission — established in 1975 — and the Department of Environment and Planning), as well as the City Council. San Sebastian, with the backing and best wishes of major development interests in Woolloomooloo, would attempt to gain compensation for losses sustained as a result of speculative investments. Court after court found the State Planning Authority's plan to be defective, but

31 *Sun*, 23 May 1972.
32 *Australian*, 24 May 1972.
33 *Sun*, 15 May 1972.
34 *San Sebastian*, op cit, p 130.
35 John Doran interviewed by Paul Ashton in *PS*, p 74.
36 *San Sebastian*, op cit, p 129.
37 Fitzgerald, op cit, p 294.
38 An Interim Development Order for largely residential use was published on 8 August 1975. See Fitzgerald, op cit, pp 289-99.
39 TC 1848/76; *Australian Financial Review*, 20 August 1976; *Financial Times*, 5 September 1978; *SMH*, 15 May 1982.
40 CSS, *City of Sydney Strategic Plan 1974–77*, (The Council, Sydney, 1974).
41 Ibid, p 43.
42 Paul Jones, 'Sydney: Inner-city boom depletes low-income stock', *Australian Planner*, November 1982, p 148.
43 See CCS, *Streetscape and Street Furniture Improvements. Action Plan No. 2*, (The Council, Sydney, 1972).
44 Paul Ashton and Kate Blackmore, *Centennial Park*, op cit, p 134.
45 *SMH*, 29 July 1974.
46 Ibid, p 5.

the ultimate judgement went against the development industry. Though finishing in the High Court of Australia in 1986, the administrative loose ends of this lengthy case were not tied up until the close of 1990.[39]

On 2 December 1974 the City Council adopted the 1974-77 Strategic Plan. This document reviewed the progress of the 1971 plan while restating objectives and policies and setting out action priorities for the next three-year planning cycle.[40] One priority was the development, utilising State and federal finance, of new, low-income residential projects. Woolloomooloo was held up as a model for redevelopment: such projects, it was thought, would also help to reverse the continued decline of the City's residential population.[41] (It has been estimated that around fifty thousand people were displaced from inner-city housing between 1945 and the mid 1970s due to redevelopment.)[42] The 'Loo was safe, at least for the foreseeable future.

Sydney's revised Strategic Plan was publicly exhibited from 29 July 1974. Attracting considerable attention, the Plan duly noted the Council's achievements. Street-scape and street furniture improvements had been affec-ted around the City and various precinct problems addressed.[43] Many more action plans were in hand, includ-ing a scheme (number thirty) for Centennial Park's residen-tial area. Under the direction of Kerry Nash (Council's Strategic Planner from 1974 to 1984), this scheme, while in preparation, had secured a moratorium on 'ill-considered, ad hoc development approvals' which were marring the area and congesting it with traffic.[44] When completed, even the grumpy, Nobel-prize-winning novelist and Centennial Park resident, Patrick White, thought it an 'excellent plan which should go ahead as soon as possible'.

Individual action plans were to affect physical improve-ments in different parts of the City. But longstanding problems were to frustrate comprehensive, long-term planning. As the *Sydney Morning Herald* was to observe, 'strategic planning' in Sydney as yet remained at best an ideal. In an editorial, appropriately titled 'The dream reviewed', the *Herald* praised the initiatives which the Council through its 1974-77 *Strategic Plan* sought to achieve. These included substituting new traffic flows along two major city streets for two proposed expressways and decreasing floor-space ratios on the fringes of the central business district (both ideas being anathema to various bodies). As the *Herald* correctly pointed out, however, it was 'the plan's reference to legislative action which . . . [was] its heart'.[45]

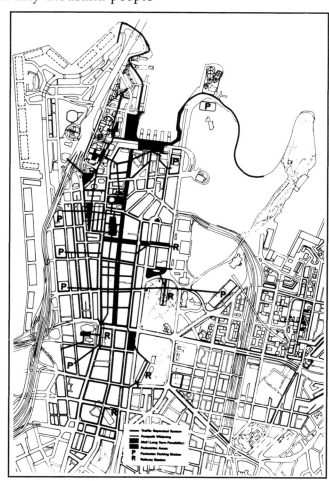

A conceptual diagram for Sydney's central pedestrian network from the 1974 Strategic Plan (CCS CRS 75/1/3)

Whatever the vision or the rhetoric, the City Council's *Strategic Plan* remained without formal legal status. Reformers on the Council were left to plead their case with the State government, as they did once again in the prefatory remarks to their latest *Strategic Plan*. 'The City Council', it was asserted in this document, believed 'that it has proven, by its initiatives and experience since 1970, its readiness to accept more responsibility, and its ability to use greater powers and resources effectively to unify and simplify the City management'.[46] The State government, however, did not share this view. Changing economic and political circumstances were also to undermine any attempts to plan.

It was ironic that the City's Strategic Plan was launched and adopted in 1974. In that year Australia's economy, as with other western capitalist economies, slumped

into recession and into a period of economic uncertainty and often hardship from which it has yet to recover. Any liberality in terms of urban environmental concessions hardened in these leaner times. Intervention by the Federal Labor Government to improve life in Australian cities had also generated landmark precedents and great expectations, but these were to outlive this reformist government which was dismissed in November 1975. At the federal level, these circumstances 'pushed urban planning off the political agenda'.[47]

More radical planners became quickly disillusioned with the various programs which purported to be working towards curing Sydney's urban ailments. At a one-day conference held at the University of Sydney, academic John Toon declared with much exasperation that 'there was no such thing as planning [in the City of Sydney] — it was all opportunism on the part of every agency'. And for Toon, the City's Strategic Plan was no exception. Given its brief history, it was clearly another 'example of political opportunism'.[48] In reply to other criticisms of the City Council's approach to planning, Alderman Andrew Briger was to indicate the Council's continued adherence to fairly straightforward physical planning. 'Council,' he told the conference, 'had to make the City function . . . [it] had to cope with the symptoms of the illness, rather than the causes of the disease'.[49]

Spatially orientated solutions to urban nuisances in the City and to urban policies

This artwork, which appeared in the City Council's 1977 Strategic Plan, *attempted to indicate the blessings which would flow from unhampered strategic planning. The praying mantis in the central image — representing the City Council — was not, however, to make it through the cross-fire which can be seen coming from the numerous little bureaucratic 'kingdoms'* (CCS CRS 312/27)

YESTERDAY TODAY AND TOMORROW

— with their euthenic undertones — came under increasing attack from a number of quarters. Leonie Sandercock's influential and widely read book, *Cities for Sale: Property, politics and urban planning in Australia*, provided a fresh and sustained critique of these and other problems confronting planning in Australia. Published in 1975, the book devoted much space to the City of Sydney. But whatever the City Council's ideology or agenda may have been, its powers remained extremely limited.

During the next review of Sydney's Strategic Plan, which commenced at the end of 1976, the City Council wrote to the Minister for Planning seeking advice as to the Department's 'current and intended future policy' regarding the control of buildings over eighty feet high in the City. The Council also requested some clarification as to its legal powers, which remained 'weak and vague', under the City of Sydney Planning Scheme, so that it might intelligently modify the Strategic Plan's floor-space ratio.

A reply was not forthcoming from the Minister. Instead, the Review Committee took the advice of one of its member, Peter Webber, who was a Commissioner of the New South Wales Planning and Environment Commission and Chairman of the State Government's Height of Buildings Advisory Committee. Webber opined that

> in view of the current recession, there was no immediate urgency to introduce a new and hastily conceived FSR code or Interim Development Order but that the problems and possible solutions should be carefully considered and any necessary action taken prior to the potential beginning of a future resurgence in application for major quantities of new office space.[50]

Thus the subject of floor-space ratios was excluded from the 1977-1980 Strategic Plan.

47 Ian Alexander, 'Capitalist city planning: A dialectical irrelevance', *Australian Planner*, April/May 1984, p 39. See also Peter Harrison, 'City Planning', in Peter Scott (ed), *Australian Cities and Public Policy*, (Georgian House, Melbourne, 1978), p 171.
48 Quoted in Graeme Sheather (ed), *Planning in the City of Sydney: Proceedings of a one-day conference*, (Planning Research Centre, University of Sydney, 1975), p 31.
49 Ibid, p 28.
50 CCS, *The Sydney City Council's Strategic Plan: Objectives and Action 1977-80*, (The Council, Sydney, 1979), annexures, p A5; Council's letter to the Minister pp A19-A20.
51 Ibid.
52 *City of Sydney Strategic Plan 1977-1980*, op cit.
53 TC 3481/77.
54 Ian Alexander, 'Strategic Planning in Central Sydney', *Royal Australian Planning Institute Journal*, November 1978, p 123.
55 CCS, *Strategic Plan 1980-83*, p 5.

Neville Wran, who became Labor Premier of New South Wales in May 1976, bluntly stated this situation a year after taking up office: 'The Sydney City Council', he pointed out, has no more power than a crippled praying mantis'.[51] And it was his intention that it remain so, particularly since the Council was controlled by Civic Reform.[52] Those who wrote the 1977-80 Strategic Plan were forced to concur with Wran's practical assessment. The City Council was only one of more than forty bodies that had a hand in running Sydney, and State authorities could hold up or veto Council initiatives. Despite improvements to some residential and commercial precincts, a program for the 'greening' of Sydney and other beneficial activities, the Strategic Plan, as Alderman Robert Tickner argued in Council, 'still . . . [left] the City of Sydney in planning chaos'.[53]

While State politicians and their apparatchiki maintained ultimate control of Sydney's growth, political commitment to planning in the City Council began seriously to flag. The *intentions* of the Strategic Plan notwithstanding, some observers were beginning to comment that this instrument, tied as it was to triennial Council elections, was 'orientated more to local government politics than to the cause of sound urban planning'. One critic, Ian Alexander, considered, justifiably, that in 'the crucial area of office development, the Council has been more concerned with political grandstanding than with actually implementing badly needed restraints on the scale and amount of development'.[54]

George Clarke, the guiding hand behind the Strategic Plan in the 1970s, abandoned all attempts at planning in Sydney during 1978. He left Australia in the following year, frustrated and angry, to undertake projects for the World Bank, the Asian Development Bank and the United Nations. Perhaps he had also seen the writing on the wall.

Old political tactics were adopted afresh by the State to bring about civic change in the City of Sydney. New boundaries were created for the City in 1977 by the Wran Labor Government and the number of aldermen reduced from twenty-two to fifteen. Later, in 1980, City leaseholders had their right to vote removed by the same State government and for the first time in over a decade the Labor Party won the Sydney Council elections.

Just prior to Labor's victory at the local polls, the Civic Reform majority Council adopted the Strategic Plan for 1980-1983. This substantial and comprehensive document was produced in-house by the City of Sydney Planning Department. But, as noted by the Strategic Plan Committee's Chairman, Alderman Andrew Briger, its implementation remained subject to 'the limited powers granted us by the State'.[55]

The last Strategic Plan for the City of Sydney was adopted by a Labor Council in 1983. Changing political and economic circumstances, however, saw the complete demise of strategic planning. Despite the State Labor Government's attempt to entrench Labor in the City Council by reamalgamating the City of Sydney with South Sydney in 1981, a large number of independents were successful in the 1984 elections and Labor lost control of the Council. On 16 September of the following year Labor was forced to

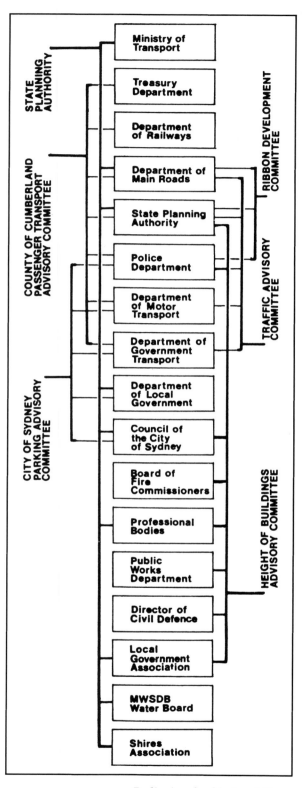

Bodies involved in Land Use and Transport Planning and Development Control, City of Sydney, 1971 (CCS, Strategic Plan [the Council, Sydney, 1971])

This cartoon by Molnar appeared in the City Council's 1977 Strategic Plan. *It was commissioned by the Council's planning consultant, George Clarke, after the NSW Premier, Neville Wran, publicly commented on 2 May 1977 that the 'Sydney City Council has no more power than a crippled praying mantis'. Council powers were to be further eroded in subsequent years. In the cartoon we see Andrew Briger (seated below the praying mantis); Lord Mayor Leo Port (speaking); Town Clerk Leon Carter (seated next right); and (standing far right) George Clarke* (CCS CRS 312/40)

take the unprecedented step of forming a coalition Council with Civic Reform, demonstrating the ideological bankruptcy of mainstream politics.

The rough-and-tumble of the City's political life continued to manifest itself in approaches to planning. On 1 May 1984 the Wran State Labor Government had announced its intention to redevelop the Darling Harbour Railway Goods Yard and some adjoining land as a major State bicentennial project. Various concerns were expressed over the proposed scheme for the area which was to cater for entertainment, shopping and tourist-orientated activities. A mammoth controversy, however, was to unfold when, only days before the Labor-Civic Reform alliance, the Wran Government unveiled a blueprint for an elevated monorail which was intended to service the new Darling Harbour complex.[56]

Eventually built by Thomas Nationwide Transport (TNT) and in 1992 going broke, the monorail saga was, as one protest body rightly noted, a prime example of 'the "crash through" or "crash" planning technique employed by the [State] Government'.[57] Like Darling Harbour (administered by an Authority which had been established in 1984), the monorail had been freed from any control by the City Council and exempted from various requirements under the Environmental Planning and Assessment Act (1979). (Ironically, the Wran Government had supposedly passed this legislation to curb the excesses of the previous boom under the Liberal Government.) Eventually, the monorail was exempt from environmental provisions in over a dozen Acts. Criticisms of the monorail proposal from most quarters could be disregarded, the need for an Environmental Impact Statement was dispensed with, and the requirement to publicly exhibit plans and accept submissions was waived.[58] Since TNT were footing the bill for capital expenditure, the State Government attempted to promote the monorail as a generous bicentennial gift to Sydney from TNT's head, Sir Peter Abeles. But it proved to be an unacceptable and unwanted gift for many Sydneysiders.

On 5 November 1985, a public meeting was held at the Sydney Town Hall to organise opposition to the monorail (or 'People Mover' as some proponents of the scheme dubbed it). Not wishing to be moved by this novel mode of transport, 400 people attended this meeting which passed a resolution to form a Citizens group to oppose the monorail. Subsequently, Andrew Kay, an ex-planner then working with

56 *Age*, 25 September 1986, p 11.
57 Sydney Citizens Against the Proposed Monorail, *Darling Harbour Public Transport Options*, (SCAPM, Sydney, 1986), Introduction.
58 Ibid, p 10.

the City Council's Information Services Department, and Chris Stapleton, a traffic planning consultant, lobbied and raised funds to place an open letter in the *Sydney Morning Herald* calling for a Citizens' Committee. This resulted in the formation of the Sydney Citizens Against the Proposed Monorail (SCAPM) late in 1985 with Kay as President. Numerous Sydney personalities joined SCAPM, including former judge and politician Jim McClelland, artist Lloyd Rees, singer Robin Archer and actress Ruth Cracknell. Jack Mundey, an independent, radical Council Alderman who had pioneered Green Bans in Sydney in the early 1970s, was SCAPM's Secretary. He was to take the helm of the monorail protest.

Supported by the City Council and aligned with competent professional opinion and bodies such as the National Trust and the Royal Australian Planning Institute, SCAPM fought the monorail proposal for over a year. 'Not since the heady days of the green bans', one newspaper reported, 'have Sydney people's passions been so stirred over an environmental issue'.[59] The State government was forced to set up a Commission of Inquiry, a preliminary hearing for which commenced on 17 September 1986 in the Sydney Town Hall. Work on the monorail, however, had already commenced and, despite a rally which saw between 7000 and 10,000 protestors march through the City's streets, the State Government was determined to see the project through. Even before the preliminary inquiry, SCAPM's legal advisor indicated that the protestors' prospects of success were thin. Writing to Mundey on 16 September, he was to 'regret that my experience of several Commissions of Inquiry has persuaded me that there is a remarkable unanimity of opinion between the Commissioners of Inquiry and the Minister for Planning and Environment.[60]

The City Council may not have had ultimate control over Sydney's development, but its independent aldermen could certainly hold up project applications. With an economy in recession and arrangements well in hand for Australia's Bicentennial celebrations — which were to centre on Sydney[61] — the State government was keen to allow maximum development in the City. Council independents, however, proved to be obstructionist. A $100 million development in Pyrmont on the Merino One woolstore site was held up for six months on the grounds that it would generate too much traffic and otherwise impinge on residential amenity and convenience. Numerous proposals for hotel developments, too, had been delayed. Extensions to the Hyde Park Plaza had been upset by the City Council; new motels in Bayswater

The logo adopted by the group Sydney Citizens Against the Proposed Monorail (CCS, in Monorail file, Planning History Archives)

59 *Age*, 25 September 1986, p 11.
60 Correspondence supplied by Andrew Kay (now in CCS Archives).
61 See Paul Ashton, *Waving the Waratah: Bicentenary of New South Wales*, (NSW Bicentennial Council, Sydney, 1989).

The Council of the City of Sydney's Strategic Plan Review Committee, c.1977. From left to right are Jeremy Bingham (Civic Reform Alderman, solicitor and later Lord Mayor of Sydney); Andrew Briger; and George Clarke. Then Deputy Town Clark, Graham Joss, is third from the right at the front of the photograph. John Doran, City Planner and City Building Surveyor, is seated on the far right (CCS CRS 312/23)

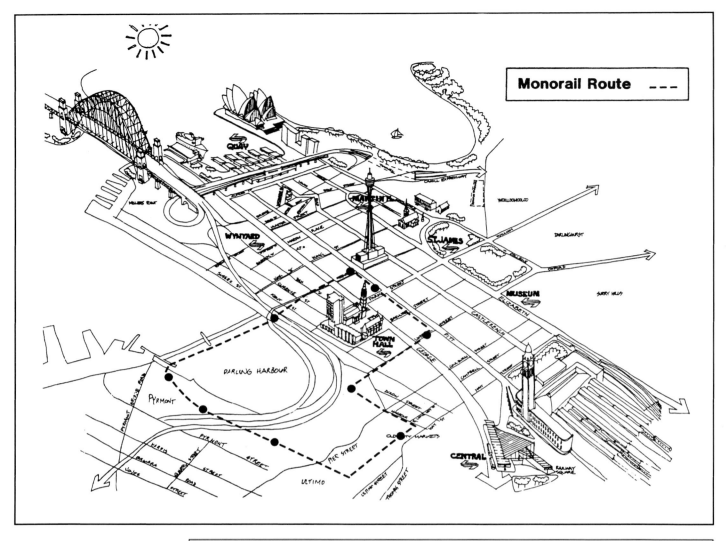

Monorail Route ---

(CCS, *Sydney's Proposed Monorail — The Facts*, [the Council, Sydney, c.1986])

Try to match the size of the State's graft with the size of the public playpens in front of which to be photographed. There are tens of thousands of people who can't eat and have nowhere not to eat in, but at least they'll be able to totter down to the Brerabbit Bicentenary Park and gaze at the multi-million-dollar Housing Museum in which the last affordable house to let in NSW will have been hermetically sealed in a vast glass dome for the public pleasure. They will also marvel at the 24-hour floodlights which will be necessary because no natural light will penetrate the forest of huge state-of-the-art concrete turds that currently tower on the spot where the city used to be, courtesy of the Goering-Blockhouse school of architecture. ('I knock 'em down, he runs 'em up.') Or as the architects sing:

> Ven ze buildings go up,
> Who cares vere zey look down?
> Zat's not our department.
> Ve don't live in town.

The Minister for Autographed Billboards, Mr Brerabbit, has realised that it is difficult to deface the street level any further and has come up with a train on sticks which will deface everything two stories up. He hopes that every time one of these uglies whizzes past, people will remember his name. They will, and in a perfect society they would hope that he is not enjoying his retirement . . .

Patrick Cook, 'Not the News', *National Times*, 6-12 December 1985

Sydney cartoonist Moir's comment in the Sydney Morning Herald *on the way in which Laurie Brereton, Minister for Public Works, and Premier Neville Wran, 'railroaded' the monorail proposal through both the NSW Parliament and public opinion* (Moir, *Sydney Morning Herald,* 1986)

Road in the Cross, Macquarie Street and Thomas Street were behind schedule; the Tourism Commission of New South Wales was showing signs of distress. Indeed, according to the Minister for Public Works, Laurie Brereton, if it had not been for direct intervention by the Minister for Planning and Environment, Bob Carr, the redevelopment of the Anthony Hordern's site by Ipoh Gardens, which included a major hotel, 'would still . . . [have been] languishing in the council chambers'.[62] 'When tens of millions of people visit Sydney next year for Australia's 200th birthday celebrations,' Brereton asserted (somewhat optimistically in terms of tourist numbers), 'the problems of lack of accommodation. . . [will be able to] be laid largely at the feet of . . . [the] City Council'.

State Government interest in a tourism-led economic recovery did not provide the sole concern about the City Council. Some feared the election of an independent to the position of Lord Mayor. In any event, on 26 March 1987, the Labor Premier of New South Wales, Barrie Unsworth, sacked the City Council, much to the shock of Labor Lord Mayor Doug Sutherland. On the following day, the Government's reason for dismissing the Council was quoted in the Sydney press. Barrie Unsworth declared that his government was firmly of the opinion

> that the City of Sydney perhaps warrants a different form of government . . . we believe [the sacking] was essential in the interests of Sydney, in the interests of New South Wales, and in the interests of Australia [to] eliminate the dissension that has occurred in recent times in the government of our city, eliminate the delay that has been occasioned to development of our city particularly, and the delay to important tourist infrastructure such as additional hotels and other major developments associated with the growth of our city's central business district.[63]

While most State politicians studiously avoided making mention of former Liberal Premier Sir Robert Askin since the lines of politics had become rather blurred, this 'expedient resort to naked power', as the *Herald* put it, saw the installation of a fourth

62 NSWPD, Legislative Assembly, 1 April 1987, p 9853. Other details are taken from this lengthy debate (pp 9838-905).
63 *SMH*, 27 March 1987. See also *NSWPD*, Legislative Council, 2 April 1987, p 9977 ff.

SCAPM advertisement, 1986
(CCS, in Monorail file, Planning
History Archives)

City Commission. The Commissioners (Sir Eric Neale, Sir Nicholas Shehadie and Norman Oakes, a former Secretary of the New South Wales Treasury) presided over Council affairs for the best part of two years. In the interim, despite its gifts to the public during the Bicentennial birthday bash, the State Labor Party lost office to a Liberal-National Party coalition. The Greiner government finalised the Legislative restructuring of the City Council which the Unsworth Government had commenced.

A City of Sydney Act was eventually assented to on 30 September 1988.[64] Re-establishing two separate councils for South Sydney and the City of Sydney, the Act also created a Central Sydney Planning Committee. Appointed by the Minister for Environment and Planning, and administered under the Environmental Planning and Assessment Act, this Committee was to have nine members. They were Sydney's Lord Mayor (who chaired the Committee), the Mayor of South Sydney, two aldermen of the City Council and the State Director of Planning along with four ministerial appointees.

Independent of the City Council and in effect a corporation, the Central Sydney Planning Committee took over all of the most significant planning functions of the City Council. Excluding those parts of Sydney controlled by the State, the Sydney Cove Redevelopment Authority (established by Act of Parliament in 1968)[65] and the Darling Harbour Redevelopment Authority, the Planning Committee was granted the exclusive right to deal with 'major' development applications and planning policy. This rendered the City Council more powerless in planning processes than any other local government body in Australia.

In the early 1980s, the Town Clerk of Sydney, Leon P. Carter, could write that the City's Strategic Plan 'embodies the corporate management philosophy of the organisation [and] . . . defines the objectives, policies and action priorities upon which the work and services program for the City is based'.[66] Less than a decade later, the reverse was true: 'the nearest thing we've got to . . . [a strategic plan]', an ex-Council strategic planner rightly suggested, 'is the new corporate plan which Council adopted in June 1991'.[67] In terms of city planning, the Council's role was one of civic watchdog on a very short leash. Economically, the roller-coaster ride of boom and bust throughout the 1980s was to culminate in a property market crash and high city office vacancy rates (over sixteen per cent by 1991). This was dramatically symbolised in the failed $1.6 billion World Square office tower, hotel and retail complex. Four soaring, silent cranes mark the site of Australia's largest private development. An adjoining monorail station provides the only activity on this deserted city block which, in 1992, was 'little more than an excavated hole that fills with murky water during heavy rain'.[68]

64 No 48, 1988.
65 See Blackmore, op cit.
66 *1983 City of Sydney Plan*, p vii.
67 Kerry Nash interviewed by
 Paul Ashton in *PS*, p 170.
68 *SMH*, 7 January 1992, p 7.

CLAIM FOR SPACE LOST TO MONORAIL

A public inquiry by the NSW Department of Environment and Planning began in Sydney this week to hear a claim by Pacific Countries Corp for compensation from the Sydney City Council as a result of the proposed Darling Harbour monorail project.

Pacific has proposed a 30-storey $180 million development on the corner of Pitt and Market Streets but wants permission to build extra office floors to compensate for shopping space lost to a monorail station in the building, plus compensation for added construction costs. . . .

The developer's solicitor, Mr Jeremy Bingham [a member of Civic Reform and later Lord Mayor of Sydney], said yesterday the development was financially viable according to the current code governing floor space ratios.

Peter Le Gras, *Financial Review*, 25 September 1986

Aldermen of the Council of the City of Sydney 1991. A smiling Lord Mayor, Jeremy Bingham, leans over a model of the City (CCS PR Unit)

In July 1991, the Central Sydney Planning Committee announced the exhibition of its draft Local Environment Plan and draft Development Control Plan for the City of Sydney. Accompanying these duller, detailed documents were two glossy, hyperbolic brochures which encapsulated the Committee's 'vision' for Sydney in the twenty-first century.

Reaffirming the 1988 Central Sydney Strategy which the State Government-appointed Committee had previously published, *City of Sydney: 2020*, as the brochures were titled, heralded a dynamic and prosperous future for the people of beautiful Sydney which would, readers were assured, be even more beautiful in time to come, given these fresh initiatives.

The Committee's vivid, if loosely framed conceptions of a Sydney-to-come were not, it was claimed, without historical precedents. According to Civic Reform alderman and Lord Mayor of Sydney, Jeremy Bingham, who signed the foreword to these documents, 'Over the two centuries of Sydney's growth, visionary statements have influenced the form and development of the city. Among them are the comments of: Governor Lachlan Macquarie; the 1908 [sic] Royal Commission; the 1971 City of Sydney Strategic Plan; and the 1988 Central Sydney Strategy.' The Central Sydney Strategy had yet to be put to the test, but had not these earlier visions already proven to be abortive or deluded?

Cutting through the 'hype and arrogance' of the public relations gloss, critics of the 'vision' noted the rather conservative nature of the Development Control Plan. One commentator wrote,

> The guilt of past ravages and blunders is apparent in the language which repeatedly stresses the need to 'retain', 'maintain', 'reinforce' and 'enhance' existing qualities. The remaining nineteenth- and early twentieth-century heritage buildings are being invariably asked to set the texture, style and character (but not always the bulk) of new development.[69]

Allowance, however, was made in this plan for a maximum floor-space ratio throughout most of Sydney of fifteen-to-one (higher than that for Manhattan), while directives as to sympathetic development and detailing were extremely vague.[70]

Unlike the Development Control Plan which, strictly speaking, was not a legal

69 Robert Freestone, 'Mayor Bingham's parting shots', *Australian Society*, August 1991, p 10.
70 See Central Sydney Planning Committee, *City of Sydney Draft Development Central Plan*, Part 1 and 2 (part 2 covers City precincts).

A 1991 comment by cartoonist John Lynch on official reactions to the bust in Sydney's development industry (Australian Society, August 1991)

document and would thus be open to 'flexible interpretation' (which in times of 'economic hardship' meant leniency with developers), the Local Environment Plan was a legal blueprint for the City. Yet it was still unable to 'break the mould of statutory instruments split between countless objectives phrased blankly for maximum incontrovertibility and a list of things you can't do'.[71] A separate heritage plan, which could be modified without recourse to legal measures, also attracted a good deal of criticism. Heritage items could be expediently and expeditiously removed from the City's heritage list by the Minister for Planning, which is precisely what happened in April 1992.[72]

The deadline for submissions regarding the Central Sydney Planning Committee's controversial plans for Sydney was 15 January 1992. By this time, even the Committee itself, which then had a number of new members representing the City Council — including Independent Alderman Frank Sartor, Sydney's Lord Mayor, and Independent Alderman, Elizabeth Farrelly — had decided, on Farrelly's suggestion, that a public hearing would be required to consider the document's various and serious flaws. This was supported by the new City Planner, ex-Melbournian John McInerney, who had been appointed to the position in July 1991. Indicating a general failing of the draft plans, one committee member wrote that the planning documents were a product of the

> current tendency . . . to have no rules — to write in vague, discretionary escape clauses so that everything in the end may be judged 'according to merit'; according, that is, to criteria which remain safely locked inside the personal black box of the decision maker(s).
>
> The effect of this is to obviate accountability and concentrate power in the hands of a few — in most cases, ultimately, the Minister, with each case decided ad hoc and no mechanism for ensuring consistency.[73]

An independent panel was set up to inquire into the Central Sydney Planning Committee's draft planning instruments. The three-member panel's conclusions were critical in the extreme. It found that the 'draft LEP and the draft DCP would not serve as an adequate basis for future planning and development control within the CBD and should be withdrawn'.[74] Some of the panel's recommendations included restricting the height of buildings in Sydney to around sixty storeys; setting a basic floor-space ratio at seven-to-one with provision for developers to *purchase* ratios of up to fourteen-to-one; and upgrading the importance of heritage buildings and areas of special significance. A number of critics were disappointed with these outcomes, arguing convincingly that if implemented, such recommendations would effectively remove any height limit in the City. They wanted to abolish the floor-space ratios which had become an entrenched part of the development industry culture, creating great expectations within that industry while reinforcing the universal assumption among developers that maximum limits were, in reality, only starting points.

Sydney's Lord Mayor, Alderman Frank Sartor, however, was generally pleased with the report. Vindicating the Committee's concerns, the inquiry, he remarked, had put 'the planning process . . . back on the rails': it had 'brought rigour to the whole process'.[75] Due process had, indeed, been reinstalled, but the outcome had yet to be seen. Once again, it appeared, a major gap would exist between 'the plan' and the reality. Biting economic depression and the machinations of the State and its planning apparatchiki bode no good for rational, humane planning in Australia's premier city. For many Sydney interests, it appears, the deeply entrenched laissez-faire approach still seems to satisfy.

71 Ibid, p 9.
72 *SMH*, 1 April 1992, p 2.
73 E. M. Farrelly, 'Our City is not going according to plan', *SMH*, 8 January 1992, p 11. See also *Financial Review*, 3 January 1992.
74 Central Sydney Planning Inquiry, *Report of the Independent Panel*, (CCS, Sydney, August 1992), p xi.
75 *SMH*, 3 September 1992.

Chronology

—————— ❦ ——————

1788	European invasion of the Australian continent; settlement established at Sydney Cove.
1833	Police (Sydney) Act passed 6 August incorporated provisions for regulating features of the built environment.
1834	Streets Alignment Act passed.
1837	An Act for Regulating Buildings and Party Walls in Sydney comes into force.
1841-44	Economic Depression.
1842	Sydney Corporation Act brings into being the Sydney Corporation (later known as the Council of the City of Sydney).
1853	Sydney Corporation Abolition Bill enacted 1853; Sydney Council sacked 1854-57.
1856	Self-government in NSW.
1879	City of Sydney Improvement Act passed.
	Select Committee appointed by colonial government to investigate City Improvement Bill drafted by Sydney Council.
	Sydney Corporation Amendment Act passed due to the enactment of the City of Sydney Improvement Act.
1890s	Severe economic depression.
1898	First municipal conference regarding the creation of a 'Greater Sydney' regional government; previous discussion re Greater Sydney during 1890s.
1900s	'City Beautiful and 'national efficiency' ideologies prevalent in Sydney planning thought and practice; waned during the late 1920s and 1930s.
1900	(January) Outbreak of bubonic plague in Sydney.
1901	Federation.
	Sydney Harbour Trust established.
1902	Sydney Corporation (Consolidation) Act; primarily exchanged electoral divisions for old City wards; no new powers to City Council.
1905	Sydney Corporation (Amendment) Act; primarily conferred powers of resumption on Council.
1906	Sydney Corporation (Amendment) Act passed to simplify the procedure for resumption settlements.
	Council of the City of Sydney begins series of major resumptions; continues until after World War II.
1908	(22 June to 10 May 1909) Royal Commission into the Improvement of Sydney and its suburbs.
1912	Sydney Corporation (Dwelling Houses) Act gave Council powers to construct flats and semi-detached houses.

Height of Buildings Act passed; Council to approve buildings up to 100 feet high; State government to approve buildings up to 150 feet (the City height limit).

(August) Professor Robert F. Irvine appointed Commissioner to undertake an *Inquiry into the Question of the Housing of Workmen in Europe and America*; published 1913.

1913 Royal Commission into the question of 'Greater Sydney'.

Formation of Town Planning Association of NSW.

Town Planning Display held in Sydney by Town Planning Association of NSW.

1914-18 World War I.

1917 (17-24 October) First Australian Town Planning Conference and Exhibition held in Adelaide; 250 delegates in attendance.

1918 (30 July to 6 August) Second Australian Town Planning Conference and Exhibition held in Brisbane.

1919 Local Government Act passed by State Parliament.

1922 (November) First Sydney Regional Plan Conference.

1924 (February-March) Sydney Regional Plan Conference holds one week Town Planning Exhibition.

Sydney Corporation (Amendment) Act; effectively secured adult franchise in City ensuring a Labor-dominated Council.

1927 (November) Bavin government succeeds in passing Sydney Corporation (Commissioners) Act; City Council dismissed; reinstated 1930.

1929 Sydney Corporation (Amendment) Act relieves a few of the problems surrounding building regulation.

1930s Severe economic depression.

1930 (25 October) Election for new City Corporation.

1931 Greater Sydney Bill passed through Legislative Assembly; amended by Legislative Council but lapsed on prorogation of Parliament.

1932 Sydney Corporation (Consolidation) Act brought into being to consolidate enabling legislation.

1934 Town and Country Planning Institute formed (split off from Town Planning Association).

Sydney Corporation (Amendment) Act includes new part regarding building regulations; effective from 1 January 1935.

1936 Housing Conditions Investigation Committee appointed by State Government to examine Sydney's slums.

City Council establishes City Planning and Improvement Committee.

1938 City Council appoints a Town Planning Assistant.

1939-45 World War II.

1941 State Premier William McKell establishes NSW Reconstruction Advisory Committee.

1943 Commonwealth Ministry for Post-War Reconstruction set up.

1945 (June) Royal Commission on Local Government Boundaries; presented Report in April 1946.

National Trust formed in NSW.

Local Government (Town and Country Planning) Amendment Act provided for the preparation of local government area planning schemes; established Town and Country Planning Advisory Committee; and provided for creation of Cumberland County Council (first Council meeting November; office operative January 1946).

1947 Select Committee on Local Government (Areas) Bill (reported 1948).

(October) City Council resolves to prepare a planning scheme for the City.

1948 (July) Cumberland County Council submits metropolitan master plan to Minister for Local Government.

City Council resolves to establish a small Town Planning Branch.

Local Government (Areas) Act passed through State Parliament; provided for amalgamation of some LGAs; required all LGAs to prepare planning schemes; included expansion of City of Sydney Boundaries.

Cumberland County Council Plans and Planning Exhibition on display in Sydney Town Hall, 28 July to 3 August; official opening 27 July.

(December) First meeting of newly amalgamated City Council under Local Government (Areas) Act 1948; included municipalities of Alexandria, Darlington,

Erskineville, Glebe, Newtown, Paddington, Redfern and Waterloo.

Sydney Corporation Act repealed; Council of the City of Sydney brought under Local Government Act (1919); effective from 1 January 1949.

1949 (29 August) Public Inquiry into Cumberland County Council Scheme Ordinances (conducted by Norman Weekes).

1950 (March) Landlord and Tenant (Amendment) Act passed; significantly decreased rent control on business premises; also removed war-time restrictions on use of building materials.

1951 (June) County of Cumberland Planning Scheme assented to by Parliament via passing of Local Government (Amendment) Act.

Local Government (Amendment) Act passed; contained County of Cumberland Planning Scheme Ordinance (as a schedule) to take effect from date of assent (27 June); also contained provisions for the preservation of places of scientific or historic 'interest'.

(December) City Council submits draft town planning scheme to Minister for Local Government (one year late).

(January) Commonwealth government refuses to co-fund Cumberland County Council Plan; scheme modified.

1952 (November) City of Sydney Planning Scheme exhibited in Sydney Town Hall.

Height of Buildings (Amendment) Act eased height controls and abolished floor-space index.

1956 (January) Circular Quay overhead railway finished.

(18 April) Commission of Inquiry commenced looking into transfer of powers from local government to Cumberland County Council (held in Sydney Town Hall).

Revaluation of Sydney's CBD.

1957 Abolition of 150-foot (46-metre) height restriction on buildings with passing of Height of Buildings (Amendment) Act; Height of Buildings Advisory Committee created (independent of City Council).

Rent control removed on all new buildings finished after September.

1958 (31 December) Draft City of Sydney Planning Scheme submitted by City Council to Minister for Local Government; scheme incomplete — final material submitted 17 August 1959.

(March) Cahill Expressway over Circular Quay completed.

1960 City Council flats completed at Camperdown and Glebe.

1962 Local Government (Town and Country Planning) Amendment Act introduced; many Cumberland County Council powers transferred to local government.

1963 State Planning Authority Bill introduced to Parliament; planning responsibilities of Department of Local Government transferred to SPA; received assent on 19 December.

1964 (2 March) State Planning Authority operative.

(31 December) City of Sydney Planning Scheme exhibited by Minister for Local Government; later modified.

1965 First year computer-assisted traffic transportation studies carried out in Australia.

(May) Boundaries Commission appointed by Askin Liberal-Country Party Government as Royal Commission to investigate City of Sydney wards and boundaries.

1966 Public Inquiry into draft City of Sydney Planning Scheme; commissioner A. F. Davis appointed 18 February; hearing commenced 21 March and closed 2 June.

1967-69 Council of the City of Sydney sacked; three Commissioners appointed by State Government.

1967 Responsibility for Heights of Building Act transferred from City Council to SPA under Local Government (City of Sydney Boundaries) Act (introduced into Parliament 13 September; passed November).

(20 November) City Planning Scheme re-exhibited.

Civic Reform Association appoints a Planning Committee.

1968 State Government promotes preparation of Plan for Woolloomooloo; SPA undertakes work on behalf of City Council.

State Government creates Sydney Cove Redevelopment Authority.

1969 (15 December) City Council resolves to commission the preparation of a strategic plan for Sydney.

	Restoration of Council of the City of Sydney.
	Betterment tax introduced by State Government; abolished 1973.
	(September) Civic Reform City Council elected.
	Woolloomooloo 'Control Plan' prepared by State Planning Authority submitted to Council by Chief City Commissioner; adopted 11 August.
1971	First 'green ban' in Sydney.
	(20 July) City of Sydney Strategic Plan published; adopted in principle on 2 August.
	Town Planning Department set up in City Council.
	(10 September) First stage of Martin Place Mall opened to public.
1972	Federal Labor Government establishes Department of Environment and Department of Urban and Regional Planning.
1973	(December) First meeting between Federal, State and City Council representatives to stop commercial high-rise development in Woolloomooloo.
1974	Planning and Environment Commission established in New South Wales; replaced SPA. Commissioners appointed 18 November.
	(13 May to 14 June) Plans for redevelopment of Woolloomooloo exhibited.
	Second Sydney Strategic Plan (review and update of first) adopted by City Council.
1975	Interim development order No 26 proclaimed on Woolloomooloo (8 August) rezoning much of area residential; NSW Housing Commission to develop residential area with Commonwealth Funding.
	Federal Government passes Australian Heritage Act.
1976	Statement of Claim filed by developer San Sebastian against former SPA and City Council re losses over Woolloomooloo redevelopment plan; resolved 1990 in favour of State Government and City Council.
1977	Third Sydney Strategic Plan (review and update of first and second) adopted by City Council.
	Passing of NSW Heritage Act.
1979	Environmental Planning and Assessment Act passed by NSW Government.
	Establishment of NSW Land and Environment Court.
	Wran Labor Government put through Parliament a series of bills to consolidate and amend planning-related legislation.
1980	Creation of Department of Environment and Planning in NSW (replaced Planning and Environment Commission).
	Fourth Sydney Strategic Plan (review and update of previous plans) adopted by City Council.
1983	Fifth and final Sydney Strategic Plan adopted by City Council.
1984	Darling Harbour Authority created by State government; removed this area from Council control.
1987	(26 March) City Council sacked by the State Government; Commissioners appointed.
1988	Bicentennial celebrations.
	City of Sydney Act passed 30 September; set-up City of Sydney Council and separate Council of South Sydney; established Central Sydney Planning Committee. Committee adopts a Central Sydney Strategy.
1989	NSW Heritage Council (part of Department of Environment and Planning) removes permanent conservation order on Woolloomooloo Bay Finger Wharf (decision reversed after public protests in 1992).
1991	Central Sydney Planning Committee adopt draft Development Control Plan and Local Environment Plan for City; documents highly criticised.
1992	Panel of Inquiry appointed by City Council to report on Central Sydney Planning Committee's draft DCP and LEP; panel recommends abandoning these documents.

Select Bibliography

Alexander, Ian, 'Strategic Planning in Central Sydney', *Royal Australian Planning Institute Journal* (November 1978), pp 123-25.
——, 'Capitalist city planning: A dialectical irrelevance', *Australian Planner*, (April/May 1984), pp 39-41.
Anderson, G. F., *Fifty Years of Electricity Supply: The Story of Sydney's Electricity Undertaking*, SCC, Sydney, 1955.
Aplin, Graeme (ed), *A Difficult Infant: Sydney Before Macquarie*, NSW University Press in association with the Sydney History Group, Sydney, 1988.
Ashton, Nigel, *From Village to Metropolis: A Brief Review of Planning in the Sydney Region*, Department of Environment and Planning, Sydney, 1984.
Ashton, Paul, *Waving the Waratah: Bicentenary of New South Wales*, NSW Bicentennial Council, Sydney, 1989.
Ashton, Paul and Blackmore, Kate, *Centennial Park: A History*, NSW University Press, Sydney, 1988.
Ashton, Paul (comp), *Planning Sydney: Nine Planners Remember*, Council of the City of Sydney, Sydney, 1992.
Australian Town Planning Conference and Exhibition, Official Volume of Proceedings, Varden & Sons, Adelaide, 1918.
Berry, Michael and Sandercock, Leonie, *Urban Political Economy: The Australian Case*, Allen & Unwin, Sydney, 1983.
Brady, E. J. (ed), *Sydney: The Commercial Capital of the Commonwealth*, Sydney, 1904.
Brown, A. J. and Sherrard, H. M., *Town and Country Planning*, MUP, Melbourne, 1951.
Central Sydney Planning Inquiry, *Report of the Independent Panel*, Council of the City of Sydney, Sydney, August 1992.
Clarke, W. G., 'The organisation of urban renewal', *Architecture in Australia*, (December 1962), pp 96-8.
Coltheart, Lenore (ed), *Significant Sites*, Hale & Iremonger, Sydney, 1989.
Council of the City of Sydney, *City of Sydney Strategic Plan*, The Council, Sydney, 1971.
Coward, Dan, *Out of Sight . . . Sydney's Environmental History 1851–1981*, Department of Economic History, Australian National University, Canberra, 1988.
Curson, P. H., *Times of Crisis: Epidemics in Sydney 1788–1900*, Sydney University Press, Sydney, 1985.

Daly, M. T., *Sydney Boom, Sydney Bust*, George Allen & Unwin, Sydney, 1982.

Davenport, C. B., *Heredity in Relation to Eugenics*, Williams & Norgate, London, 1912.

Fitzgerald, J. D., 'Town Planning and City Beautification', *The Lone Hand*, (1 May 1914), p 389.

Fitzgerald, Shirley, *Rising Damp: Sydney 1870-90*, Oxford University Press, Melbourne, 1987.

——, *Chippendale: Beneath the Factory Wall*, Hale & Iremonger, Sydney, 1990.

——, *Sydney 1842-1992*, Hale & Iremonger, Sydney, 1992.

Fitzgerald, Shirley and Keating, Christopher, *Millers Point: The Urban Village*, Hale & Iremonger, Sydney, 1991.

Freeland, J. M., *The Making of A Profession: A History of the Growth and Work of the Architectural Institutes in Australia*, Angus & Robertson, Sydney, 1971.

——, *Architecture in Australia: A History*, Penguin, Ringwood, 1974.

Freestone, Robert, *Model Communities: The Garden City Movement in Australia*, Nelson, Melbourne, 1989.

——, 'The Sydney Regional Plan Convention: A 1920s Experiment in Metropolitan Planning', *Planner*, 3, 9, (1989), pp 7-13.

——, 'Mayor Bingham's parting shots', *Australian Society*, (August 1991), pp 10-11.

——, 'John Sulman and "The Laying Out of Towns"', *Planning History Bulletin*, 5, 1, (1983), pp 18-24.

Frost, Lionel, *The New Urban Frontier: Urbanisation and City Building in Australasia and the American West*, New South Wales University Press, Sydney, 1991.

Hall, Peter, *Cities of Tomorrow: An Intellectual History of Urban Planning and Design in the Twentieth Century*, Basil Blackwell, Oxford, 1990.

Irvine, R. F. et al, *National Efficiency . . .*, Melbourne, 1915.

Irvine, R. F., *Town Planning: What it Means and What it Demands*, Town Planning Association of NSW, Sydney, July 1914.

——, *Report of the Commission of Inquiry into the Question of the Housing of Workmen in Europe and America*, W. A. Gullick, Government Printer, Sydney, 1913.

Jones, Greta, *Social Darwinism and English Thought: The Interaction Between Biological and Social Theory*, The Harvester Press, Brighton, 1980.

Keating, Christopher, *Surry Hills: The City's Backyard*, Hale & Iremonger, Sydney, 1991.

Kelly, Max (ed), *Nineteenth Century Sydney: Essays in Urban History*, Sydney University Press in association with the Sydney History Group, Sydney, 1978.

Kelly, Max (ed), *Sydney: City of Suburbs*, NSW University Press in association with the Sydney History Group, Sydney, 1987.

Kelly, Max, *A Certain Sydney 1900*, Doak Press, Sydney, 1977.

Larcombe, F. A., *A History of Local Government in New South Wales*, Sydney University Press, Sydney: Vol 1, *The Origin of Local Government in New South Wales 1831-58*, (1973); Vol 2, *The Stabilization of Local Government in New South Wales 1858-1906*, (1976); Vol 3, *The Advancement of Local Government in New South Wales 1906 to the Present*, (1978).

Maslen, T. J., *The Friend of Australia; or, A Plan for Exploring the Interior and Continent of Australia . . .*, Hurst, Chance & Co, London, 1830.

Mawson, Thomas, 'The Design of Public Parks and Gardens', *Town Planning Review*, 1, 3, (1910), pp 205-11.

Mayne, A. J. C., *Fever, Squalor and Vice: Sanitation and Social Policy in Victorian Sydney*, UQP, St Lucia, 1982.

McFarlane, B., *Professor Irvine's Economics in Australian Labour History*, ASSLHC, Canberra, 1966.

Miller, J. D. B., 'Greater Sydney, 1892-1952', *Public Administration*, 13, 2, (June 1954), pp 118-19.

Morris, Jan, *Sydney*, Viking, London, 1992.

Nairn, Bede, *Civilising Capitalism: The Beginnings of the Australian Labor Party*, Melbourne University Press, Melbourne, 1989.

O'Flanagan, Neil, 'John D. Fitzgerald and the Town Planning Movement in Australia', *Planning History*, 10, 3, (1988), pp 4-6.

Planning Research Centre, *Urban Redevelopment in Inner-City Areas*, James Bennett, Collaroy, 1966.

Roe, Jill (ed), *Twentieth Century Sydney: Studies in Urban and Social History*, Hale & Iremonger in association with the Sydney History Group, Sydney, 1980.

Rowse, Tim, *Australian Liberalism and National Character*, Kibble Books, Melbourne, 1978.

Sandercock, Leonie, *Cities for Sale: Property, politics and urban planning in Australia*, Melbourne University Press, Melbourne, 1975.

Scott, Peter (ed), *Australian Cities and Public Policy*, Georgian House, Melbourne, 1978.

Sheather, Graeme (ed), *Planning in the City of Sydney: Proceedings of a One-Day Conference*, Planning Research Centre, University of Sydney, 1975.

Spearritt, Peter, *Sydney Since the Twenties*, Hale & Iremonger, Sydney, 1978.

Spearritt, Peter and DeMarco, Christina, *Planning Sydney's Future*, Allen & Unwin, Sydney, 1988.

Sulman, John, 'The Laying Out of Towns', in Australasian Association for the Advancement of Science, *Report of the Second Meeting*, (Melbourne, 1890), pp 730-36.

Sydney Regional Plan Conference, *The First Brochure of the Sydney Regional Plan*, Sydney, 1922.

Taylor, George A., *The Town Planner and His Mission*, Monograph No 2, Town Planning Association of NSW, March 1914.

———, *Town Planning with Common Sense*, Building Limited, Sydney, 1918.

Toon, John, 'Sydney Cove — a Proposal for Urban Redevelopment', *Australian Planning Institute Journal*, (October 1962), pp 75-9.

Town Planning Association of NSW, *Town Planning Display*, Sydney, 1913.

Troy, P. N. (ed), *Urban Redevelopment in Australia*, Australian National University Press, Canberra, 1967.

Webber, G. P. (ed), *The Design of Sydney: Three Decades of Change in the City Centre*, The Law Book Company, Sydney, 1988.

Wilcox, Murray R., *The Law of Land Development in New South Wales*, The Law Book Company, Sydney, 1967.

Wilson, S. E., *Is Planning Stifling Development?*, Shepherd & Newman, Sydney, 1953.

Winston, Denis, et al, *Australian Cities: Chaos or Planned Growth?*, Angus & Robertson, Sydney, 1966.

Wotherspoon, Garry (ed), *Sydney's Transport: Studies in Urban History*, Hale & Iremonger in association with the Sydney History Group, Sydney, 1983.

Index

Compiled by Alan Walker

The index covers all of the text, including the Tables. Page numbers in **bold type** refer to the major treatment of topics. The abbreviation (n.) refers to footnotes.

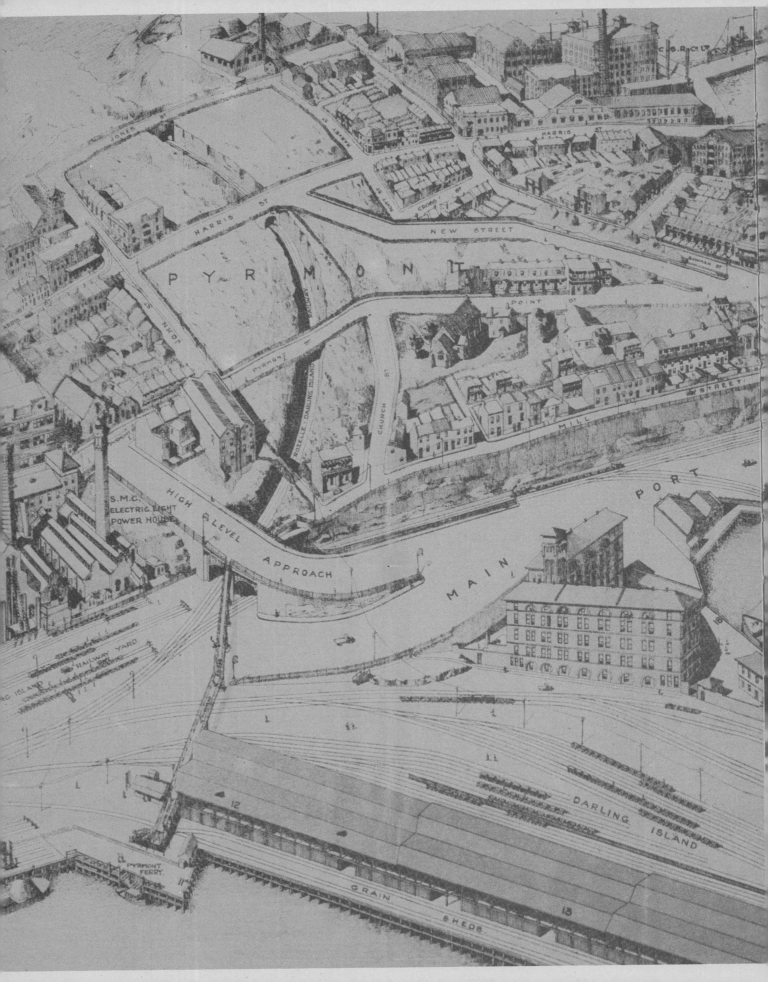